SEAPORT

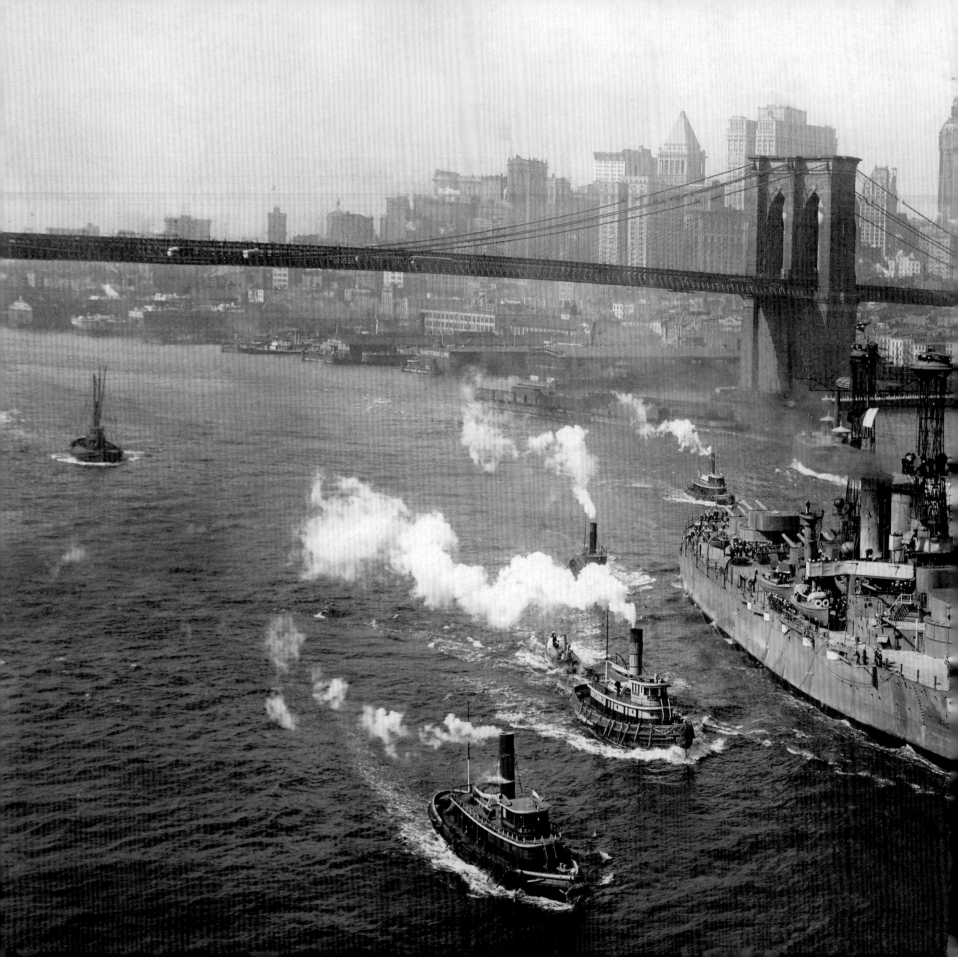

SEAPORT
New York's Vanished Waterfront

PHOTOGRAPHS FROM THE EDWIN LEVICK COLLECTION
TEXT BY PHILLIP LOPATE

In association with
The Mariners' Museum

Smithsonian Books
Washington

Beverly McMillan developed and edited this volume for The Mariners' Museum. Special appreciation goes to the following individuals at The Mariners' Museum: Thomas Moore, Senior Curator of Photography; Claudia Jew, Photo Research; Jason Copes, Digital Scanning and Restoration; Betty Zattiero, Publications.

Library of Congress Cataloging-in-Publication Data
Lopate, Phillip, 1943–
 Seaport : New York's vanished waterfront : photographs from the Edwin Levick Collection / text by Phillip Lopate.
 p. cm
 ISBN 1-58834-163-1 (alk. paper)
 1. New York (N.Y.)—History—1898–1951—Pictoral works. 2. New York Harbor (N.Y. and N.J.)—History—20th century—Pictoral works. 3. Waterfronts—New York (State)—New York—History—Pictoral works. 4. Ships—New York (State)—New York—History—20th century—Pictoral works. I. Edwin Levick Collection. II. Mariners' Museum (Newport News, Va.) III. Title.

F128.5.L84 2004
974.7'1041'0222—dc22

2003065914

British Library Cataloging-in-Publication Data available
Printed in China, not at government expense
10 09 08 07 06 05 04 1 2 3 4 5

∞ The paper used in this publication meets the minimum requirements of the American National Standard for Information Sciences—Permanence of Paper for Printed Library Materials ANSI Z39.48-1992.

CONTENTS

Preface

Thomas Moore

vii

The Port of New York in Its Heyday

Phillip Lopate

1

Photographs from the Edwin Levick Collection

38

Notes on the Photographs

175

Snub nose of a subma-
rine in the New York
Navy Yard.

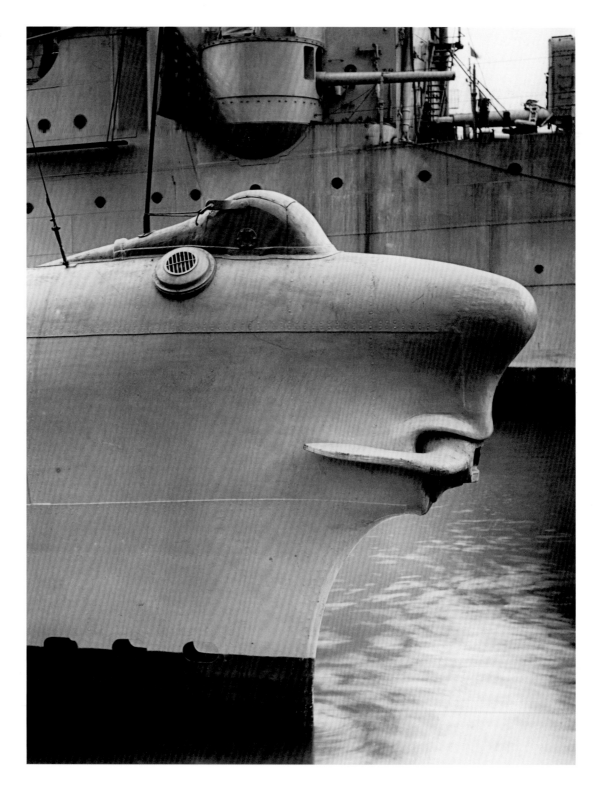

PREFACE

In 1955 the Frederick Lewis News Agency in New York City contacted The Mariners' Museum in Newport News, Virginia, to inquire if the museum was interested in purchasing 30,000 negatives and approximately 28,000 vintage photographs dealing with a range of maritime subjects, including New York's harbor and waterfront in the early decades of the twentieth century. Accompanying this massive photographic collection were logbooks that recorded details for most negatives, including size, a brief title or description, date of the shoot, and the name or initials of the photographer who had completed the assignment. Quick to recognize the historical potential in such an archive, The Mariners' Museum eagerly acquired it and began the laborious process of cataloging its contents. Approximately 16,000 negatives were added later, in two groupings acquired from the Lewis agency in 1961 and 1985, respectively.

With time it became clear that although the collection included pictures by numerous photographers, it was dominated by the striking work of a British émigré named Edwin Levick. Hence the corpus The Mariners' Museum bought from the Lewis agency is known today as the Edwin Levick Collection. The photographs in the following pages are from this remarkable assemblage, and most were taken by Levick. Among the other Levick Collection photographers represented are Percy L. Sperr, Lionel Green, and J. Jay Hirz.

At the close of the nineteenth century, when Levick was launching himself as a maritime photographer in his adopted country, the great Nathaniel Livermore Stebbins still reigned supreme in Boston, but pioneering New York maritime photographers such as Edwin Bolles, James Burton, and John S. Johnston had passed on. Accordingly, Levick found himself in a field that was virtually wide open to new blood. Employing

several assistants, around 1902 Levick established a commercial photography business at 108 Fulton Street, in the midst of New York's then-thriving waterfront.

Levick didn't limit himself or his business to maritime topics. He and his assistants photographed breaking news stories, sports and society events, street scenes, and architectural views—as well as doing bread-and-butter commercial work. Along with other local photographers, Levick even contributed images for a series of postcards promoting New York City attractions and events.

Yet the waterfront and waterfront people, as well as boats and ships of every description, clearly were Edwin Levick's abiding passion. It was not long before his maritime and yachting photographs began to grace the pages of *Rudder* and *Motorboat Magazine*, as well as *Vanity Fair* and *Scientific American*. At the same time, Morris Rosenfeld was beginning his successful career—he even accepted assignments from Levick early on—and during the first two decades of the twentieth century Levick and Rosenfeld had a virtual monopoly on maritime photography in and around New York. During the yacht-racing season their photographs often appeared essentially side by side on the photogravure pages of the *New York Herald Tribune*. As Phillip Lopate notes in his thoughtful essay for this volume, Levick also took pictures for the *Chicago Tribune* and the *New York Times*, excelling at capturing scenes of waterfront life and doings. For years he was considered the "official" New York Yacht Club photographer, covering events ranging from local club regattas to the America's Cup races. Levick's vintage America's Cup images are among his most beautiful pictures—two appear in this volume—and are the heart of the book *An America's Cup Treasury* published by The Mariners' Museum in 1999.

In the days of the speed Graflex camera and 4 × 5- and 5 × 7-inch glass-plate negatives, maritime photography was challenging at best. The introduction of the gelatin dry plate in the 1880s transformed the photographic process, making picture taking much more convenient and instantaneous photography the standard. Exposure times were dramatically shortened, allowing moving objects to be captured with precision and in great detail. Edwin Levick lost no time in exploiting innovations, and he soon developed great technical proficiency.

Levick had grown up around boats and moved easily among sailors, dock workers, and the motley array of vessels that passed through New York's then-bustling waterfront. As readers will discover in the following pages, he also had a keen-eyed understanding of his material. In the right place at the right time, he

documented maritime activities during a period of active shipbuilding and rapid expansion of maritime commerce—the halcyon days of the Port of New York in the early 1900s. His images capture the energy of a confident nation unflinchingly marching into a new and promising century. The tired but expectant faces of immigrants arriving in New York Harbor, muscled longshoremen shouldering break-bulk loads, majestic luxury liners and their affluent passengers, fleets of fishing boats and merchant schooners, massive hulls being riveted in cavernous dry docks, the exhilarating America's Cup races—all these subjects were evidence and symbols of the new age. Levick could capture the grace and power inherent in the lines of vessels as different as colossal transoceanic liners and the yachting world's classic J-boat, photographing each in perfect visual symmetry. He also was welcomed aboard the sleek, stylish boats of his yachting clientele, photographing the vessels' crews and lavish interiors. Levick was at the peak of his career when he died at age sixty-one at his home at 173 Mount Joy Place in New Rochelle. His sons, John and Phillip, carried on with the family business under the name Levick Photo, Inc., until the company's demise around 1940.

Many of the photographs in this volume came to The Mariners' Museum as acetate negatives—a vulnerable form for irreplaceable visual records of the past. In 1991 a preservation grant from the National Endowment for the Humanities allowed the museum to duplicate thousands of the finest Levick Collection negatives onto an archival film base. The daunting task of creating a comprehensive database of the collection's holdings goes on, challenged and inspired by the extraordinary diversity of subjects Edwin Levick and his associates captured with their cameras. Meanwhile, The Mariners' continues to incorporate images from the collection into exhibitions and publications, offering to visitors and readers alike a compelling glimpse into Edwin Levick's rich photographic legacy.

<div align="center">

Thomas Moore
Senior Curator of Photography
The Mariners' Museum

</div>

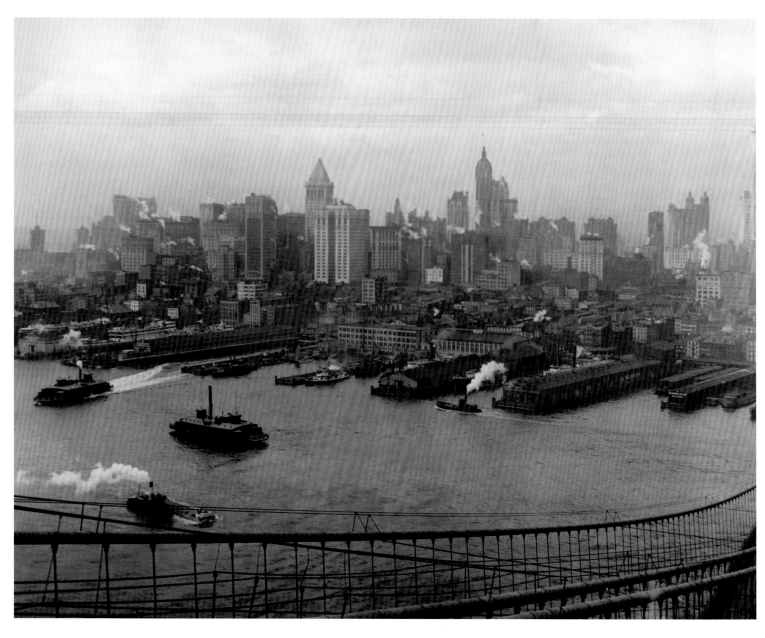

New York and its harbor through the lens of Edwin Levick in November 1912.

The Port of New York in Its Heyday

PHILLIP LOPATE

Between 1830 and 1960 the Port of New York was the busiest in the world. It was also the largest in terms of available waterfront: The Greater New York area, including Yonkers, Jersey City, Newark, and Long Island, had a waterfront extending 771 miles, of which 362 were developed with piers. Manhattan alone had a direct waterfront of 43 miles, with its developed waterfront (measuring along the piers and the heads of slips) totaling about 76 miles. On Manhattan's West Side, a continuous line of finger piers extended up the Hudson River to accommodate all the ships in port, while on the other side of the island, the East River teemed with every kind of vessel—tugboats, liners, sailboats, steamboats, freighters, tankers, barges, and fishing trawlers—passing to and from the ocean.

The Port of New York was not only a massive economic engine powering the whole region; it was also a crucial piece of the legend America was generating about itself. From as early as 1850, Walt Whitman had sung of Manhattan as a city of ships, and Herman Melville, in the early pages of *Moby-Dick*, had portrayed a landlubber populace standing on these same shores, aching to go to sea. Paul Rosenfeld went so far as to title his study of American early modernist artists (Stieglitz, Dove, Marin, O'Keefe, and others) *Port of New York*; and movies, from *The Docks of New York* to *On the Waterfront*, spread its fame worldwide, casting it as a site of sin and redemption.

Today, almost all that activity is gone. Particularly in Manhattan, the city's glamorously synecdochic center, you would be hard pressed to find any evidence of the old working waterfront. Oh, a few small pieces hang on in Brooklyn and Staten Island, but most of the port's activities have been relocated to New Jersey. The major reason for this displacement was the shift from break-bulk loading (page 40), a multiple-handling system by teams of longshoremen, to containerization, which began in the mid-1960s. Containerization makes it possible for cargo to be handled only once, from ship's hold until it reaches its destination. The cargo is hoisted in standardized crates by enormous cranes and forklifts, then loaded onto trucks or trains, a system that requires considerable back-up space to store the containers and machinery. Manhattan, certainly, had no such back-up space to offer; its valuable skyscraper real estate had long since begun to encroach hard against the shore. The same phenomenon has happened in one major urban center after another around the globe, disconnecting the old symbiotic relationship between city and port. In any event, by 1980 the seemingly unstoppable waterfront environment of New York City had all but vanished, as effectively as the fabled underwater city of Atlantis.

Although we know the reasons why it happened, such an uncanny transformation from bustling to empty harbor still strikes us with the force of mystery. In the face of that absence, we turn to this remarkable photographic record of the Port of New York and New Jersey in its heyday, which has been culled and assembled by the Mariners' Museum in Newport News, Virginia, from its vast Levick Collection holdings. Poring over these photographs, we can take in at our leisure the marvelous details of casual intimacy and cheek-by-jowl proximity by which the gritty working waterfront and the rising metropolis coexisted, once upon a time.

AT THE WATER'S EDGE

The city grew up around the port, which had existed from its inception, when it was still the Dutch colony of New Amsterdam. (Indeed, there is evidence that Native American tribes who inhabited the area before the Europeans arrived also used it primarily for maritime trading and fishing, rather than for agriculture.) The harbor's advantages were immediately grasped: It had deep channels, was sheltered from the ocean's worst storms, had a choice of two river routes leading to the sea, and was rarely ice bound. Moreover, it enjoyed potentially excellent access to the western frontier—a situation capitalized on by the digging of the Erie

Canal, which opened in 1825. By 1860 the Port of New York was handling 52 percent of the nation's combined imports and exports; and the New York Custom House collected enough duties to pay all operating expenses of the national government, except the interest on the debt. In 1900 New York's shippers were still handling two-thirds of the nation's imports and one-third of its exports.

The waterfront districts next to all this robust shipping activity offered every kind of specialized maritime business or supportive service imaginable, from rigging outfitters and drydock repair yards to shipping agents, chandlers, and warehouses. Hotels, rooming houses, taverns, brothels, and seamen's chapels catered to the needs of visiting crews. (Pages 43 and 44 offer two views of the Seamen's Church Institute, which housed the men in port while ministering to their souls.) It was a transitional zone, a village within the city, and many seamen and sailors who put into port never ventured beyond its confines. We can see the storefronts and signs of these establishments beckoning in the background of photographs depicting the harbor. What is most striking, however, about these pictures is how the New York streets went right down to the river's edge. This was before the construction in the 1930s and 1940s of perimeter highways, such as the West Side Highway and FDR Drive, that would cut off the citizenry from river access.

The earliest photographs (pages 46–48), undated but probably from around 1908, show horse-drawn carts lined up row after row, waiting to pull the unloaded cargo through the streets. Already evident was the problem of bottleneck traffic that would beset the downtown Manhattan waterfront district throughout its shipping life, partly caused by the old, narrow, cobbled streets that fed into the piers. The introduction of motor vehicles both complicated and simplified circulation; when covered in snow (pages 49 and 50), heavily trafficked South Street would bog down even more. A 1911 photograph shows cars militantly lined up, with more order if less charm than the horse-drawn conveyances, in front of dock shed and warehouse (page 51). The stunningly composed bird's-eye cityscape, overleaf, portrays a wide, automotive-and-horse-vehicled South Street, piers, ocean liner, the Brooklyn Bridge and the skyline in the background, and a foreground building painted with the piquant slogan, "Children Cry for Castoria," a heavily promoted castor oil of the day.

Most of the docks were of makeshift wooden construction, thrown up hastily. Wood was king: Curiously enough, the already-polluted harbor drove away shipworms, thereby protecting the timbers and acting as a disincentive for more durable waterfront structures to be built. The Chelsea Docks (page 52), completed in

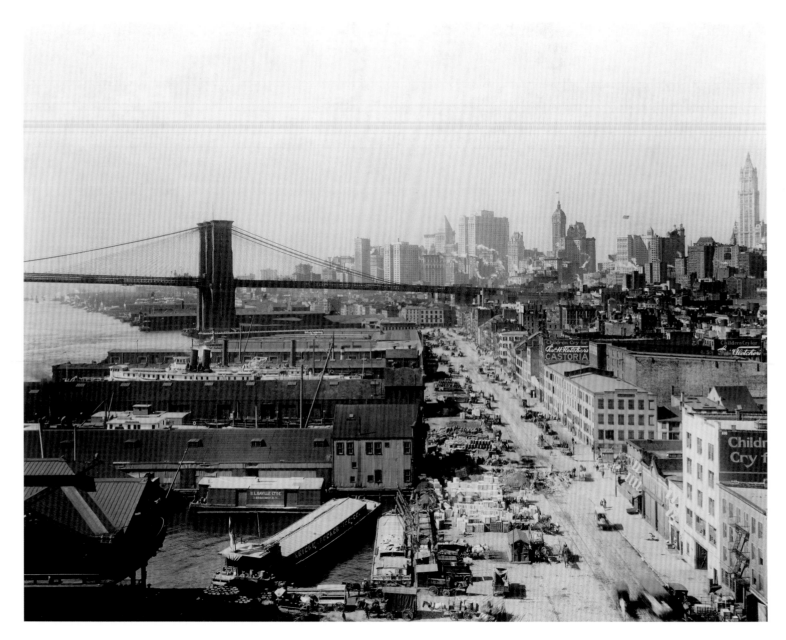

Overlooking South Street. In this undated photograph, horse-drawn carts mingle with the encroaching tide of motor vehicles. The Woolworth Building rises in the distance (right).

1910 by Warren and Wetmore, the architects of Grand Central Station, represented a rare exception: an imposing Italianate stone edifice catering to the new, ocean-going liners. The ill-fated *Titanic* was set to dock there.

In the first three decades of the twentieth century, the edges of downtown Manhattan were blessed with a filigreed skyline: This harmoniously graduated ensemble of stepped-back masonry towers is what foreign visitors, immigrants, and other ship passengers saw when they first entered New York Harbor (page 54). The local skyscraper style—a blend of fantasy, advertising, and practicality dubbed "Manhattanism" by the architect Rem Koolhaas—offered a sort of eclectic, pleasure-principle, ornamental alternative to the boxy austerities of international modernism. Many of the photographs collected here deliberately include glimpses of the celebrated New York skyscrapers as everyday waterfront components. The visual entanglement of skyscraper forms and vertical masts is dramatically conveyed in a shot of the schooner RR *Govin* unloading: Thanks to the photograph's collapsed space, the mighty modernist city seems to be breathing down the neck of the old vessel, which is still holding its own.

For a truly romantic view of that photogenic 1920s architecture presiding over the docks, look at page 55: The stepped-back forms of the giants (Ralph Walker's art deco mountain, the Barclay-Vesey Building, and Cass Gilbert's earlier, terra-cotta faced Woolworth Building) graciously lean away from the water's edge, under a darkening sky, allowing the low-slung Fall River Line pier its dignified place in the foreground.

THE PHOTOGRAPHERS

It will not do to discuss these photographs as anonymous artifacts. The majority reproduced in this volume were taken by Edwin Levick, a successful commercial photographer who left behind an archive of some 30,000 prints and negatives, which form the core of the Levick Collection at the Mariners' Museum. Born in London in 1868, Levick grew up in the Middle East, in Suez, where his father was a packet agent for the East India Company and later the British vice-consul. As a boy, wandering around the canal, he conceived an early fascination for ships. He later received part of his education in France. Levick was already thirty-two years old when he emigrated to America in 1900. Speaking French and Arabic fluently, he secured a translating job with the Guarantee Trust Company. But banking was not for him; he took the plunge as a freelance journalist, illustrating his general news stories with photographs. Soon his camera work attracted more attention than his writing, prompting a switch to photography.

Deck scene on the four-masted schooner RR *Govin*. This merchant vessel regularly sailed between northeastern ports such as New York and Halifax, Nova Scotia, often bearing cargoes of lumber and wood pulp. In this photograph a produce truck waits to receive burlap-bagged potatoes while the Farmers Trust Building looms in the distance.

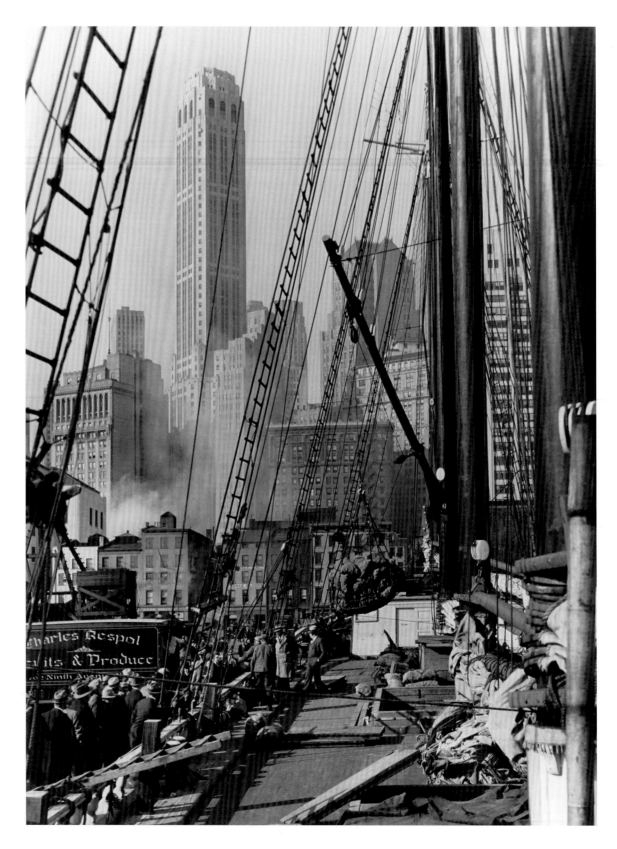

With his English accent, trim mustache, and well-bred air, Levick was quickly accepted into New York society. Though he took pictures of almost every New York society sport for which there was a market (including golf, polo, horse shows, and fox hunts), he came to specialize in marine photography. He was in fact one of the founders of that field, along with John S. Johnston, James Burton, the Loefflers, Charles E. Bolles, and Morris Rosenfeld. Given the popularity of yachting and the America's Cup (then held in New York's lower bay, between Brooklyn and Staten Island), the demand for marine photography was sufficient to support him and his rivals. The vogue for marine photography lasted roughly four decades; the New York–based America's Cup races ended in 1939, and after World War II, travel went airborne. But the field was still going strong in the 1920s, when Levick's photographs appeared regularly in the *New York Times, Chicago Tribune,* and *New York World* and in well-paid spreads for the *New York Herald Tribune* photogravure sections. By then, he was prosperous enough to have hired half a dozen assistants (including the aforementioned Morris Rosenfeld and the equally accomplished Anthony Lanza). The advertising placard for his Fulton Street studio, festooned with boating images, read:

Established 25 Years

Edwin Levick

Expert Marine and General Photographers

Photographers to the leading Naval Architects and Steamship Lines

Photographs in Stock of Ships, Liners, Sailing Ships and Vessels of Every

Description—Shipping Scenes—Every Type of Pleasure Craft Afloat

To speak of Levick's having an identifiable photographic style might be stretching a point, especially considering that some of the pictures signed "Edwin Levick" were taken by his sons or assistants. However, the overall work suggests that the boss and principal photographer believed in certain values: accuracy, clarity, and drama (see pages 57–60). Without reviving that old argument about whether photography is a craft or an art, we can see that many of these photographs exist right on the cusp of both categories. Although they may not have been intended as art photography, some of Levick's photographs are breathtakingly

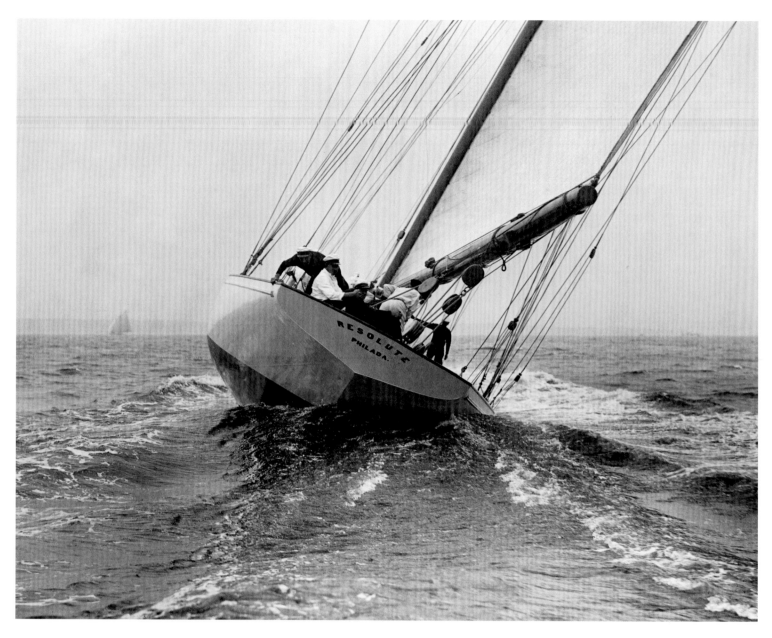

One of many Levick photographs of the *Resolute*, a racing yacht owned by a syndicate founded by Cornelius Vanderbilt.

beautiful. All show, in any case, what a powerful contribution commercial photography can make to the documentary record of a time and place.

If you look at early-twentieth-century views of New York Harbor and the Brooklyn Bridge by art photographers of the day, such as the pictorialists John Francis Strauss and Karl Struss or the young Alfred Stieglitz, their soft-focused, glimmering, painterly effects contrast dramatically with Levick's more straightforward, crisp-detailed work. (Ironically, American art photography would soon move in that sharp-focused, factual direction.) Levick took pains to get the visual facts right and to keep the compositions bold, direct, and uncluttered. His technique also reflected an understanding of the larger problems of marine photography: how much water to include, how much sky, and how to balance these two mediums while varying each sufficiently to make for an interesting picture. There was only so much you could get with a quick exposure from one moving boat snapping another, but in the darkroom, working with the prints, he could disappear the clouds, make the sails whiter or darker. Often he brought a brooding, poetic quality to these atmospheric elements, as on page 62.

There were also decisions to be made about whether to take the shot from land or from a neighboring vessel. Levick bought a motorboat, *Kathleen* (named for his daughter), as well as a 27-foot launch, *Snapshot,* and was perhaps the first photographer to use dedicated boats to get closer to his subjects. Previous marine photographers had been content with more conventional broadside compositions from the stationary vantages assigned them. But Levick had an intrepid nature, almost like a war photojournalist, as when he shot America's Cup races from a small boat that risked being capsized. "He shot bow-on. He shot from the wake. He shot from the deck with spray about to drown his image. He shot under the boom and into the rigging," notes Anthony Peluso, an authority on marine photography. "There was a masculine, robust quality about his work. He belonged to yacht clubs and had a sailor's point of view. He appreciated what he was photographing: he knew what the wind was doing to the sails and water, he understood the vagaries of weather."

Over the course of his career, his photographs became considerably less static, incorporating greater action and dynamism, as in the shots of a navy boat rushing to a yacht aflame, a barge battered by high winds, or tugs working to unclog an ice-bound New York harbor (pages 63–65). This change may have been partly an aesthetic development, but more likely it had to do with technological improvements in camera lenses, film, and shutter speeds.

Wherever there was any anecdotal possibility, Levick seized on the human drama—or comedy—both of which the New York waterfront supplied in good measure. A stevedore nearly swallowed up by a boa constrictor–like hawser sticks his head out with a smile. A mystery man in a homburg, like a dark figure in some spy movie, supervises cartons of cargo as they disappear into the hold. Levick was especially good at capturing the contrasting torsion of engrossed bodies meshed together, while a long figure stands out in intriguing isolation. One riveting example shows a crew unloading burlap-wrapped hawser lines at the dock, balanced by one hatted man staring down into the massive coil. In another, the droll figure of a disengaged cook, all in white, is surrounded by businessmen in dark overcoats who are witnessing a large propeller lifted aloft by a crane, next to the waiting liner *Majestic* (pages 66–69). No attempt has been made to "pretty up" daily life onboard.

One does not want to make excessive artistic claims for these photographs. Certainly, many of them were influenced by commercial considerations—the client's wish to commemorate his or her boat or service. This is particularly true of the thousands of individual yacht portraits Levick took, many of them blandly impersonal, for *Yachting*, *Rudder*, and other specialty magazines. But he was a respected craftsman among his peers: He won the blue ribbon of the Photographer's Association for his marine studies, and he was called the "best known marine photographer in the nation" and "a genuinely artistic soul" in the obituary that appeared in his hometown *New Rochelle Standard-Star*.

Levick, who suffered from heart problems, died in 1929 at his home in New Rochelle at the age of sixty-one, while the vogue for marine photography was still strong. His sons, who were not photographers, took over the business and ran it into the ground.

A dozen or so images in these pages come from sundry firms and freelancers, such as Lionel Green, the Atlas Photo Company, and J. Jay Hirz (whose strikingly composed shot on page 70 shows a dog and cat facing off on a grungy stack of mattresses, while the deckhands try to organize their task on the other side of the frame). But the only other maritime photographer to be featured in this volume is Percy Loomis Sperr, who entered the profession after Levick and outlived him by several decades. Born in Columbus, Ohio, in 1889, P.L. Sperr (he was known professionally by his initials) gravitated to New York after college, sometime around 1924. Curiously enough, he too began with literary ambitions, illustrated his writings with photo-

graphs, and then, finding that there was more demand for the photographs, switched professions. This shared literary interest may explain the strong narrative element in both their photographic outputs. Sperr acknowledged the importance of storytelling in a written statement. "I confess I am not much of a camera fan," he said (a surprising admission from such a skilled technician.) "My own interest is rather in the story than in the picture. . . . The story which interests me is the one which lends itself to unlimited photography—the tale of the City of New York."

So identified was Sperr with his adopted metropolis that at some point he began to be referred to as "official photographer for the city of New York," though whether this was a real position or a self-awarded honorific remains undetermined. In any case, he went about photographing municipal ceremonies and properties; but his chief interest was marine photography. According to Anthony Peluso, who wrote a fine article about Sperr in the *American Neptune* (volume 1, 1998), the photographer's business card read: "A growing collection of over 30,000 views of: New York Harbor; Ships, old and modern; Sky-lines, Dock Scenes, Harbor Craft, Sunsets Bridges, Naval Vessels, New York City, all five boroughs; Street Scenes, Skyscrapers, Old Houses, Foreign Quarters, Pushcarts, Farms, Old New York Scenes." A certain antiquarian bent is detectable in this list. Sperr loved to frame New York's skyscrapers through the spars and rigging of old vessels (pages 6 and 182), just as he loved to capture old schooners, like the sail-training ship *Suomen Jousten*, entering port in 1937 with the modern skyline in the background (page 71).

More so than Levick, Sperr had certain Photo Secessionist, art-photography leanings. He took misty pictures of ferry boats at sunset, or whimsically surreal ones, as on page 72, where he captures a zeppelin, the *Akron*, suspended over the ferry *President Roosevelt* like a pasted cigar.

Technically, Sperr's prints sometimes have more of a line-cut quality than Levick's, an all-over light with fewer gray values. His photographs are also perhaps a bit more static—not surprisingly, since Sperr was a cripple and it was harder for him to clamber about decks in crutches. His coverage of less-traveled locations in the Port of New York, such as the Staten Island shipbuilding yards or the Harlem River tug docks (page 77), are thus all the more noteworthy. Peluso, who regards Sperr as "an important artist of immense talent," drew an interesting comparison with another, more famous photographer who was his contemporary: "By coincidence, Berenice Abbott was recording her own vision of New York City, occasionally of the same subjects as

was Sperr. Whereas she took the occasional shot of a tug or ocean liner, her focus was mainly about the streets of the city. Sperr saw the city from the docks and the decks of ships, or the city in terms of the life on the water around it."

Sperr sold enough photographs to get by, but he was not a huge financial success. Certainly, he never hobnobbed with the yachting set the way Levick did. When the market for marine photography began to wane, he gave it up and opened a secondhand bookstore, where he peacefully stationed himself until his death in 1964.

Both Levick and Sperr loved the maritime milieu and photographed it endlessly, whether for a client or their own amusement. The line between commerce, hobby, and artistic creativity thus becomes very sketchy, as in this photograph of the *Olympic* (opposite). Who is to say what the verdict of future art criticism will be? Curators today value Marville and Atget, two commercial photographers who documented the buildings and streets of Paris, as high art. Levick's and Sperr's legitimate business reasons for hanging around the docks gave them unexcelled access to the working waterfront that more "purist" art photographers would not have enjoyed.

The remarkable intimacy of these views should not mislead us into thinking that the New York waterfront was in all places a public space; many parts were off-limits to the flaneur or idle spectator, with "No Visitors Allowed" signs and concrete walls and watchmen to exclude the nosy public. A few fortunates, such as Levick or Sperr, had carte blanche, and they made the most of it. We are indebted to them for taking us along, as it were, on this retrospective tour.

A WORLD PORT

The Port of New York was a crossroads for mundane and exotic goods flowing to and from every corner of the world. In these photographs, we see cartons of coconuts from the South Seas filling a locker and walls of auto tires cramming the hold of a cargo vessel. Bales of cotton destined for export cross paths with bunches of bananas from Central America. A work-chain of men, vigorously striding plank and scaffold, hands the fruit off to each other. Cases of Haig Irish whiskey and other consumables are loaded under the watchful eyes of a purser, while a toque-wearing cook on his break stares indifferently at the river. Sacks of money are transferred by security guards from a 1930s armored car, curiously round and tanklike, on the

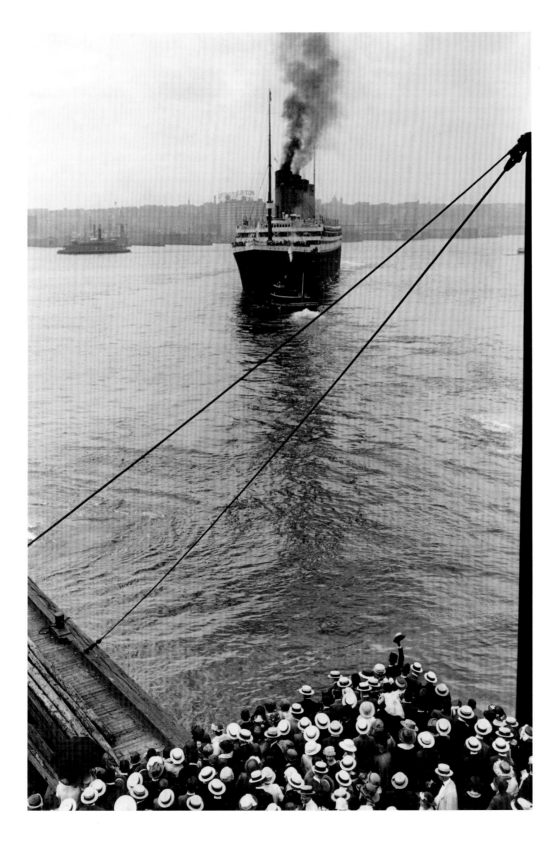

Crowd seeing off the *Olympic*. In this beautifully composed picture, a lone spectator at the leading edge of the pier raises his hat to the departing luxury liner, as if on cue for the photographer perched above.

South Street waterfront. The passenger compartment of a bus, the route "Damascus–Baghdad" lettered on its side, is suspended in midair like a flying carpet. Shipments of Waco (Weaver Aircraft Company) airplane parts are loaded onto the older mode of transportation, and a crate from Rio de Janeiro, stenciled with a label that links it ominously to the Ministry of War, slides diagonally on board. Sometimes the cargo is livestock, as in the photographs showing Argentine cattle being loaded on and off the *Santa Teresa* and the *Santa Rosalia*.

The work crews, too, were becoming international. At the turn of the century, the waterfront had been an Irish preserve. Italians and African Americans were initially introduced as scab labor during strikes, then stayed on, joined by other immigrant groups. In Ernest Poole's 1915 New York novel, *The Harbor*, the narrator sounds a nativist lament at the diminution of Anglo-Saxon presence at the waterfront: "Gone, too, were the American sailors. All races of men but ours gathered around this hog of the sea. From barges filled with her cargo, the stuff was being heaved up on her deck by a lot of Irish bargemen. Italian dockers rolled it across this German ship, and on deck a Japanese under-officer was bossing a Coolie crew."

More accepting of ethnic variety, sociologist Charles B. Barnes, in his study *The Longshoremen*, managed still to express concern that the new breed of Italian longshoreman would be too scrawny for the work traditionally performed by the larger-boned, "more easily assimilated Celt or Saxon." Nonetheless, two bandana-swathed, Italian-looking dockworkers unloading cork in a vivid Levick photograph appear quite adequately muscled and at ease. Whatever their backgrounds, the men on the docks had to put aside their tensions and learn to work in unison.

The work was back breaking: A longshoreman handled about 3,000 pounds per hour. The heavy lifting led to hernias and muscular exhaustion, and the pressure to work quickly, sometimes for thirty hours straight, resulted in many accidents. The fatality rates were higher than for any other profession in America. There was scarcely a single veteran of the docks who had not sustained some bone-crushing injury or lost a finger or toe. The extremities of hot and cold weather also yielded high rates of heat prostration and pneumonia. The inhalation of harmful particles from, say, loading bulk grain or bone dust or the dangerous fumes from sacks of potatoes, rags, or chemicals, could overcome men on the spot, not to mention having serious long-term effects on their health. One image shows a crew casually unloading sulfur in the open air, without respirators or any

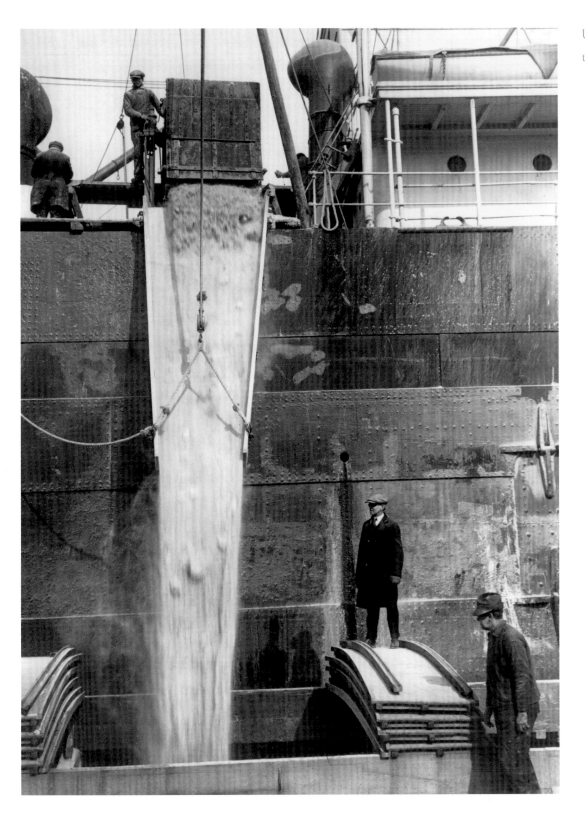

Unloading sulfur from
the *Mandelta*, 1922.

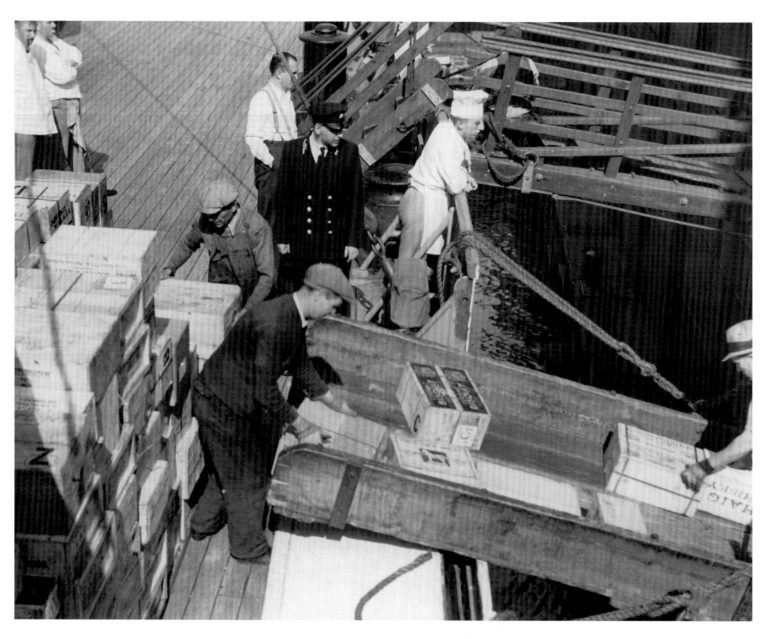

As a cook and ship's purser stand by, a steamship's hold swallows wooden boxes of food and libations including rum, brandy, and whiskey.

With his co-worker, this African American dock-worker is nosing a barge up to a pier, probably in the 1930s. By then, African American workers were becoming increasingly common along New York's waterfront.

of the protection that would be mandatory today. The men on the docks loading garbage scows would also have been taking a chance—and probably not doing their lungs any favor—around those noxious clouds.

As for the sailors and seamen, they too were kept busy, even in port, with ship maintenance, as on page 97, where a crewmember paints the side of a ship with a long brush. On page 96, an old salt with a white beard enjoys a moment of peaceful contemplation between chores. Such solitary reveries were considered a prerogative of those who put out to sea.

THE ART OF SHIPBUILDING

Along the waterfront, the spectacle of labor could also be glimpsed in the shipyards, where new vessels were fabricated or old ones repaired. New York had a long, proud history of shipbuilding, now sadly underappreciated and almost forgotten locally. Its innovative craftsmanship was on such a high level that, during the transition from sailing ships to steamships, the East River yards (located between Corlears Hooks and Fourteenth Street), led the country in shipbuilding activity, and their only rivals worldwide were the famous shipbuilders of Clydebank, near Glasgow. In the early 1850s, considered the golden age of American shipbuilding, the East River shipbuilders turned out sturdy packet ships, clippers, yachts, steamships, and warships, using the finest imported white oak, cedar, locust, and pine. Often they would lay out a half hull on the ground and build the rest from that template. In a close-up shot on page 100, a shipbuilding workman, with cigarette dangling and paint-spattered trousers, applies a patch to the pleasure boat *Uncowa*.-

The enormous scale of some of these vessels, when assembled upright, can be seen in a shot of the *Hickman* dwarfing the workmen below (page 101). One of the earliest images in the collection portrayed the navy cruiser *Maine* in the stocks at the Brooklyn Navy Yard in 1889, tended by her rigidly posed workmen. The shipbuilding yards were dispersed throughout the boroughs of New York: P.L. Sperr caught the scruffy-looking but bustling Staten Island Shipbuilding Company Yards at Kill van Kull, which built cargo ships, minesweepers, and naval tugs. The Ira Bushey Shipyard of Brooklyn built components for warships in World War II. Many of the shipbuilding firms ran engine and boiler shops near the shipyards and then installed such equipment from their own piers onto ships about to be launched. On page 107 workmen move a humongous boiler that looks like an iron-plated whale.

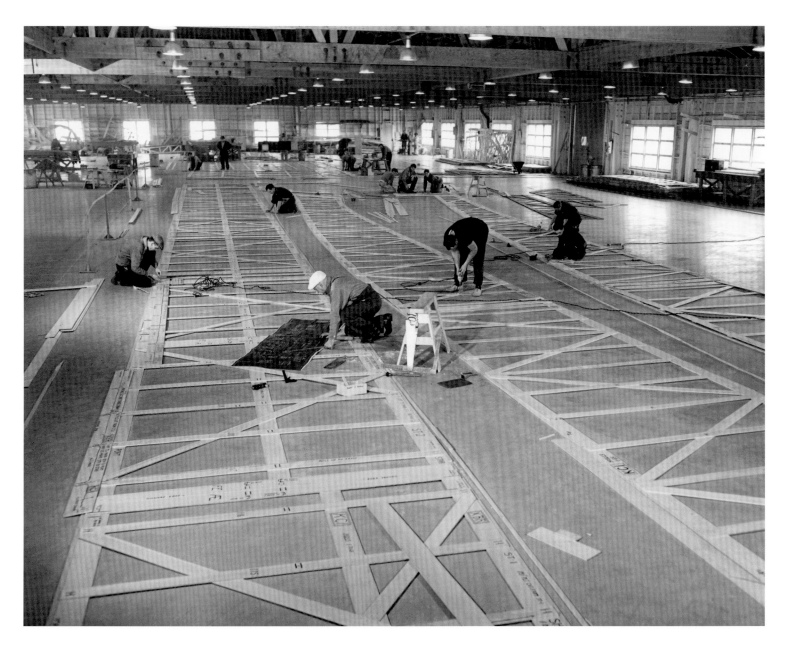

Crafting templates for a ship's shaft tunnel.

The shipbuilding industry has long since departed from the shores of Manhattan, but there are still a few remnants in Brooklyn and Staten Island, where foreign ships that have suffered damage in transit often put in for repairs.

THE PASSENGERS

Now let us move from labor to leisure—that is, to the passenger's point of view. The spectacle of affluent living forms another essential aspect of the Port of New York's iconography, especially as it comes down to us in these photographic collections.

The purchase of a liner ticket itself was an event, worthy of being caught by the camera. On page 108, Levick shows us upper-crust customers of 1911, in their best suits and dresses, at the wood-paneled steamship ticket office, booking passage on the *Titanic*'s sister ship, the equally elegant *Olympic*. Later, the luggage of the *Olympic* passengers is carefully arranged and tended to on deck. Passengers' dogs were pampered as well: We see several grown men, members of the *Berengaria* crew, attending to these no-doubt pedigreed animals. The sartorial care with which people undertook all travel in those bygone days was maintained scrupulously on board. On page 112, the *Majestic*'s passengers, the men in homburgs, the women in picture hats, press against the ship's railing, seemingly hypnotized by the grisaille views of Manhattan near the Battery. Sometimes the proprieties of the well-off set could be stifling: A young girl stands on deck looking thoughtful, as if plotting to escape the three old biddies around her (page 109).

Ship launches were colorful, newsworthy events, milked by shipping companies for their drama and ritual. Every stage was photographed—the top-hatted launcher with trigger mechanism signaling the crew, the dignitaries ascending to bunting-draped reviewing stands, the climactic moment when someone of the stature of Gertrude Vanderbilt would christen the *Virginia* with a champagne bottle, and the actual launch of the *Virginia*, seen slipping away from its supporting berth (pages 114–117). The greeting and seeing-off of transatlantic cruises likewise were festive public occasions. Mobs would assemble on the waterfront, tensely waiting or gaily waving. Levick catches a big-bellied man ostentatiously turning away from the crowd that has gathered to see off a departing liner, his interest already diverted elsewhere.

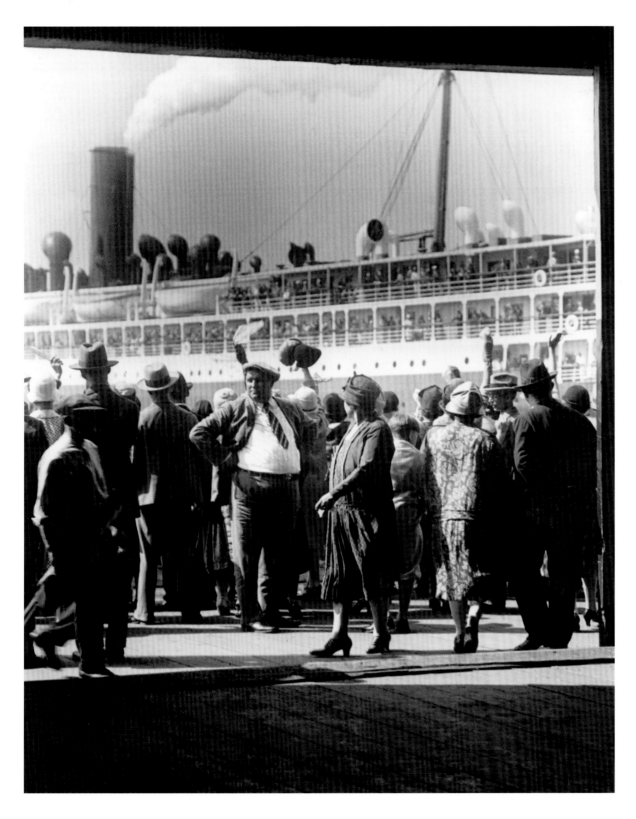

Crowd at a steamship departure. Here Edwin Levick has captured the moment after a ship's departure when the drama of churning propellers is ebbing, and for those onshore all there is left to do is wave at a rapidly receding stern. Onlookers are beginning to lose interest and leave; the distracted fellow in the center of the picture, with his expansive, white-shirted midriff, provided a focal point for Levick's composition.

How to account for these crowds? Ocean liners in that era were art deco skyscrapers coasting on their sides, floating worlds devoted to leisure and fun, with supper clubs, ballrooms, casinos, swimming pools: dream palaces where you half expected to see Fred Astaire dancing on deck with Ginger Rogers, or Charles Boyer courting Jean Arthur against the ship railing, or Henry Fonda falling for the perfumed wiles of Barbara Stanwyck. One view, with the *Conte di Savoia*, the *Aquitana*, the *Georgia*, the famed French liner *Normandie*, the *Columbus*, and the *Bremen* all stacked alongside each other, recalls that peak of ocean-liner romance, when fathers would drive their families past Luxury Liner Row on weekends, just to catch a glimpse of their glamour.

One of the largest, most impressive ocean liners was the *Normandie*, built in France in 1931–1932. It is seen passing in magisterial self-possession before the downtown skyline, wreathing the buildings behind it in white puffs of smoke; another view shows the liner, with its three huge funnels, jauntily leading a procession of smaller vessels into the harbor (pages 120 and 121). When World War II broke out, the *Normandie* could not return to Europe, and it was forced to idle for some years at Pier 88 until catching fire in 1942.

Perhaps the grandest ocean liner of all, the *Queen Mary*, was photographed in 1936 on its maiden voyage, steaming into New York harbor. A dramatic view of the *Queen Mary* from below conveys both its sleek moderne lines and its unthinkable dimensions.

An ocean liner, arriving or sailing, offered frequent celebrity photo-ops. Newsreel crews and newspaper photographers were dispatched to the docks to snap movie stars, heads of state, sports idols, and savants. The curious image of elderly, wizened Madame Marie Curie, surrounded by her daughters and mobbed by the paparazzi of the day, attests to the appetite of the media for every sort of celebrity. It was not even necessary for the subject to have achieved something; membership in high society was sufficient grounds for newsworthiness, as with the well-heeled couple cornered by photographers on page 125.

The yachting scene was another highly documented aspect of the Port of New York in its heyday. An evocative 1928 photograph by Edwin Levick shows Mr. and Mrs. Vincent Astor with a party of elegant guests going out to his yacht, the *Nourmahal*, on a New York Yacht Club cruise (page 126). Levick was official photographer to the New York Yacht Club, the preeminent yacht club in the country, and he photographed the establishment's spectacularly ornate interiors as well as its docks and most of its members' well-appointed boats.

Of course, not all passengers who went through New York Harbor traveled in such style. The crush and chaos of lower-class passengers waiting on docks could not have been further removed from the elegant treatment that was shown luxury liner clientele. Even when social classes traveled on the same vessel, they rarely mixed. Then there were the immigrants, a huge part of the Port of New York's story.

Between 1880 and 1919, 17 million immigrants (of the national total of 23 million) entered through New York City. Driven from their homes by crop failure, wars, pogroms, political persecution, and want or lured by ambition and the promise of streets paved with gold, these millions made the arduous ocean voyage in steerage or on deck, such as the old Russian man reading on board the *Leviathan.* Entering New York Harbor, they caught their first stirring sight of the Statue of Liberty, with its promise of refuge and freedom.

Then they were processed—initially at Castle Clinton, the old fort in Battery Park, until 1892 when the Ellis Island immigration station opened. "Before this door," wrote Henry James in 1907, "which opens to them there with only a hundred forms and ceremonies, grindings and grumblings of the key, they stand appealing and waiting, marshaled, herded, divided, subdivided, sorted, sifted, searched, fumigated." Popular belief has it that their names were also mangled and shortened to conform to sounds more "American," but some historians today question the prevalence of this practice. In any event, the vast majority began to make their way into their new country and to acquire a new identity.

Many immigrants stayed on in New York City; by 1910, 40.8 percent of the city's population was foreign born. Indeed, they settled not very far from the waterfront that first received them, in ghettoes such as the Lower East Side, Williamsburg, Little Italy, and Chinatown. The two largest groups of immigrants during this period were Jews and Italians. Those with skills (tailors, bakers, printers, jewelers) tried to find business opportunities; but many others became unskilled laborers, taking what work they could find on the docks, in construction, or in factories. Between 1900 and 1960, New York had more manufacturing jobs than any other American city. It specialized in finished, nondurable consumer goods, such as clothing, printed materials, leather articles, and tobacco products. Of these, the leading employer was the garment industry, turning out ready-made apparel for the nation and for export. Immigrants quickly took over the sewing machines and cutting tools, working at home or in sweatshops, often under appalling conditions. (The Triangle Shirtwaist Factory fire in 1911, which killed 146 women, mostly young immigrants, was but the most flagrant instance

Immigrants on the *Olympic* as it cruises past a distant, mist-shrouded Statue of Liberty. At its launch in 1911 the *Olympic* was hailed by the press in New York and elsewhere as the "World's Wonder Ship."

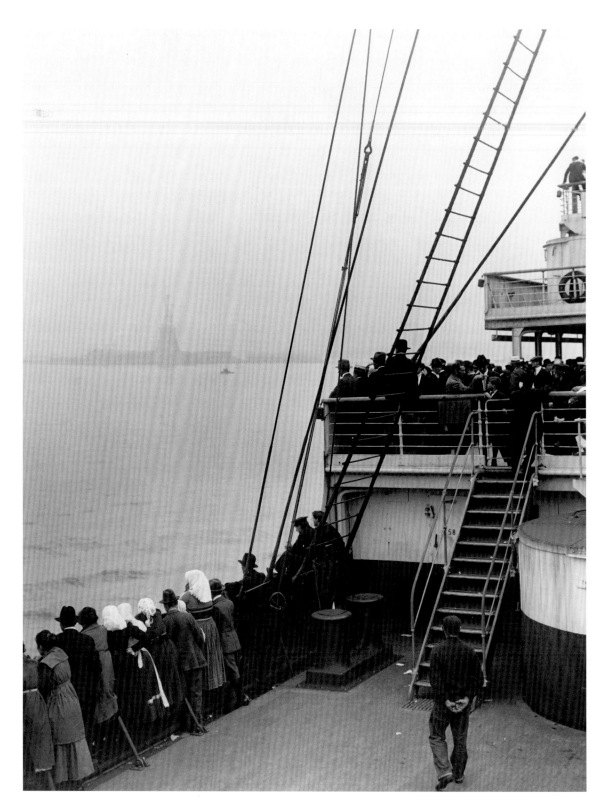

of those dangerous, squalid working conditions.) The more socialist-minded immigrant laborers began organizing protests and strikes, and the union movement blossomed in New York.

For all their immense contributions to the local economy, there were fears that immigrants were taking jobs away from native-born Americans or depressing wages by their competition. In 1924, federal laws were passed restricting immigration and quotas were set up, formalizing a system of discrimination based on national origin, which remained in place until it was finally rescinded with the Hart-Cellar Act, passed in 1965.

In the early twentieth century, the metropolis, fueled by expanding port and manufacturing jobs, had seen an enormous population increase. New York City grew from 3.5 million in 1900 to nearly 7 million in 1930. Even after immigration restrictions were instituted, the census showed this population figure maintaining itself, fluctuating between 7 and 8 million people from the 1930s through the 1970s. During the 1950s, Puerto Ricans and Southern blacks were drawn to the region in large numbers by its thriving postwar economy. The city also continued to accommodate a goodly supply of undocumented immigrants, estimated conservatively at half a million people. In the last two decades, hundreds of thousands of immigrants, mostly from Asia, the former USSR, the Caribbean, and Latin America, have continued to settle in the area, although today they arrive for the most part by airline rather than by boat. Ellis Island is of course now a tourist attraction rather than a site of intense anxiety and hope for the newly arrived.

OTHER USES OF THE HARBOR

Adding to the considerable traffic of vessels in New York Harbor on any given day was the municipal fleet, which included fireboats, police boats, garbage boats, ferryboats, tugs, pile drivers, and other floating equipment. Both Edwin Levick and P.L. Sperr went out of their way to document this municipal fleet, Levick making a fine picture of a Department of Plants and Structures boat toodling along, while Sperr gives us a clear view of the same department's office shed, behind the East Twenty-third Street Ferry Terminal. The good-sized police boat, shot by Levick in 1923 as it passed Ellis Island, looks as though it would have had enough engine power to chase smugglers and cargo thieves, of which there were many operating from their own junk boats in New York Harbor. These marine police patrols would also have to fish corpses from the water in a grisly ritual known as "Float Week," usually in early April, when the bodies would start to rise to the surface.

Ferries, both private and city owned, had long served the New York populace; Walt Whitman's great poem, "Crossing Brooklyn Ferry," cast them symbolically as incubators of urban democracy. In the nineteenth century, many of the railroad companies, such as Pennsylvania, Erie, and Lackawanna, started their own ferry lines. But the Brooklyn Bridge, which opened in 1883, and the later East River bridges and tunnels took away much of the ferry business. By 1925 all commercial ferry lines across the East River had stopped operating. There were still city-run ferries to and from Staten Island and private ferry lines connecting Manhattan to New Jersey. "Those wonderful long ferry boats!" wrote Lewis Mumford in his autobiography, *Sketches from Life*. "Alas for a later generation that can only guess how they opened the city up, or how the change of pace and place, from swift to slow, from land to water, had a specially stimulating effect upon the mind." We see the *President Roosevelt* docking at South Ferry in 1932, her thick load of commuting passengers waiting in sober, orderly lines to disembark. The New Jersey ferryboats *Wilkes-Barre* and *Bound Brook* are shown at a decisive moment, heading in different directions, with the Manhattan skyline mistily hanging in the background and a stark, fenced-off gangplank framing the foreground. Another intriguing photograph captures two men in hats, looking like FBI agents, pushing a wheeled, possibly confiscated, object off the ferry at Ellis Island.

The fact that New York Harbor is an estuary, where ocean and river meet, meant that a rich variety of saltwater and freshwater fish—striped bass and mackerel, bluefish, cod, and even lobsters, eels, and oysters (the pride of New York, once upon a time)—would congregate there. Commercial and sport fishing boats were not slow to follow, especially in the years before water pollution led to regulations forbidding the consumption of fish that were caught in the local rivers. (Actually, New York Harbor had been seriously polluted from 1900 onward, having been used too long as an open sewer, but consciousness of the health hazards involved in swimming there or eating fish from its waters dawned slowly.)

The métier of commercial fishing was grueling, hazardous, and continuous, regardless of weather, but it suited the temperaments of those hardy souls who loved the sea and loved to fish. According to Norman J. Brouwer, a historian of the Port of New York, "From March to June mackerel was brought there by a large fleet of schooners from New England that operated between North Carolina and eastern Long Island. Farmers living near the shore supplemented their income by fishing and delivering their catch to the market themselves or loaded it on steamboats that operated between local landings and Manhattan." One image

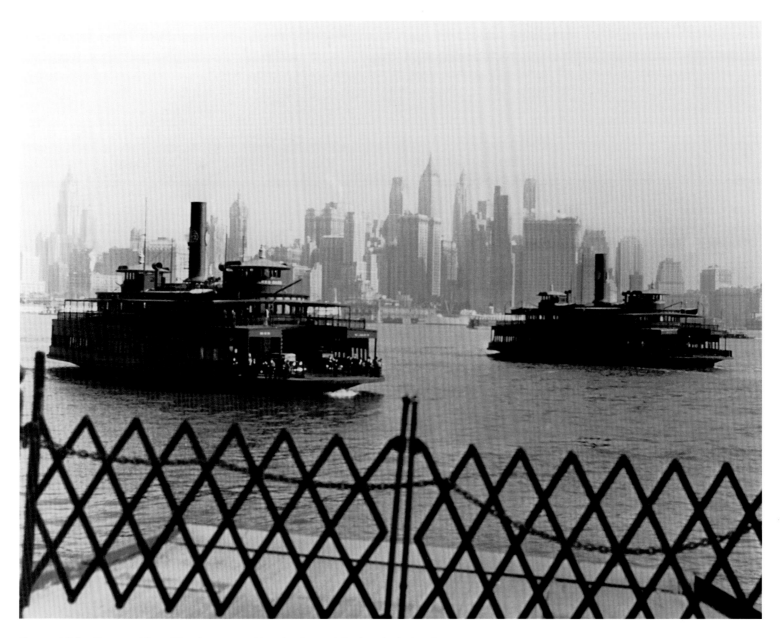

Ferries *Wilkes-Barre* and *Bound Brook,* operated by the Central Railroad of New Jersey.

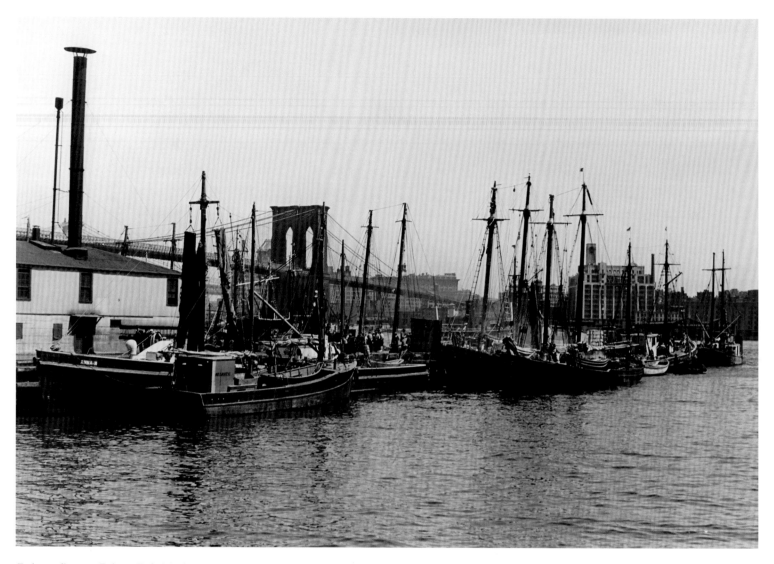

Fishing fleet at Fulton Fish Market.

shows a fishing crew cleaning out its old ice, with the Brooklyn Bridge in the distance; in another, a fishing boat has itself become caked in winter ice.

The fishing fleet's final destination would often be the Fulton Market docks, the regional distribution center for seafood, captured in lovely photographs by Levick and Sperr. Since the 1830s, this wholesale fish market had been in business on these same two East River waterfront blocks south of the Brooklyn Bridge, and it continued to operate there, becoming the oldest wholesale fish market of any city in the Western world to have survived at the same spot. It remains, in its last days before relocation to Hunts Point in the Bronx, a world unto itself: tough-nosed, largely masculine, expert, obeying age-old codes of loyalty and honor.

We get some splendid views here of that world, scenes of everyday life in the Fulton Fish Market: ice for the fishing boats being crushed in a Rube Goldbergian device; men sniffing at the day's catch in crates set up before the fishing stalls or dickering and hoisting barrels before the old, Federal-style townscape that would one day be cleaned up and turned into the South Street Seaport tourist district. The precise line demarcating water from land, and the fate of fish that end up on the wrong side, is evoked in this powerful photograph taken at the market. The market stalls still come alive, as previously, in the middle of the night when the area resembles a huge film set under arc lights. Perhaps the main difference between the old Fulton Market, as seen in these photographs, and the one we have now is that the catch was once brought in by fishing boats, making for a certain poetic justice or imagistic appropriateness, whereas today it is transported in and out by refrigerated trucks.

DEFENSE AND WAR

From the earliest days of New York's settlement, the city has had to defend itself, initially with fortifications such as Fort Amsterdam, at the foot of Broadway, or cannons at the Battery's edge and gunboats offshore. The Port of New York has also played host to the armed forces and has had a significant role to play in most of the nation's wars. Even before the First World War was declared, the port was a focus of military activity. "The most important spot in this nation for the transfer of munitions to Allied troops was Black Tom, a mile-long peninsula jutting into the Hudson River from Jersey City just behind the Statue of Liberty," wrote Edward Robb Ellis in *The Epic of New York City*. "Freight cars were nosed along a network of tracks to piers, where their supplies could be unloaded onto barges for transfer to waiting vessels in the harbor. . . . Two hundred

thousand pounds of explosives were stored in the railroad cars, on piers, and in barges tied alongside docks." One night in July 1916, Black Tom was blown up by explosions, possibly the result of sabotage.

After Congress declared war in 1917, the very first act of war was the seizure of eighteen German ships anchored in the Hudson River. The piers of the North German Lloyd and Hamburg-American lines, on the Hoboken waterfront, were also seized. During the war, Ward's Island was turned into a military hospital, and Governors Island billeted troops. New York became the main port for cargo and troop movement, sending 1,656,000 troops overseas. The soldiers' enthusiasm for the city may be glimpsed from the photograph of World War I uniformed men on deck gawking at the skyline. Sailors in white on the USS *Pennsylvania* are seen standing at attention, more or less, including those suspended in midair from a launch.

In both world wars, the city's shipyards built battleships and minesweepers, aircraft carriers and destroyers, patrol craft and cruisers. Whether fabricated here or elsewhere, the entry of a battleship into the city was always a spectacular sight. The *Wyoming*, built in 1912, is seen commandeering New York Harbor. The rugged-looking battleship *Maryland* crosses under the Manhattan Bridge, big guns poised. The *George Washington*, a former ocean liner converted to a battleship, is shown leading a pack of smaller boats past the Statue of Liberty. One of the oldest battleships, the USS *Florida*, built in the New York Navy Yard in 1910, trails clouds of black smoke as it clears a bridge. The *Lexington* sits anchored calmly at the West Fiftieth Street Dock, its deck jammed with biplanes. The snub-nosed stern of a submarine, framed provocatively by J. Jay Hirz, looks like a cartoon dolphin or shark as it marks time in the New York Navy Yard.

Ships of all kinds, military and commercial, kept growing larger and sitting lower in the water, with the result that the Port of New York, which always took pride in its natural deepwater harbor, had to be dredged periodically, the sediment removed and, according to law, buried elsewhere (sometimes, however, merely dumped). From the 1930s on, dredges became familiar harbor sights. And with the city rising ever higher and denser, requiring a constant supply of fresh cement, the construction companies' mixers and pilers were also not to be denied. Whatever parts of the New York waterfront were not assigned to shipping became increasingly given over to industrial uses. Historically, the Manhattan waterfront was seen as a seedier, smellier, or in any case much less desirable residential address than the middle of the island, with its proximity to Central

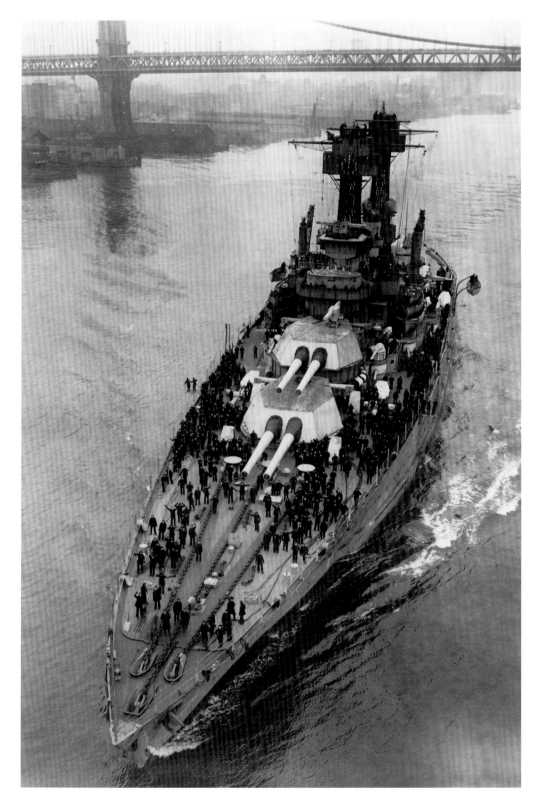

Battleship *Maryland* in the East River. Although Edwin Levick's vantage point for taking this shot is uncertain, he was visible to sailors on deck, some of whom are peering skyward and waving.

Park: hence the ease with which concrete plants, power companies, sugar processing companies, and other industrial firms were able to commandeer the remaining waterfront property.

THE RAILROAD/LIGHTERAGE SYSTEM

In the first half of the twentieth century, most of America's goods were still moved by rail. Thirteen different railroad lines operated in the region, but because of New York City's geography (the Hudson River's interruption separating it from the mainland), twelve of the thirteen had, for reasons of convenience, established their freight terminals on the New Jersey side. Only New York Central entered the island of Manhattan, and even it maintained a terminal in Weehawken, New Jersey. To remain competitive, the railroads offered free cargo transport across the harbor.

Consequently, most freight had to be placed on barges, scows, car floats, and other types of lighters and floated across the harbor. ("The term *lighter* originally referred to vessels used to *lighten the load* of ships attempting to dock in shallow waters," explain the authors of the catalog *The Lighterage System in the New York/New Jersey Harbor*). Some of these floating vessels were simple wooden flatbeds, open-decked scows moving rubber, coal, or lumber; others were covered barges, used to transport materials such as grain that needed protection from the elements; some were even refrigerated cars, like the ones used to convey bananas or other perishable produce. The car floats, loaded from land to water by a tricky mechanical device known as a transfer bridge or float bridge, were designed to handle railroad cars two or three lines across and up to 300 feet deep. One photograph is a clear picture of numerous barges lashed together, making the cross-harbor trip, while another shows some rail freight on the Brooklyn side preparing for transport to Manhattan.

Since almost none of these lighterage vessels were self-propelled, tugboats became an essential part of the freight delivery operation. At the Port of New York's peak in the early twentieth century, there were more than 750 tugs in New York Harbor, and each tug had its own whistle to distinguish it amidst the river's frequent traffic jams. Commonly, the tugs were long and narrow, with a deckhouse and windows all around the wheelhouse. The larger boats, or transfer tugs, were used to haul car floats and other heavy loads; the smaller ones, known as shifting tugs or drill tugs, could maneuver better in tight corners. Of course, tugboats were needed for everything that moved into and out of New York Harbor, not just rail freight: Page 167 shows us a row of

tugboats moving the Steamship *Mutual*; page 168 gives us a dramatic view of three tugs in concert trying to dock the steamship *Caronia*; on page 169, a tug is towing a dry dock section. But the majority of their trips involved freight barges, and weather conditions and tricky tides could complicate the operation.

A veteran deckhand who had worked on the Erie Railroad's marine operations, Hollis Maupin, recalled the challenges: "In New York Harbor, you have an ebb and flow of tide. A flood tide. On certain piers, you can't land with the tide, you've got to go against the tide. The other way it'll just push you down the river. It's scary when I think of it now. In the wintertime, in ice and snow, these barges only had about a foot-wide walkway around, and if you slipped off, you had it. You had to be very relaxed. You had to be ready to grab or drop, or you'd be knocked over the side. What made it interesting and nerve-wracking was that you had to know your tides."

The barge captains, who kept the lighterage vessels shipshape and in safe operating order, did not have to have a pilot's license, but the job could be demanding. If cargo needed to be kept refrigerated, they would have to load the area with ice; or if kept warm, tend to the fire; and logs and manifests needed to be maintained properly. Between trips, however, the occupation became rather more relaxing and contemplative. Page 170 shows a crewmember of the barge *P. J. Lynch*, being used here to transport rock and crushed stone, gazing at an ocean liner. Immigrants often gravitated to these scow maintenance jobs because of their many benefits: They were rent-free, the company provided coal for stoves and kerosene for the lamps, and their families were encouraged to live on board, as their presence was considered a spur to commitment and cleanliness.

We get a sense of normal domestic barge life on pages 171–173—the tranquil photograph of white laundry strung on clotheslines across the *Damass*, in close if oblivious proximity to the New York skyline; in P.L. Sperr's shot of the charming girl with ringlet hair, engrossed in her book, sitting on a barrel with her dog beside her on the deck of a grain barge; or on an old ice barge, a bit of patterned cloth dressing up the window. Then there is this oddly haunting picture by Sperr of a girl and her mother playing with what that photographer chose to call "Canal Barge Pets." Were these white rats, clambering around the Quaker Oats box, an indication of the ubiquity of such vermin? (Joseph Mitchell, in his 1944 essay, "The Rats on the Waterfront," reported that the creatures were always abundant in the seaport; but "a steady increase in shipboard rats began to be noticed in New York Harbor in the summer of 1940."). Or were they store-bought, "clean" rats, a less-genteel equivalent of hamsters? Somehow, the photograph conjures up a familiarity with

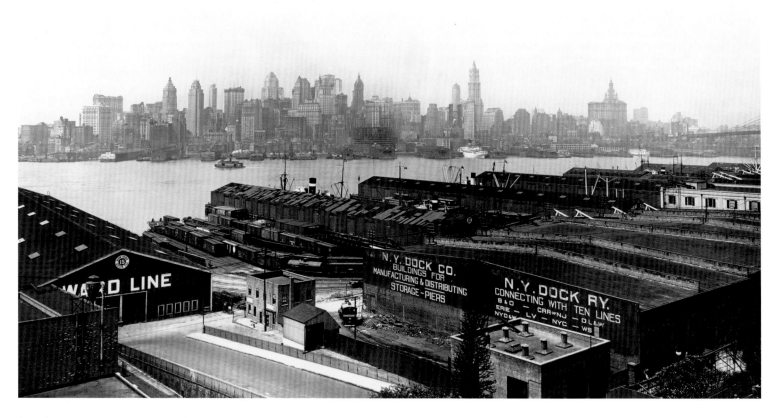

Manhattan skyline circa 1925 from the Brooklyn shore of the East River. Dock railways flourished in Brooklyn during the first half of the twentieth century. The New York Dock Railway, founded in 1901 and prominent in this photograph's foreground, may well have hired Edwin Levick to photograph its operation, located on the former site of the Brooklyn Wharf and Warehouse Company.

everyday poverty, suggesting that Sperr, with his empathetic lens, may have known something about the condition himself.

Overall, the lighterage system worked efficiently to convey freight between trains and vessels. An estimated 3,000 to 5,000 railroad cars floated every day across New York Harbor in the first half of the twentieth century. But there were logjams, and to the degree that each part of the marine-rail equation was dependent on the other, the whole system became vulnerable to breakdowns on either end. During World War I, for instance, a shortage of civilian workers to unload railroad cars and a simultaneous congestion in the port led to near paralysis. President Woodrow Wilson had to intervene and place the New York port operations under emergency national oversight. After the war, shippers doing business in the Port of New York continued to encounter time delays, caused by spatial gridlocks and labor inefficiencies, that drove up the costs and encouraged the proliferation of a mob-run system of kickbacks, bribes, theft, and intimidation.

One solution would have been to build a rail-freight tunnel under the New York Harbor from New Jersey to Brooklyn. This sound idea, proposed originally in the 1920s and many times since, was unfortunately never acted upon. In fact, New York City continued to operate its seaport with archaic docks, outmoded equipment, and inadequate connecting links to other transportation modes, putting off the needed infrastructure investments that other world ports were undertaking, until finally there seemed to be no other option but to move the whole port west to New Jersey. In the meantime, the railroads had fallen on hard times, and trucks came to replace rails and barges as the preferred mode of moving goods.

Of course, the ascendancy of truck and airplane over rail and ship networks did not happen by accident; these winners of the transportation sweepstakes were heavily subsidized by federal and local governments, which paid for an unprecedented program of highway construction and roughly two-thirds of every air traveler's ticket. As it happened, this policy of favoring truck and air for freight transport made no economic sense, tying the nation into a wasteful energy habit that would have repercussions in foreign policy, environmental pollution, and health care that endure to the present day.

Although this problem of misguided transportation priorities exists nationwide, its fallout is much worse in New York. Today, less than 2 percent of all freight passing through the New York region is transported by rail, compared with 40 percent in cities nationally. So much for the road not taken.

Alas, the decline of the Port of New York was not merely the fault of the highway lobby or the result of converging global forces; some of the blame must rest with the locals. Through the first half of the twentieth century, the Port of New York had been lazily and passively operating according to a model of nineteenth-century technology in the face of widespread changes that were transforming the maritime industry. The photographs assembled here record the quaint appeal of that homemade, jerrybuilt, narrow-wooden-berth, human-chain, old-fashioned waterfront, even as they help us to understand, reading between the lines, why such an environment was not permitted to last.

In the past thirty years, with the disappearance of hundreds of thousands of port and manufacturing jobs, New York has had to reinvent itself as a postindustrial city. The city's economy is based increasingly on its function as a center for corporate headquarters; on its financial, legal, and accounting services; on its ever-more-desirable real estate; on its entertainment/media concentration; and on its tourist and leisure activities. The ability of New York to market its own image to the world has become, in effect, its central "product."

One final photograph should be considered: that of Riverside Park overlooking a marina, as seen from a formal balcony. Riverside Park had been laid out first in the 1870s by the great landscape architect Frederick Law Olmsted (who designed Central Park) in English pastoral style, then expanded and completed under the guidance of Robert Moses, the city's parks commissioner, in the 1930s. Until recently, it was one of the only tracts given over to public recreational purposes in the whole of the Manhattan waterfront. Observers have often commented on the fact that New York has made little civic use of its magnificent waterfront, compared with other great cities. The reason is simply that, for the most part, this land had already been dedicated to shipping, industry, and other commercial uses. Now that the Port of New York has been relocated to New Jersey, an extraordinary opportunity exists for the waterfront to be converted to recreational uses—for the public to be granted access as never before to the rivers' vistas and breezes and the beautiful expanse of New York Harbor. A good start has been made with the Hudson River Park, now being constructed to run along the West Side, and smaller parks are being added along the East River. Someday, one hopes, a continuous public promenade and bicycle path will circle the perimeter of Manhattan Island. In this sense, the photograph of Riverside Park represents a prophecy of the future New York waterfront: no longer as jaunty or functionally intense as the old port, but maybe more spiritually restorative and serene.

Riverside Park overlooking the Hudson River, 1920s.

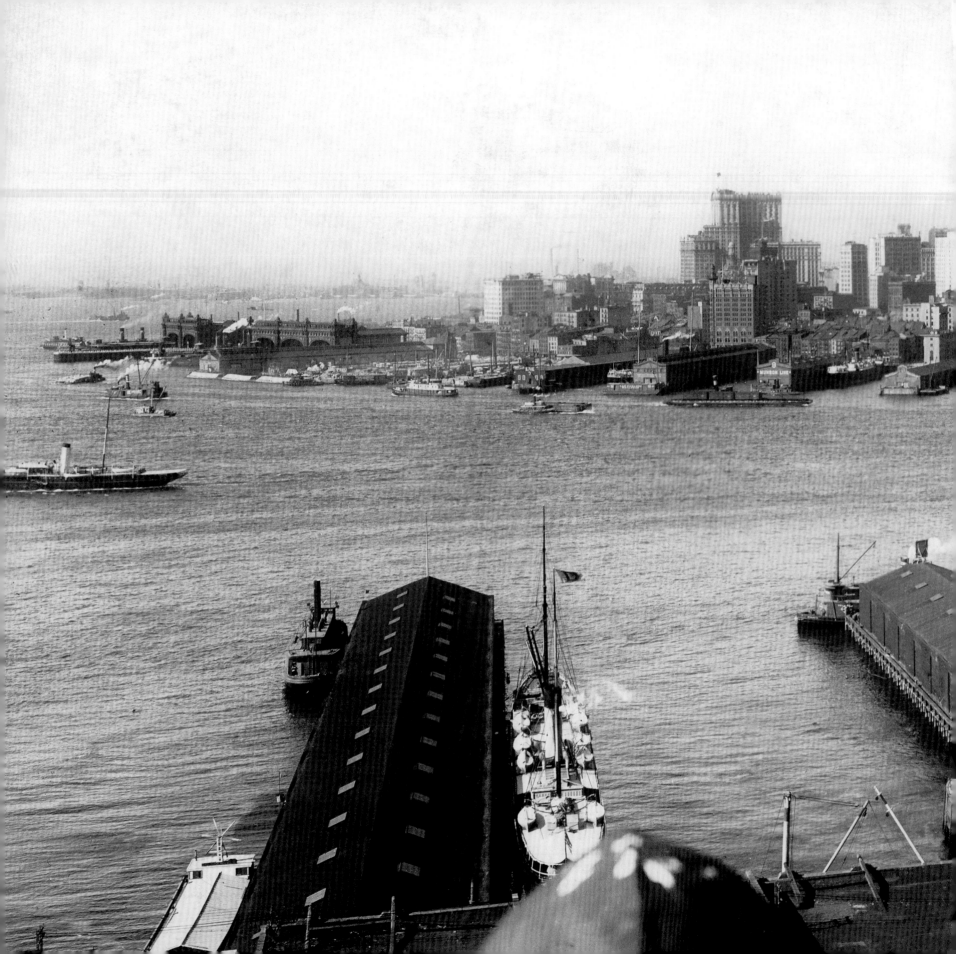

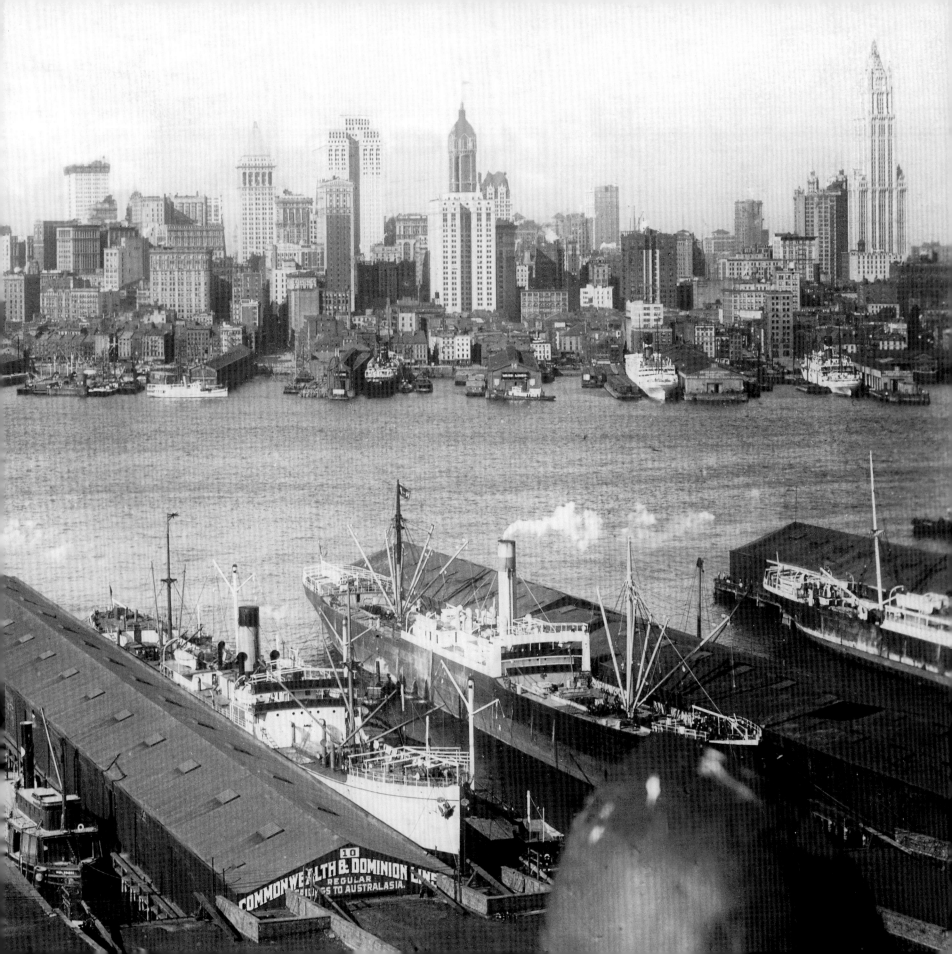

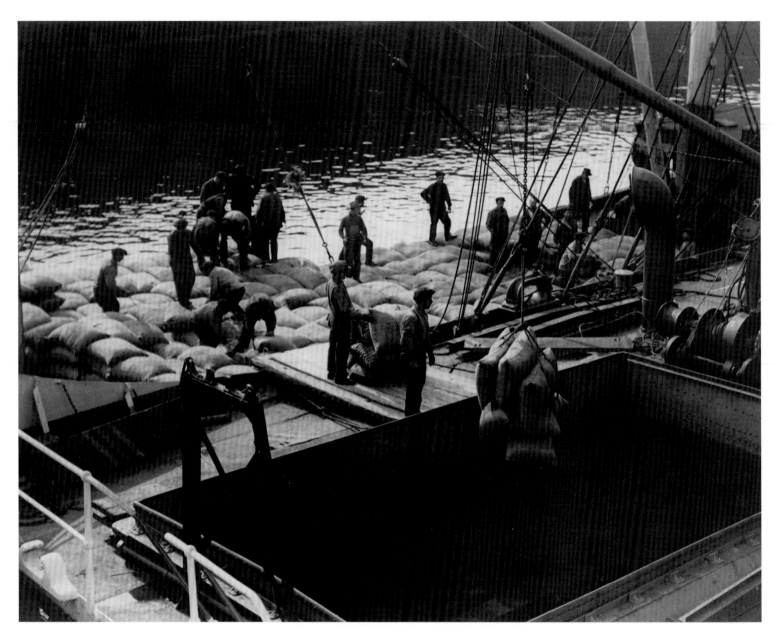

Longshoremen transferring a burlap-bagged cargo from barge to ship's hold. Edwin Levick made this photograph in an era when the labor of many was required to handle cargoes on the New York waterfront. A 1912 congressional investigation disclosed that longshoremen on the West Side might be required to work twenty-hour days and heft sacks of sugar or coffee weighing up to 350 pounds.

Previous spread: View over the East River to Manhattan, circa 1920. Merchant ships belonging to the Commonwealth and Dominion Line (foreground) sailed from New York to South Pacific ports, including Australia and New Zealand.

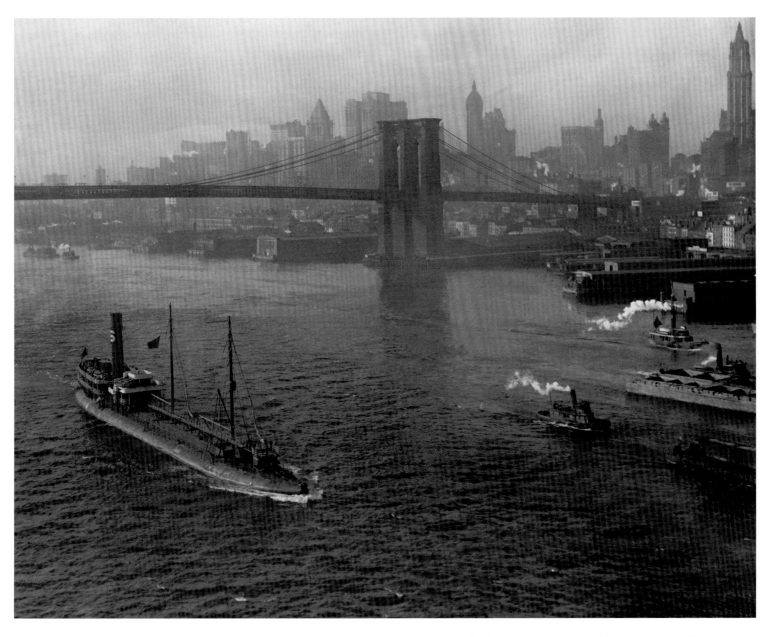

View of the East River and Brooklyn Bridge, photographed by Levick circa 1912. In the foreground is a "whaleback," a type of lighter operated to resupply fuel—here, coal—to harbor tugs and other vessels.

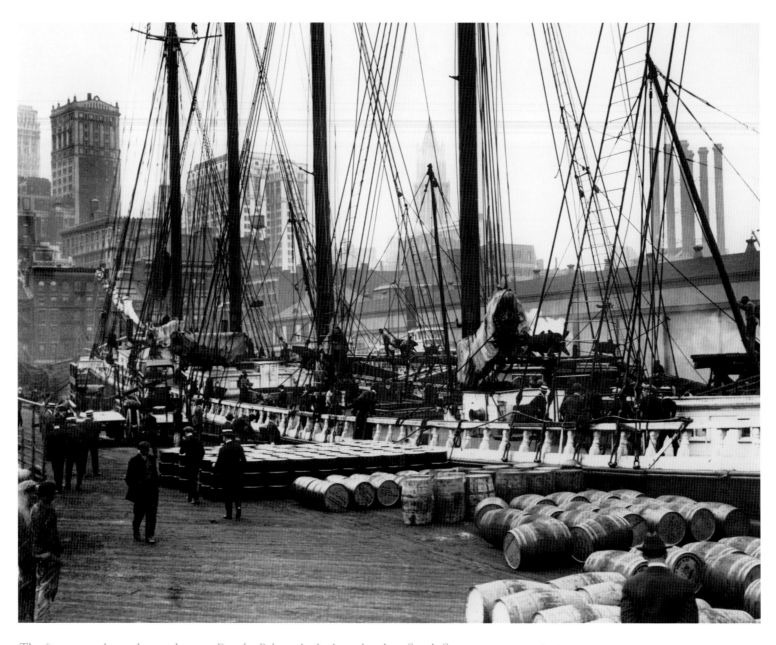

The five-masted merchant schooner *Dorothy Palmer*, docked at a bustling South Street pier, circa 1910.

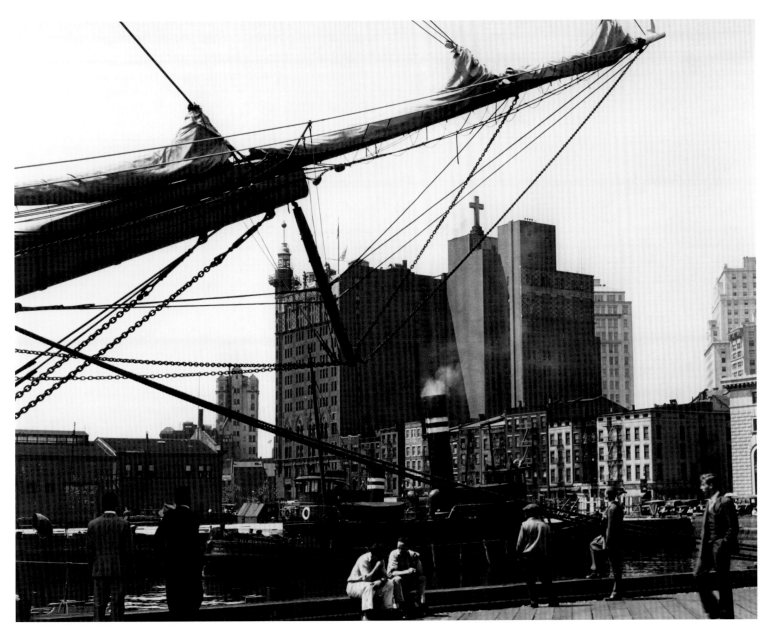

The Seamen's Church Institute, framed by the bowsprit of the *Edna Hoyt*. Visible through the schooner's rigging is the institute's ball tower. For years, the ball would be lowered each day precisely at noon Greenwich Mean Time, the mariners' standard. The *Edna Hoyt* was the last of the five-masted schooners to operate between North America and ports in Europe and Central America.

The imposing Seamen's Church Institute dominated its section of Water Street and became known to locals as simply "the Seamen's Building." Sailors who stayed there referred to it as "the doghouse."

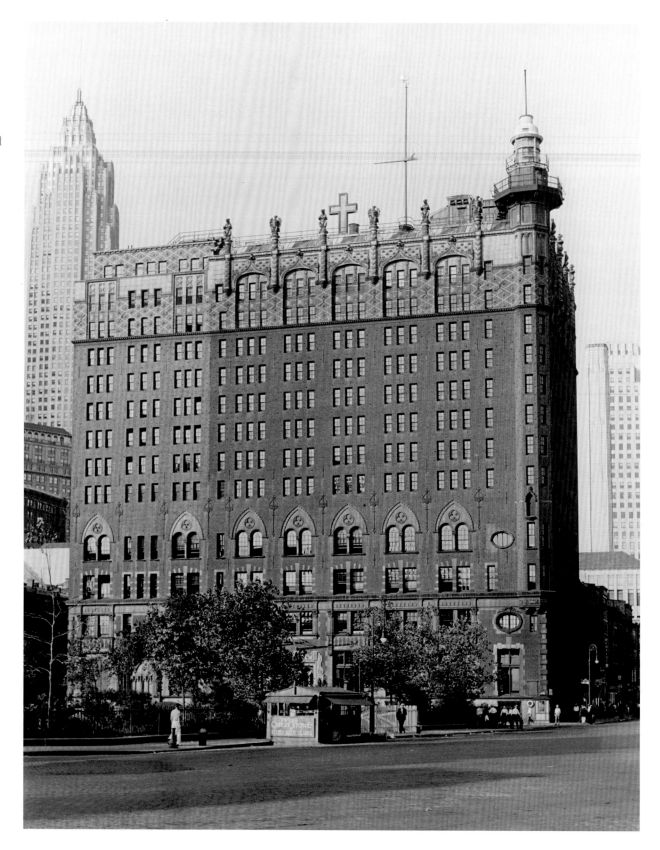

44

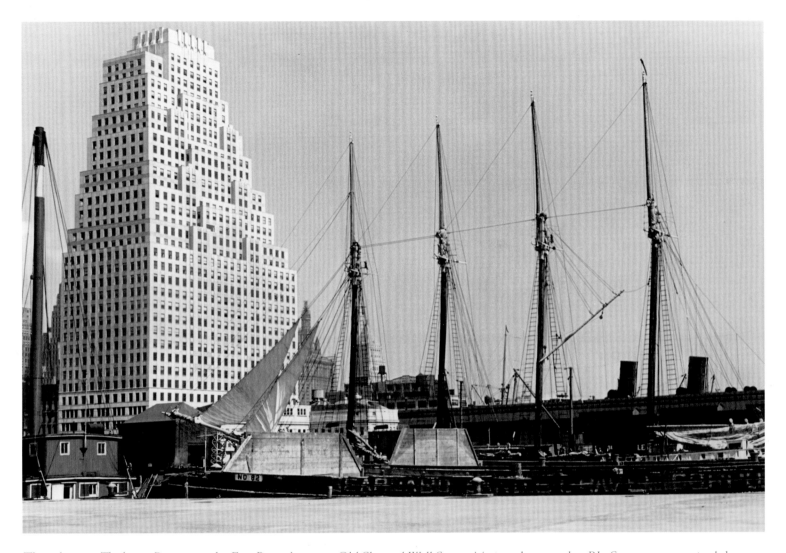

The schooner *Theoline* at Pier 11 on the East River, between Old Slip and Wall Street. Marine photographer P.L. Speer counterpoised the ship's airy rigging and graceful sails against the blocky edifice at 120 Wall Street. Built in 1917, *Theoline* called at New York several times a year through the decade of the 1920s. The schooner became a favorite subject of various New York photographers, including Berenice Abbott, who photographed it in 1936. It reportedly was the last working merchant schooner to ply the waters of the Port of New York.

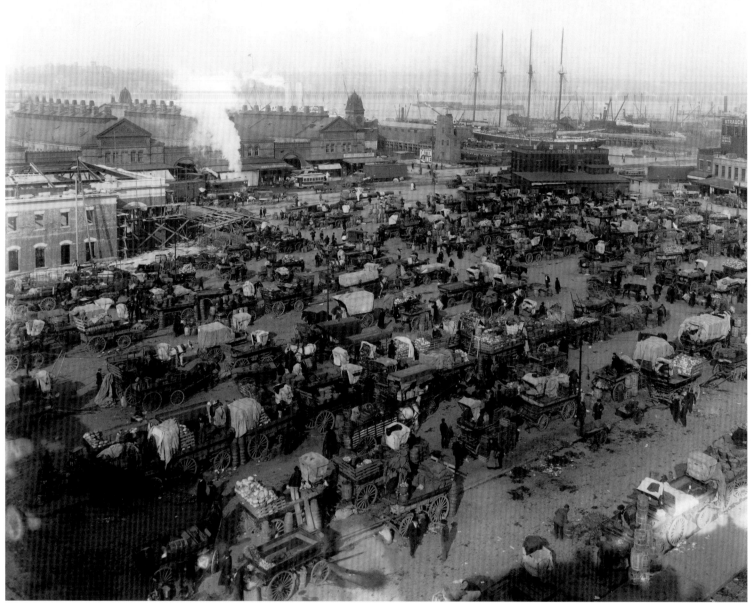

A welter of horse-drawn wagons along the wharf on New York's Lower West Side in the first decade of the twentieth century, when automobiles were rare.

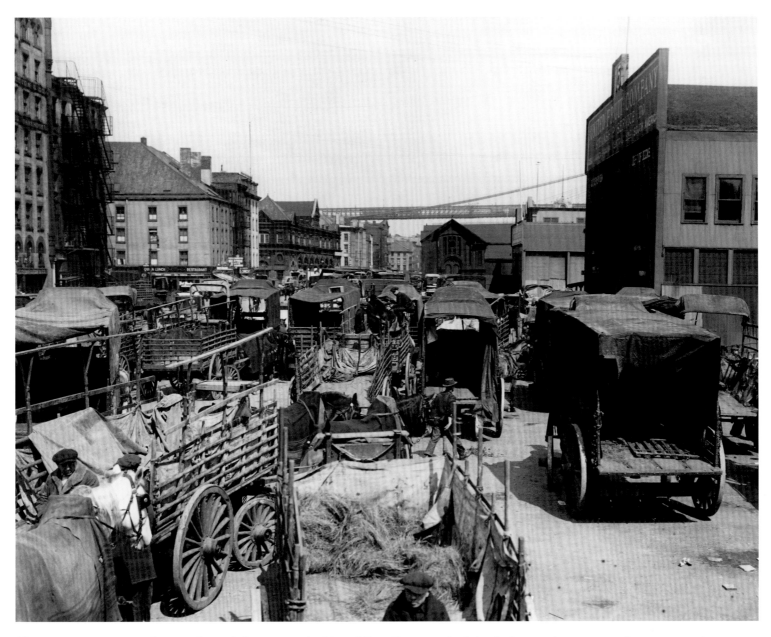

Horse carts waiting outside a warehouse belonging to the United Fruit Company (right), which earned its owners a fortune importing bananas from Central America—by 1908, some 16 million bunches a year. A major force in the company's growth was Minor Keith, a Brooklyn-born entrepreneur who built a railroad in Costa Rica, then planted banana trees along its right-of-way.

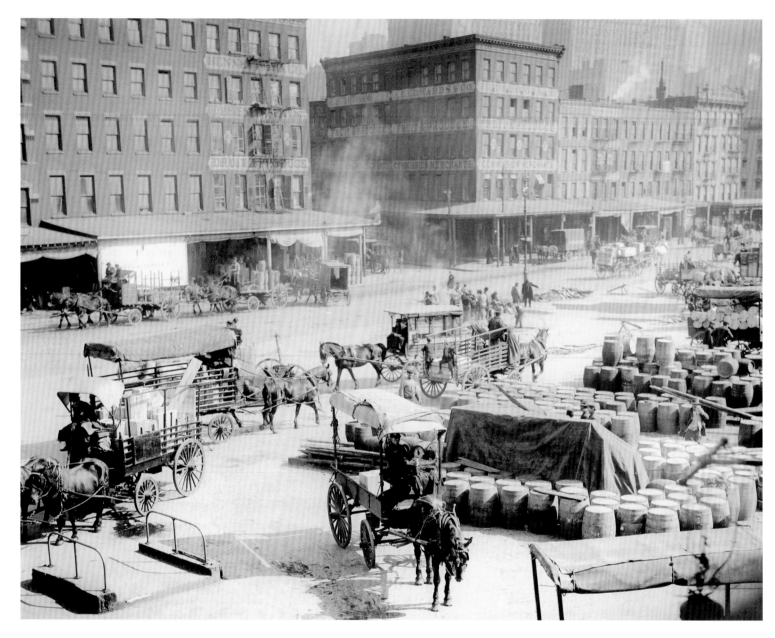

Dock Street at the beginning of the twentieth century. The building in the center of the image bears the name Edwards Fruit & Produce Commission Merchants.

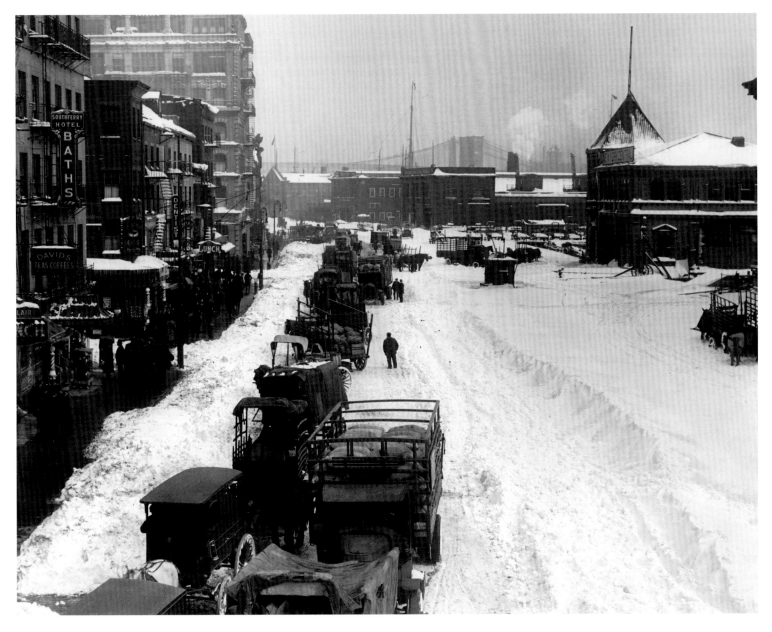

The southern end of South Street around 1920, with its motley array of budget hotels, eateries, and other businesses catering to the needs of a working waterfront clientele.

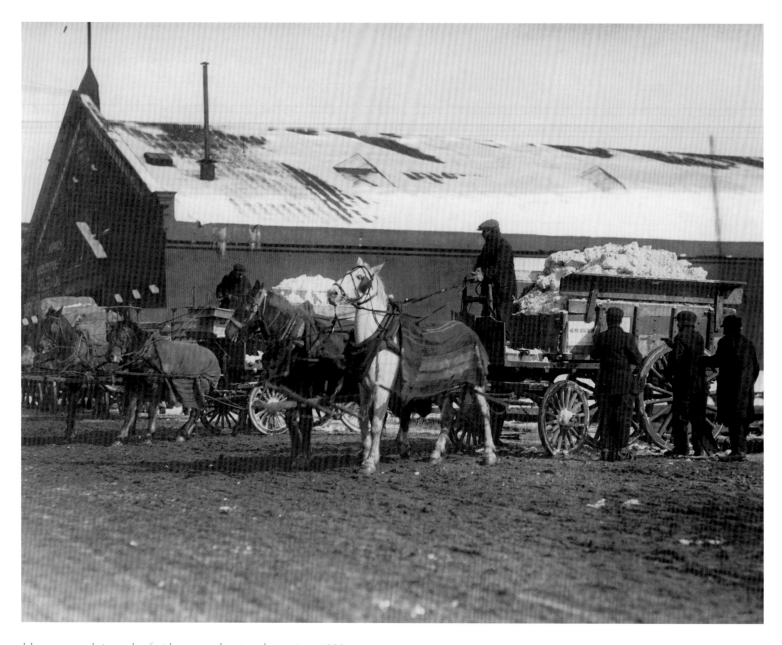

Horse carts doing wharf-side snow-clearing duty, circa 1903.

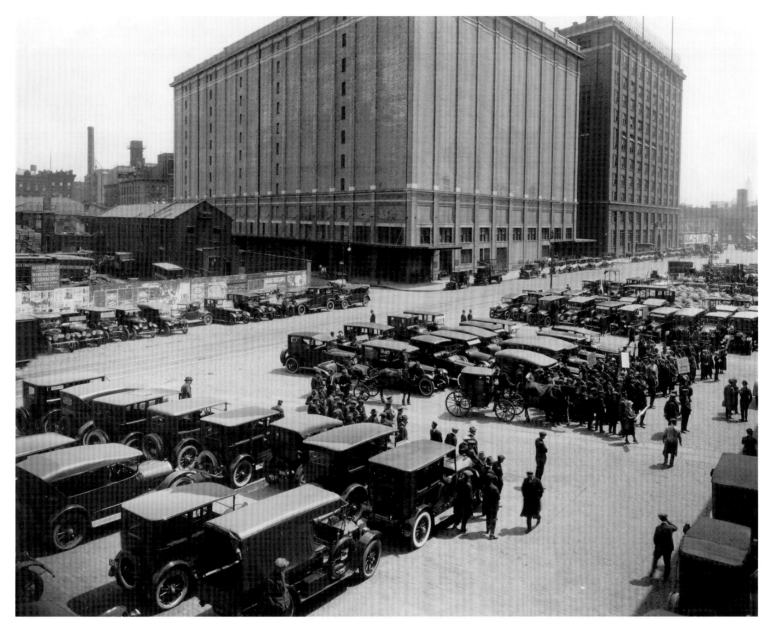

In the center-right of this 1911 photograph, a mix of motor vehicles and horse-drawn carriages buttress a crowd that includes businessmen, women, workers, and uniformed police. Several onlookers are carrying placards, suggesting that the gathering may have been part of New York's boisterous political scene.

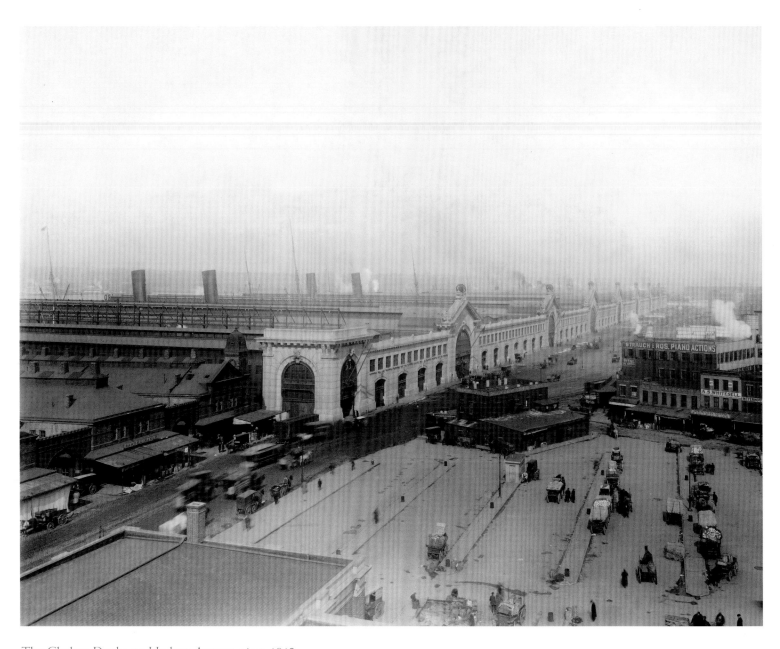

The Chelsea Docks on Hudson Avenue, circa 1912.

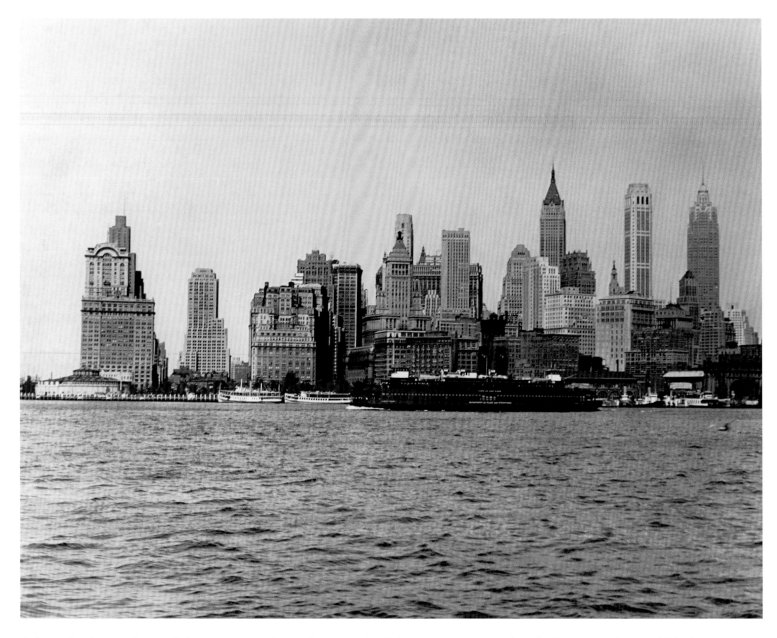

A ferry, the *American Legion*, gliding past an amalgam of spires and stolid towers as it approaches the Battery, at the tip of Manhattan, in the early 1930s.

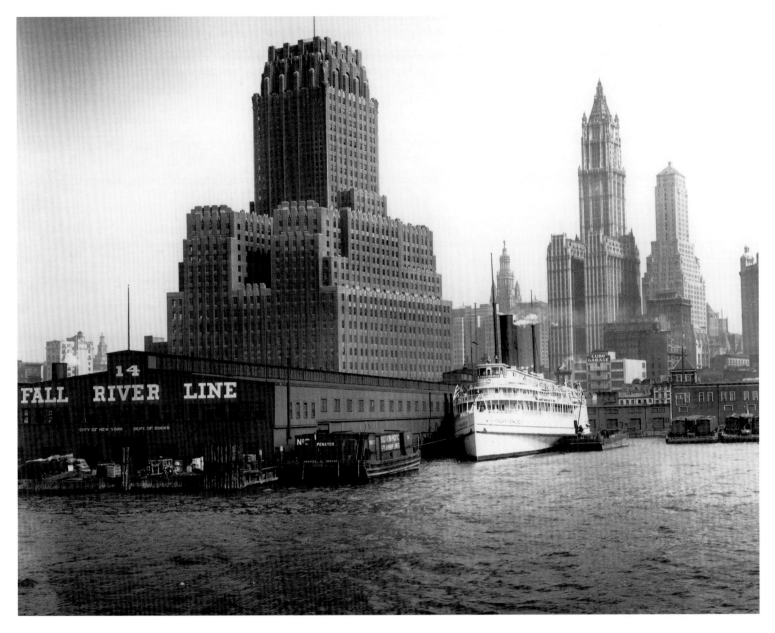

New York's emergent twentieth-century skyline as it appeared along a section of the North (Hudson) River. Moored hard against the Fall River Line's Pier 14 is the steam ferry *Providence*. The Fall River Line provided passenger and freight service from New York City to Fall River, Massachusetts, and Newport, Rhode Island, until 1937.

Levick's powerful image of the British yacht *Shamrock IV* vying with the New York Yacht Club's *Resolute* for the America's Cup in 1920. *Resolute* won the cup that year. While the races were under way, boatloads of avid spectators, who could number 50,000 or more, clogged the waters of New York Harbor.

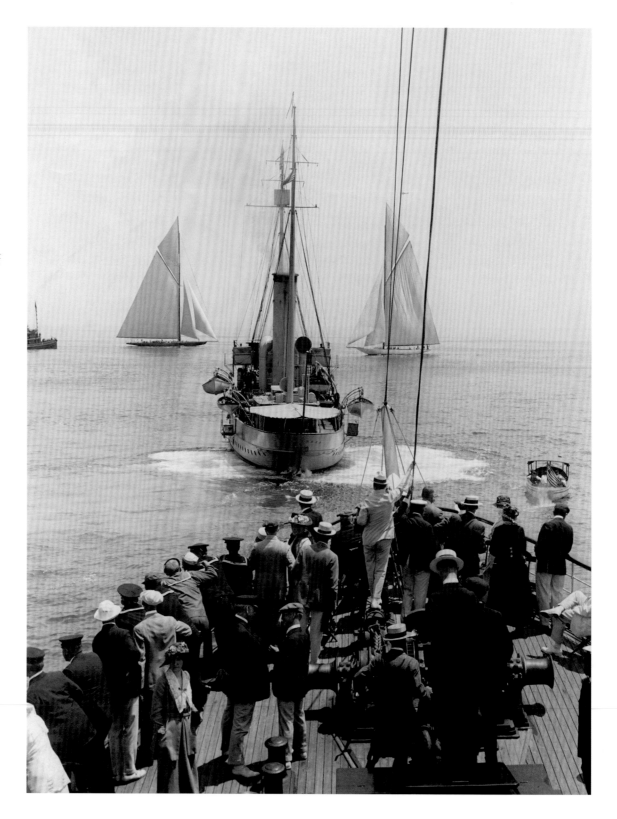

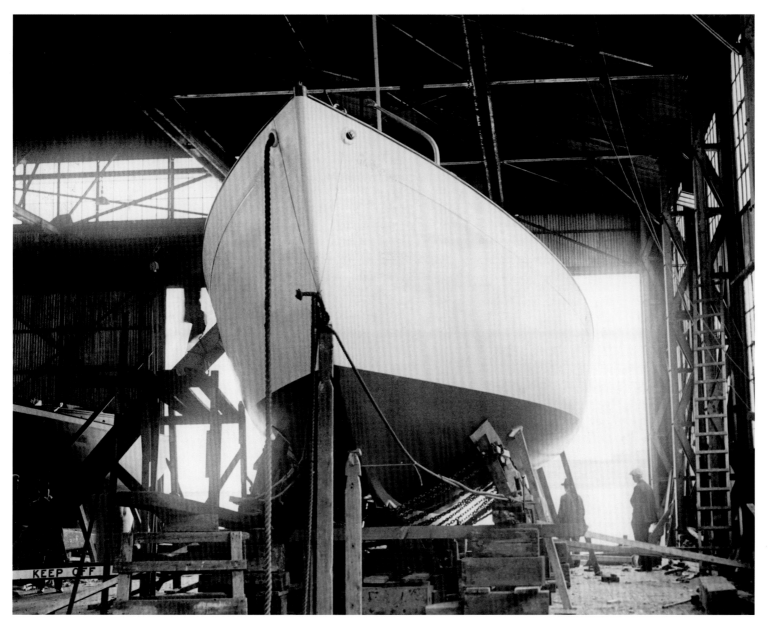

The yacht *Tamerlane* on the ways in 1933. The photographer may have been Edwin Levick's son John Levick, who attempted unsuccessfully to keep his father's marine photography business going after the elder Levick's death in 1929.

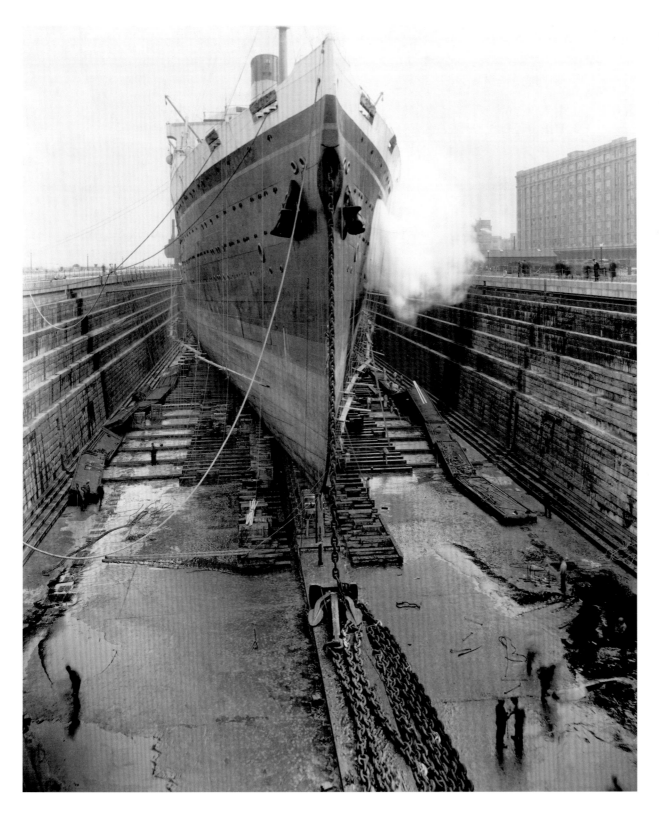

Majestic, sister ship of the *Titanic*, in dry dock. From 1922 until the French liner *Normandie* was launched in 1935, *Majestic* was the largest passenger liner in the world.

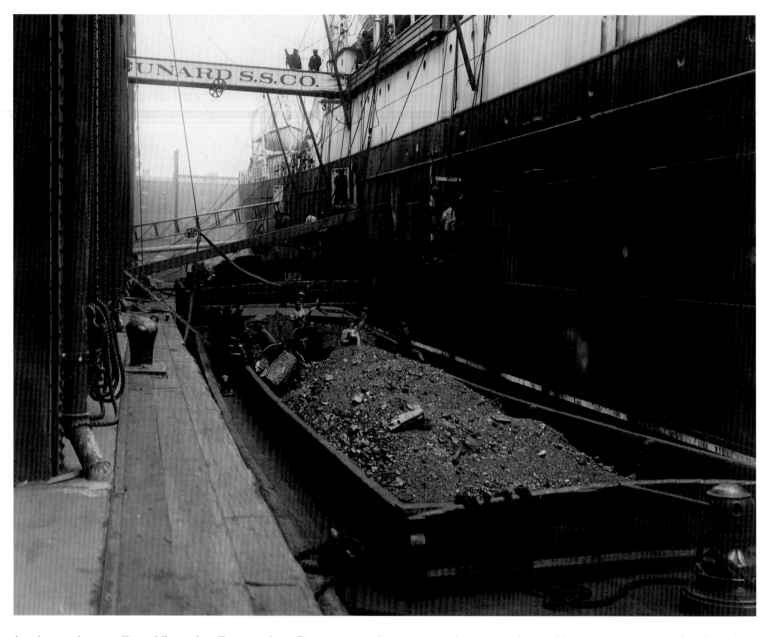

Loading coal onto a Cunard Steamship Company liner. During a transatlantic voyage a large steamship could consume 1,000 tons of coal per day.

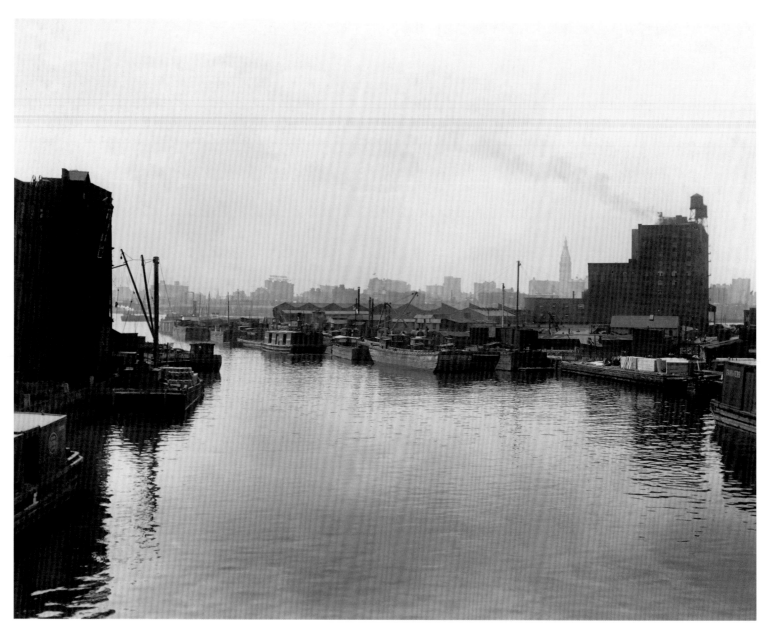

Quiet water on Brooklyn's Newtown Creek, a tributary of the East River. Such bucolic scenes must have been rare; according to the *Encyclopedia of New York City*, in the early twentieth century the East River was second only to the Mississippi in terms of its commercial ship traffic and cargo tonnage.

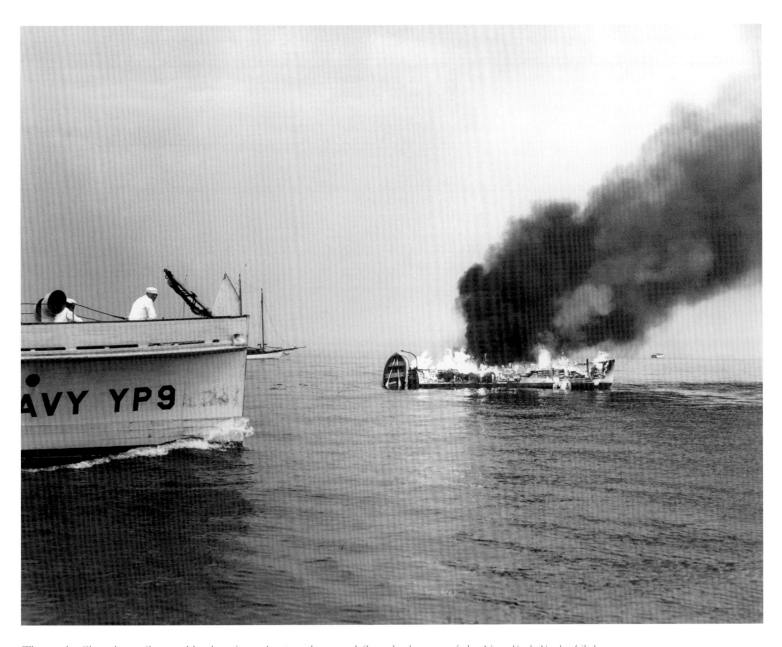

The yacht *Chrysolite* in flames. Until its fiery demise, the vessel flew the burgee of the New York Yacht Club.

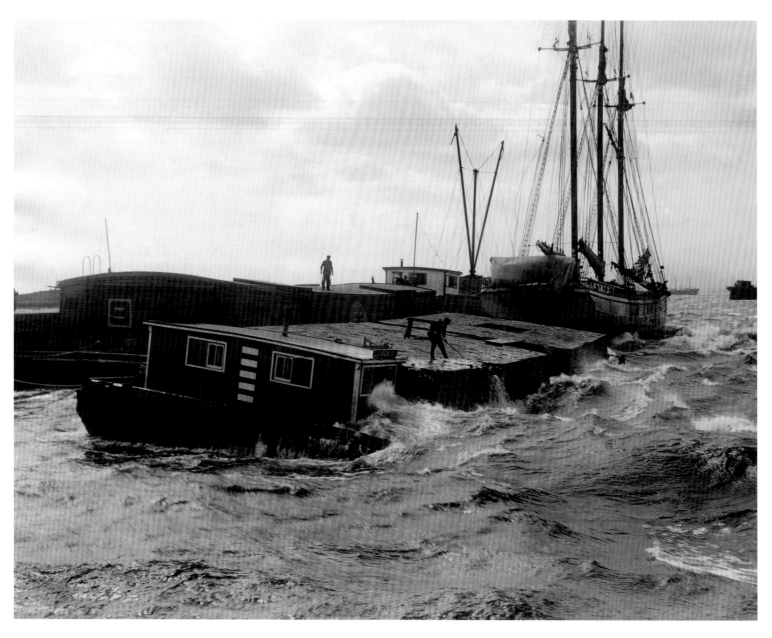

A harbor barge buffeted by wind-driven chop. Although the three-masted coaster behind it appears considerably more secure, it had nearly outlived its era.

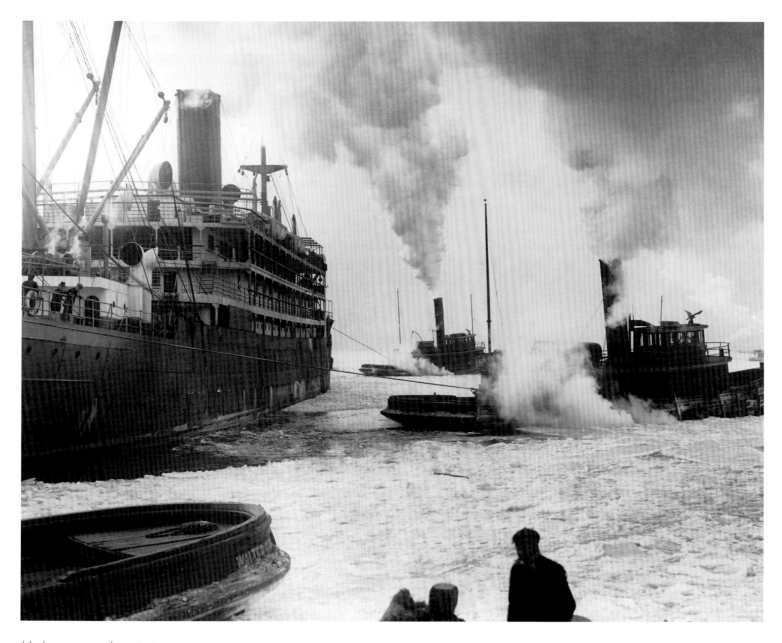

Harbor tugs working in ice.

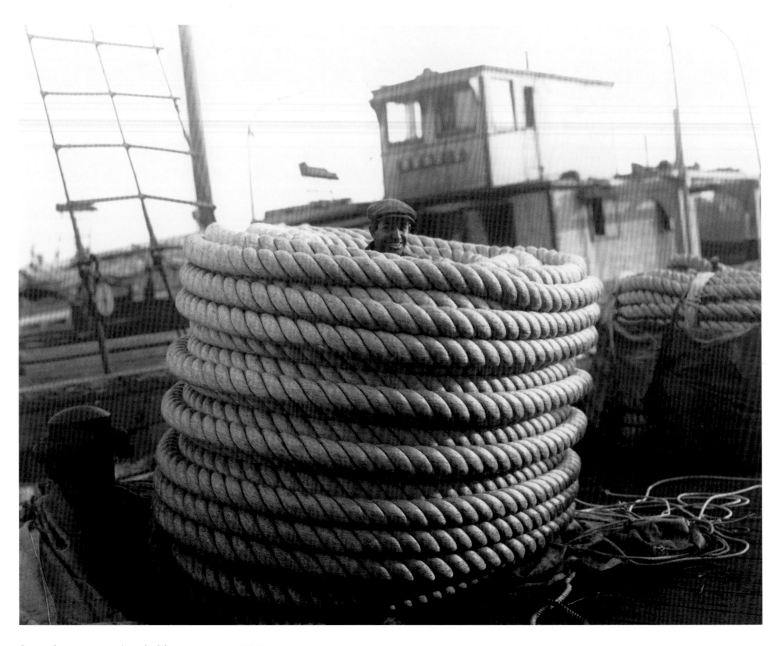

Longshoreman and coiled hawser, circa 1925.

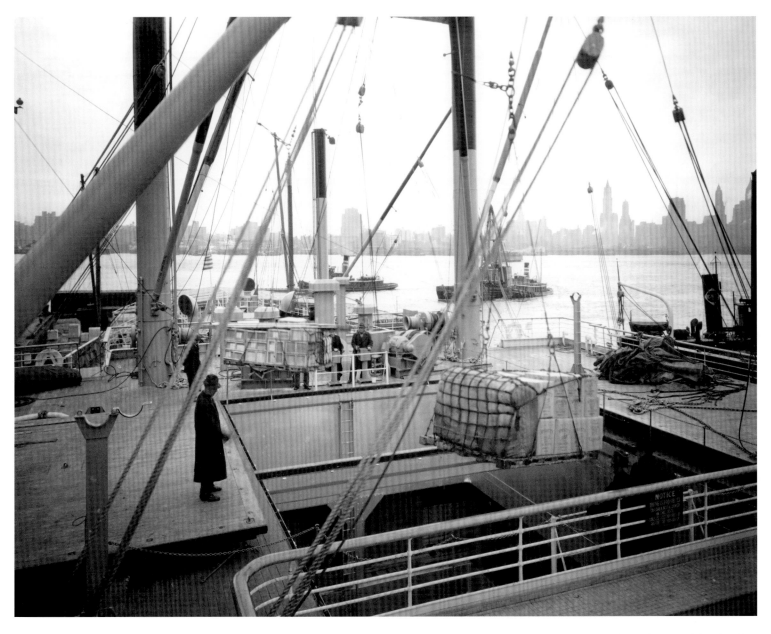

Loading cargo in winter. The mixed cargo is strapped onto pallets, a harbinger of ever more efficient cargo-handling that would radically alter the cadence of work, and the need for human labor, in seaports around the world.

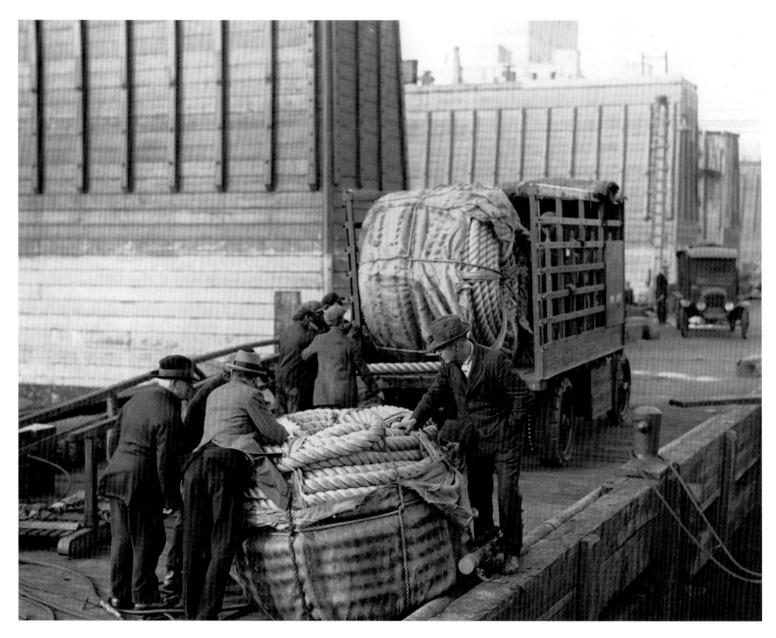

Men with hawsers. The three men at left in the foreground, one with the distinct look of an owner, are poring over papers, perhaps delivery documents. This photograph is a companion to the preceding photograph and is recorded immediately before it in Edwin Levick's logbook.

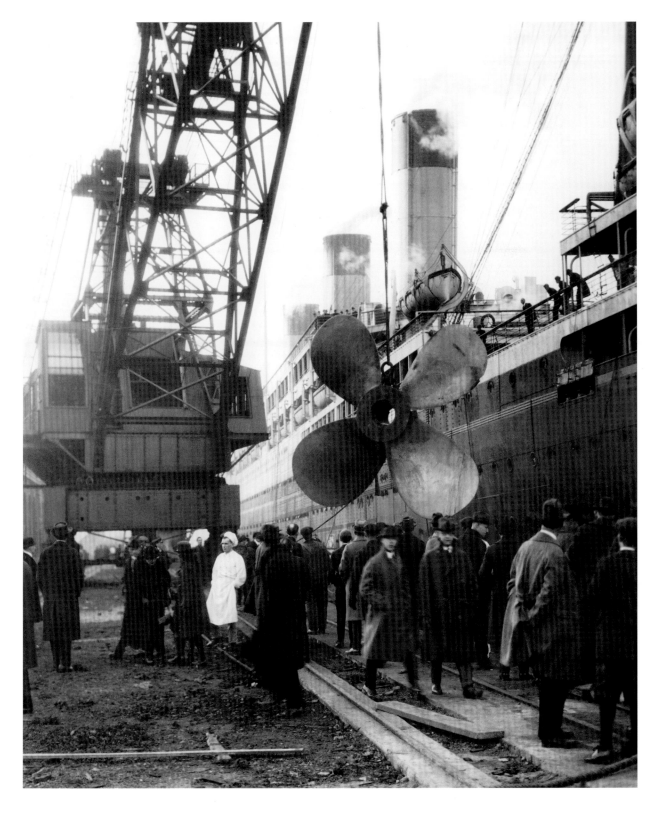

Steamship *Majestic* with propeller, 1914. Edwin Levick's notes do not tell us whether the crane hoisting the propeller is loading or unloading its burden, but steam emanating from the *Majestic*'s boilers and the presence of passengers on deck suggests that the mighty vessel is being readied for departure.

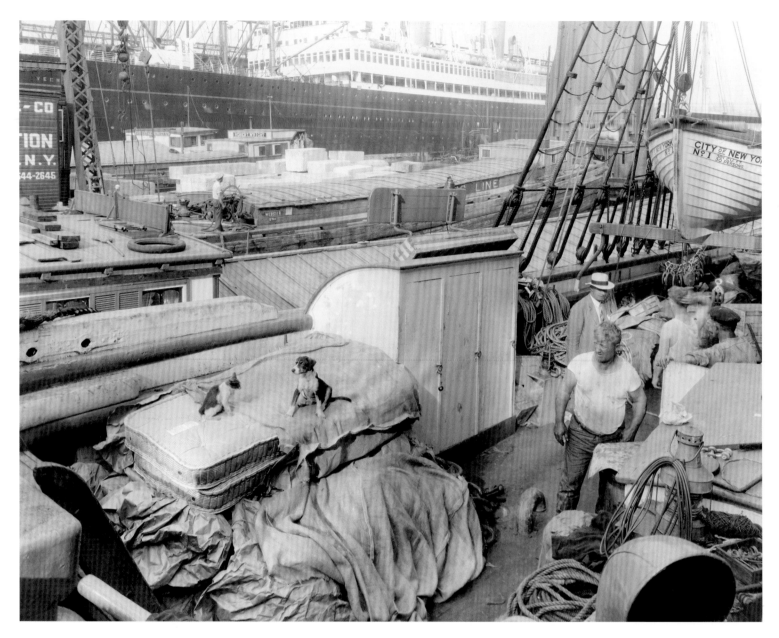

Deck scene aboard the *City of New York*, circa 1923. Moored in the background is the Dutch liner *Veendam*, which regularly plied routes between New York City, the Mediterranean, and the Caribbean.

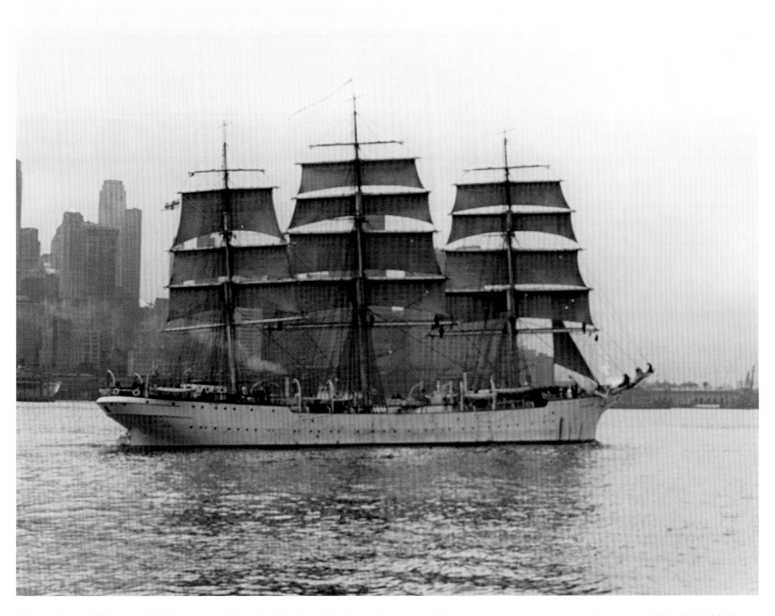

Suomen Joutsen. Photographed in 1937, when the heyday of sail was long past, this square rigger was an anachronism in New York Harbor and may have been on a sail-training voyage.

The zeppelin *Akron* over the ferryboat *President Roosevelt*. The 785-foot *Akron* may have been on its maiden flight from the Lakehurst, New Jersey, naval air station when P.L. Speer photographed it in the autumn of 1931. Less than two years later it crashed during a storm off Beach Haven, New Jersey.

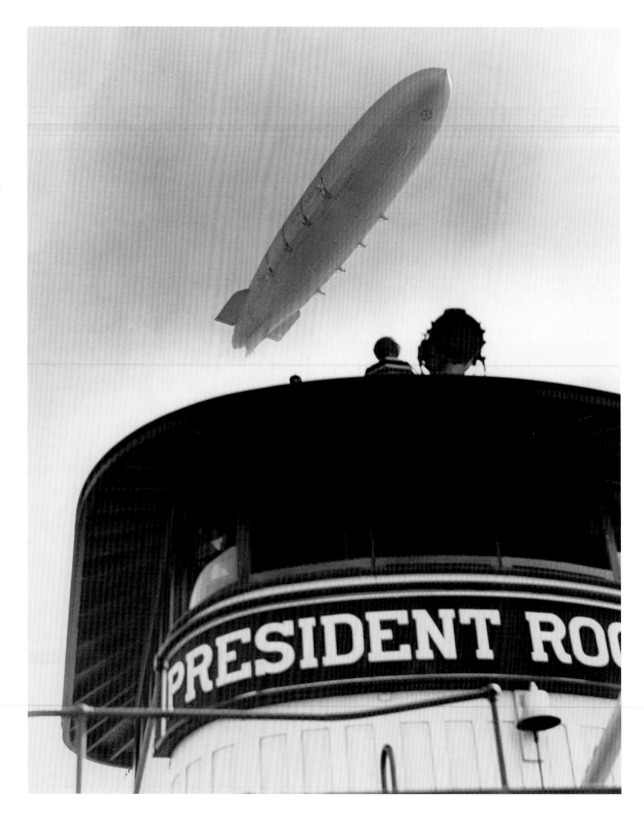

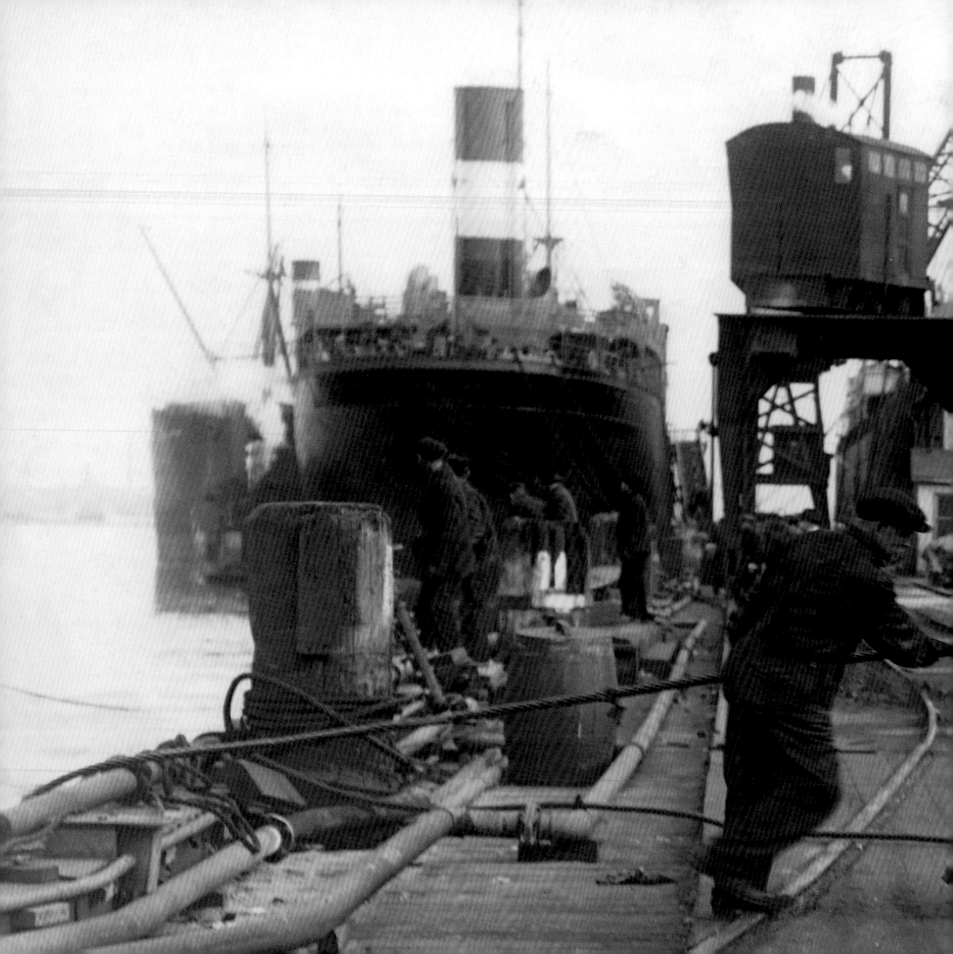

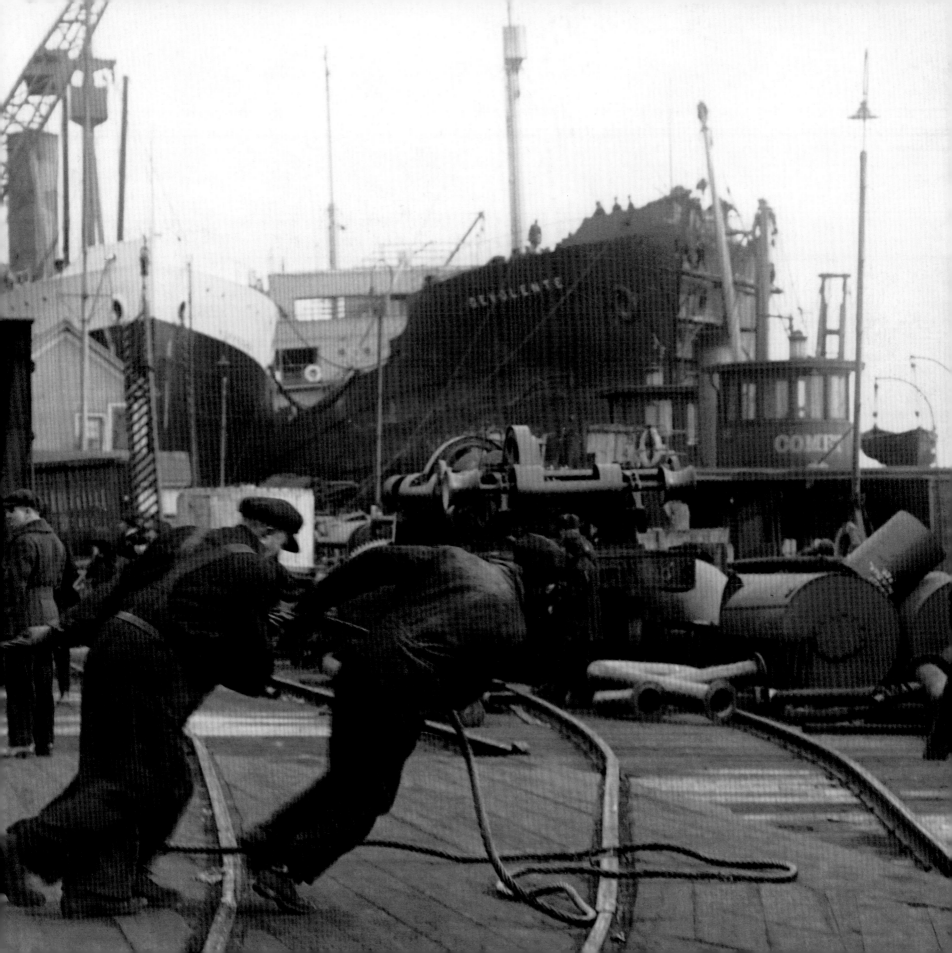

Previous spread: Hauling in a hawser at the railroad docks. The picture offers no clue as to what load these workers are straining so hard to move.

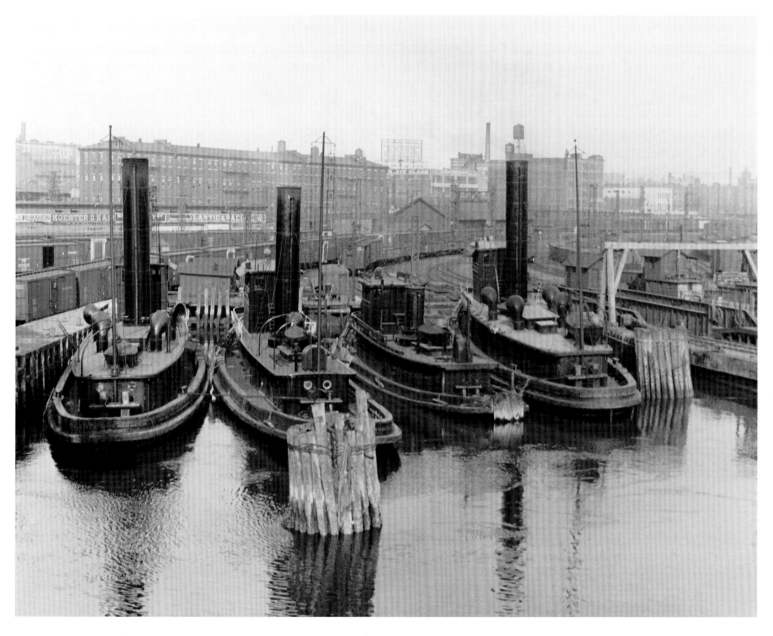

Tugs belonging to the New York, New Haven, and Hartford Railroad—commonly called the New Haven Railroad—berthed along the Harlem River. At the company's peak in 1929, it commanded more than 2,000 miles of track linking New York with destinations in Connecticut, Rhode Island, and Massachusetts.

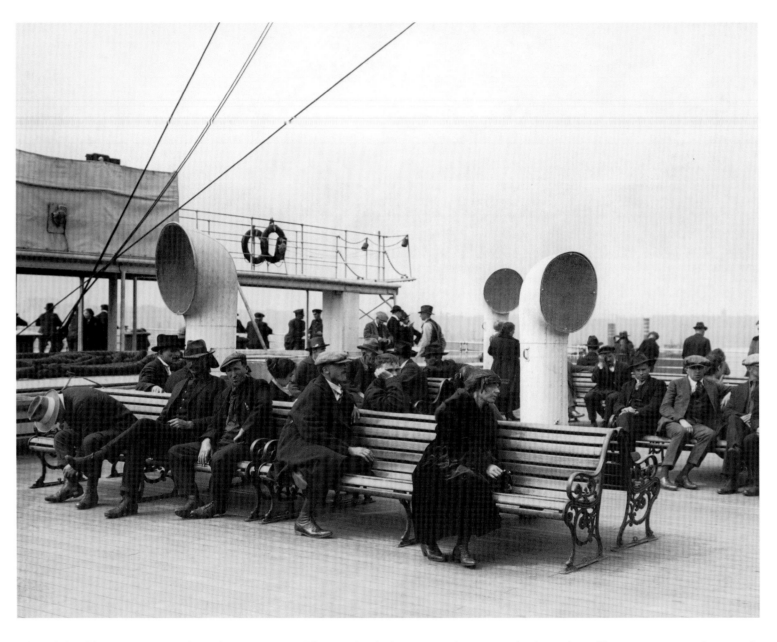

Aboard the *Olympic* in New York Harbor, circa 1911. These individuals appear to be among the liner's less affluent passengers, the sort of ordinary folk that Edwin Levick seems to have been so often drawn to photograph.

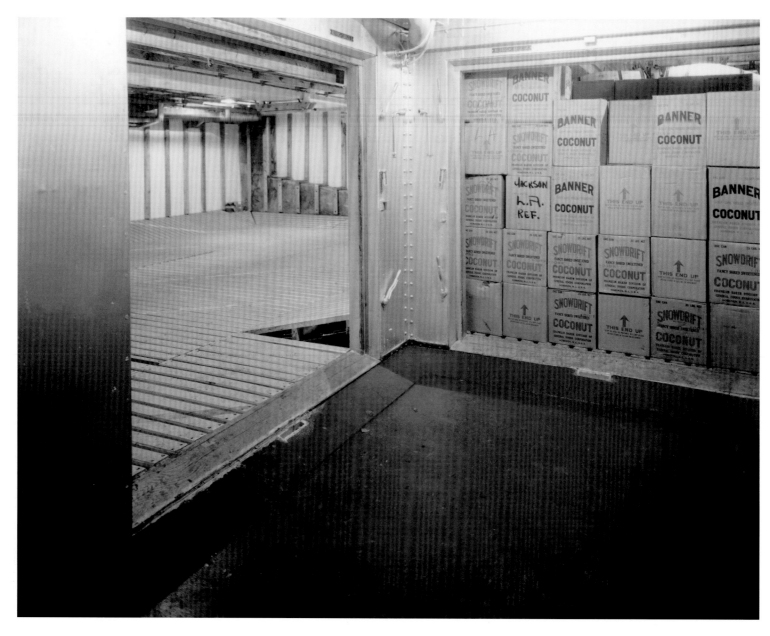

Boxes of coconut—"Fancy Shred Sweetened"—in refrigerated storage, probably in the 1930s.

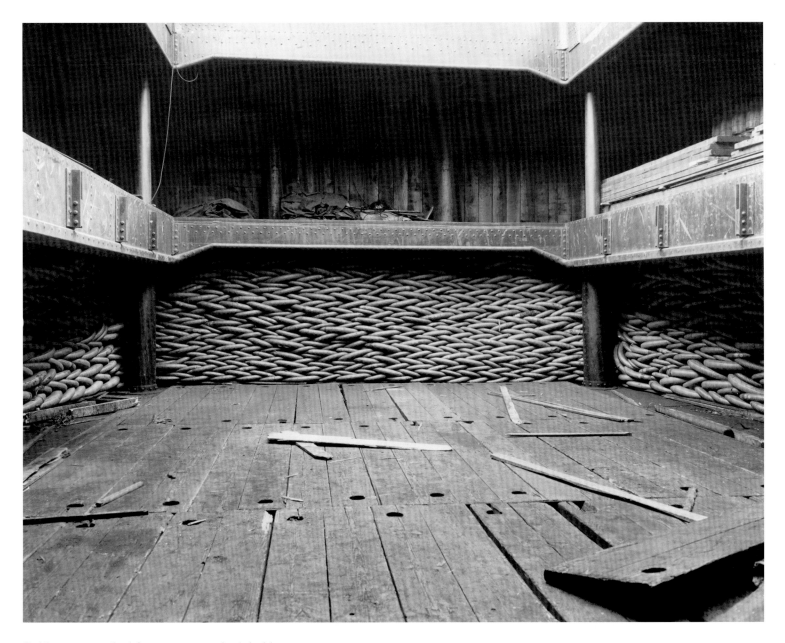

Rubber tires stacked for export in a ship's hold.

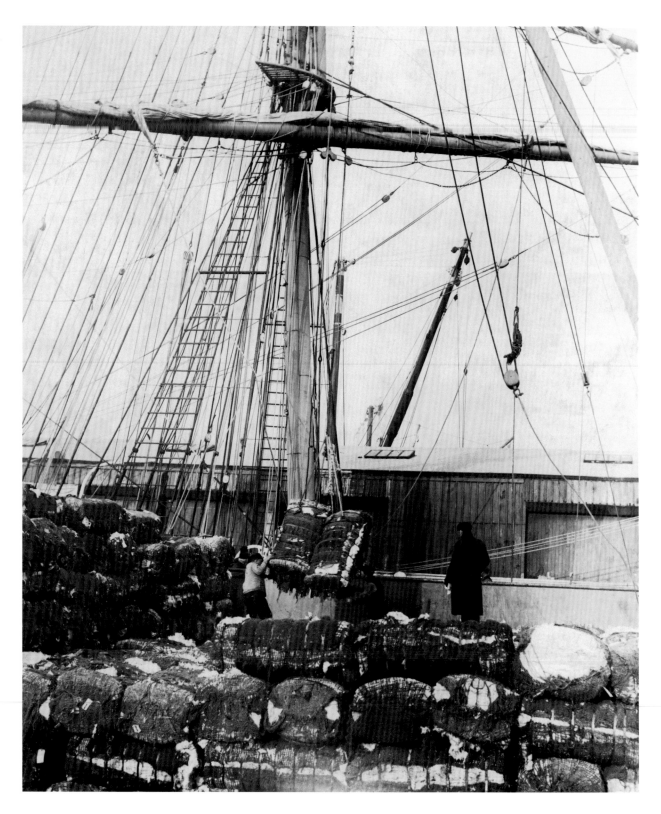

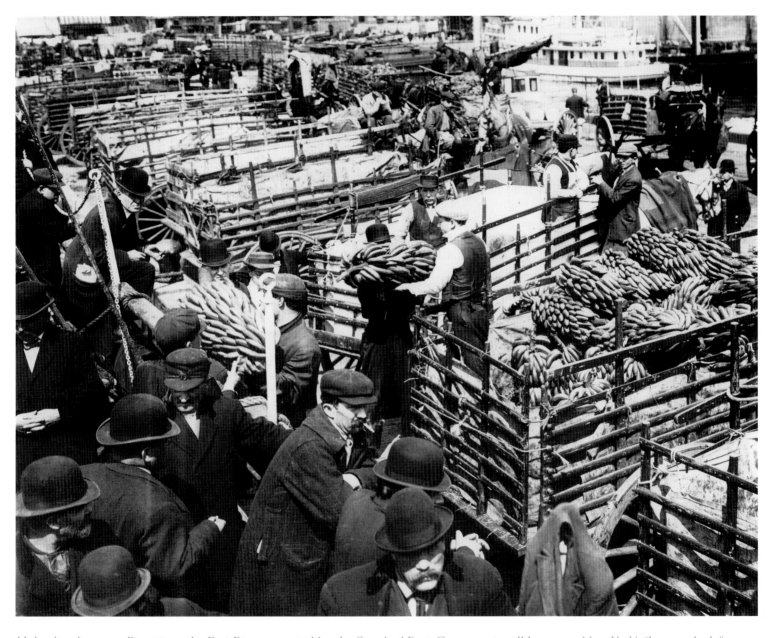

Unloading bananas. Pier 13 on the East River, operated by the Standard Fruit Company, is still known as New York's "banana dock."

Bananas being loaded
into waiting carts at the
banana dock.

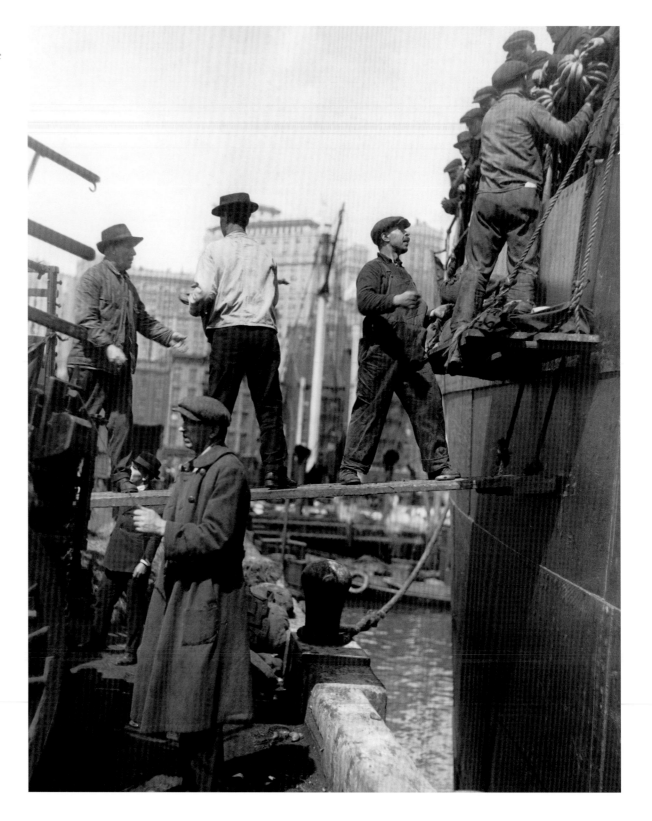

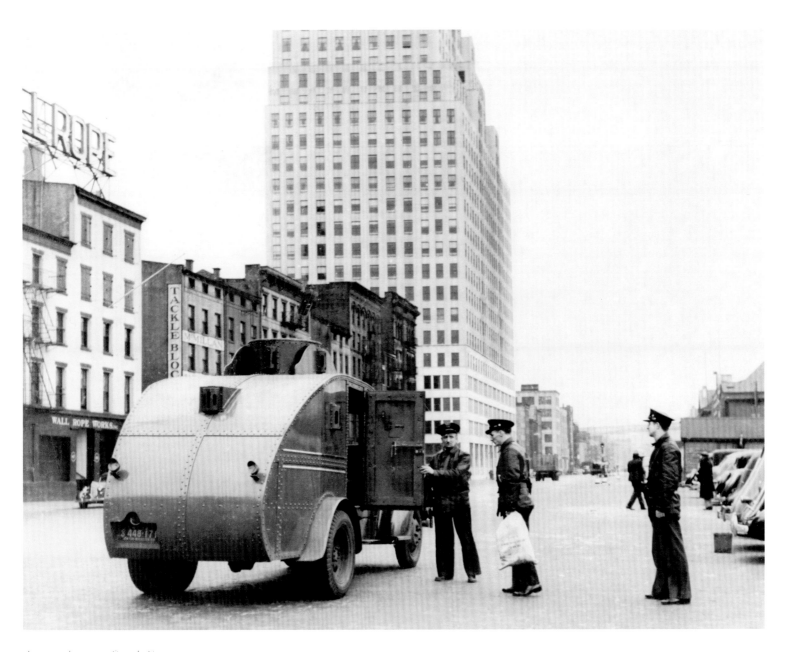

Armored car on South Street.

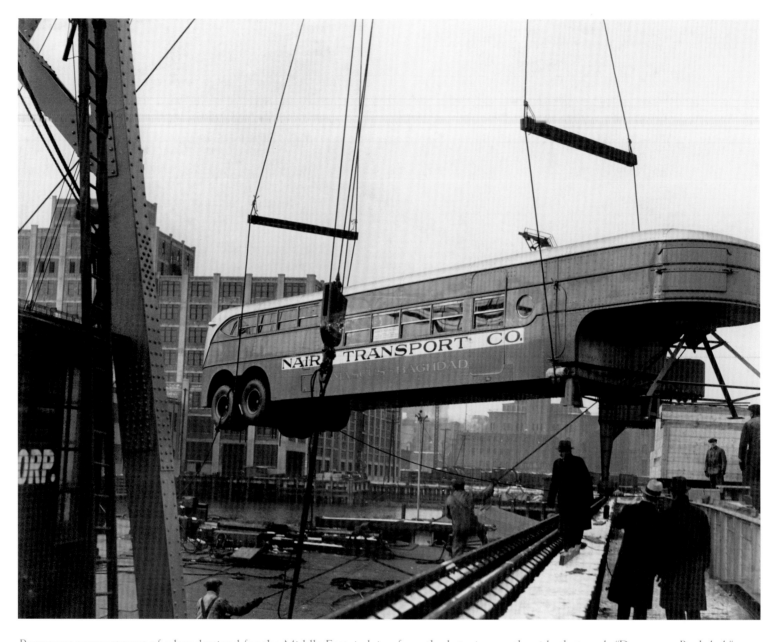

Passenger compartment of a bus destined for the Middle East, judging from the lettering on the side that reads "Damascus–Baghdad."

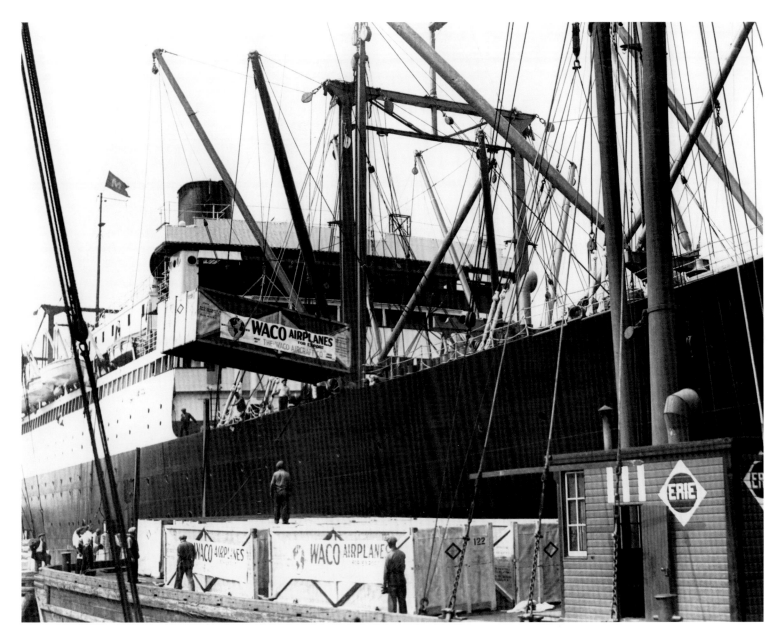

Crates from the Weaver Aircraft Company (WACO) of Troy, Ohio, being loaded from an Erie Company barge onto the steamship *Pan America* in the 1920s. Barnstormers made WACO a household word in the American Midwest; in the late 1920s and early 1930s the company enjoyed a reputation as one of the world's major aircraft producers.

Crate destined for Rio de Janeiro. Edwin Levick photographed this scene in 1922, his composition ominously juxtaposing the cold angularity of steel booms, ropes, and the mysterious crates unmarked except for the owner, Brazil's "Ministerio da Guerra"—the War Ministry.

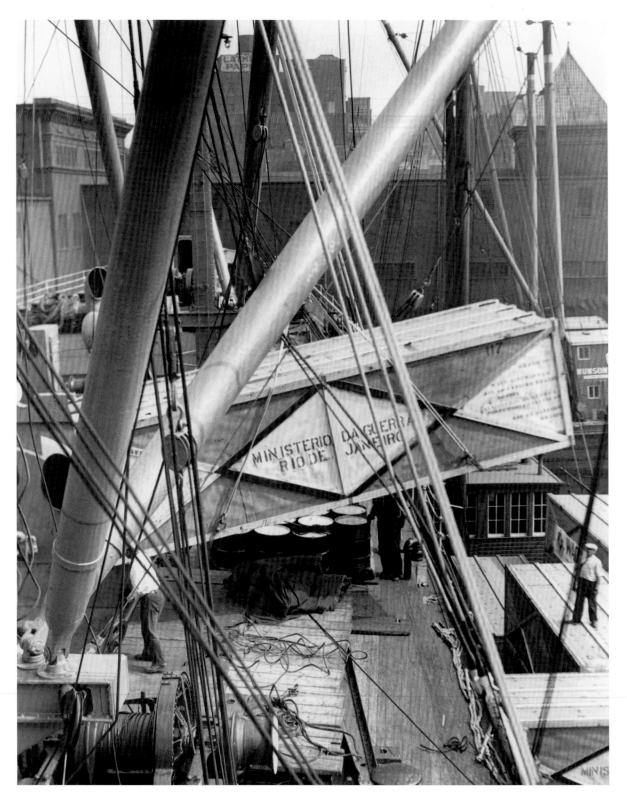

90

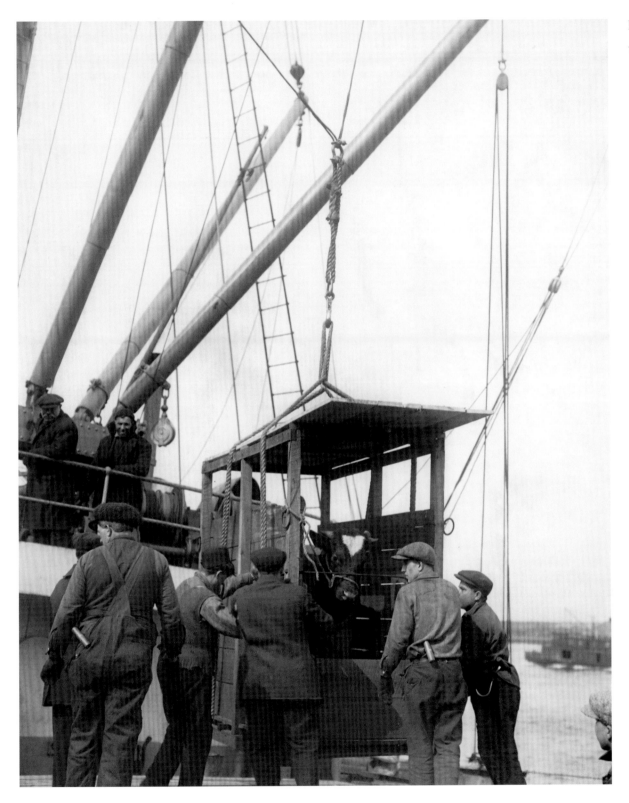

Bull being loaded onto
the *Santa Teresa*, 1918.

91

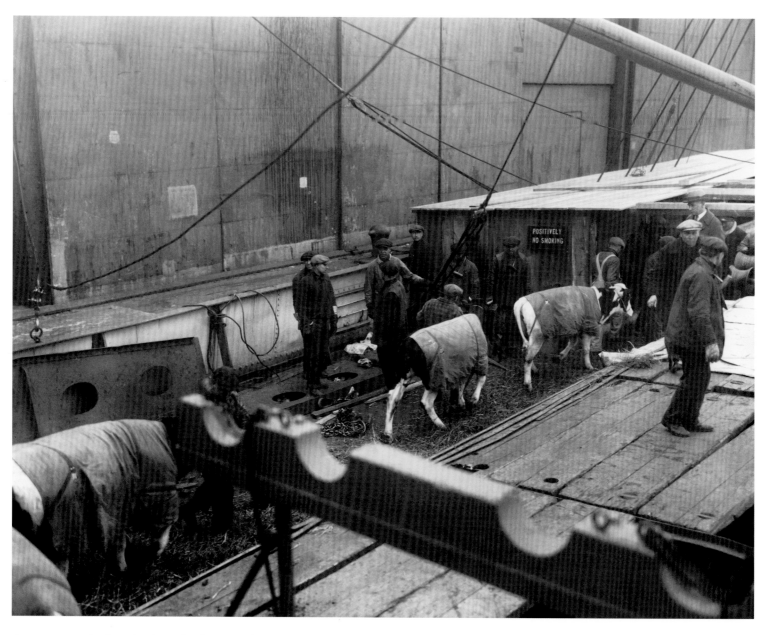

Argentine cattle disembarking the *Santa Rosalia* in 1911. The protective blankets worn by the animals suggest that these were not ordinary bovines, but valuable breeding stock.

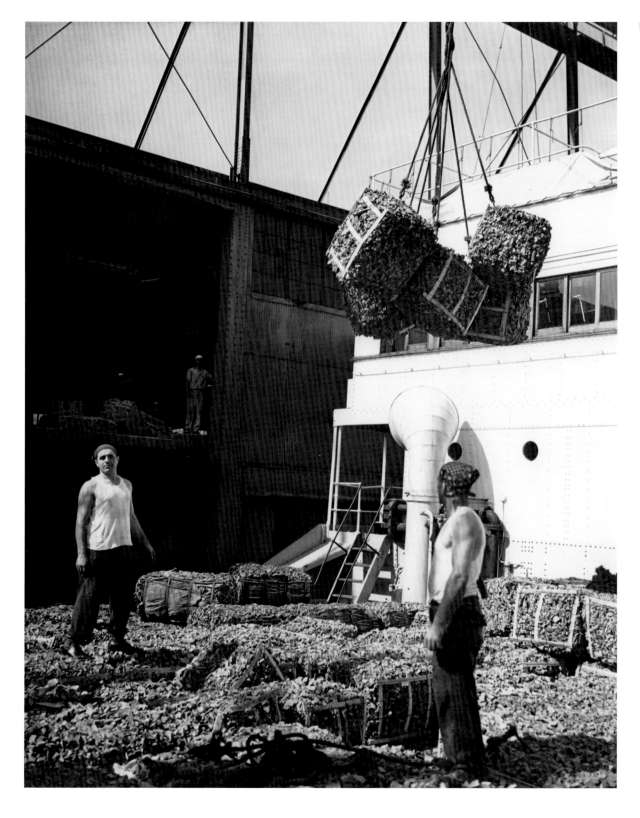

Unloading cork.

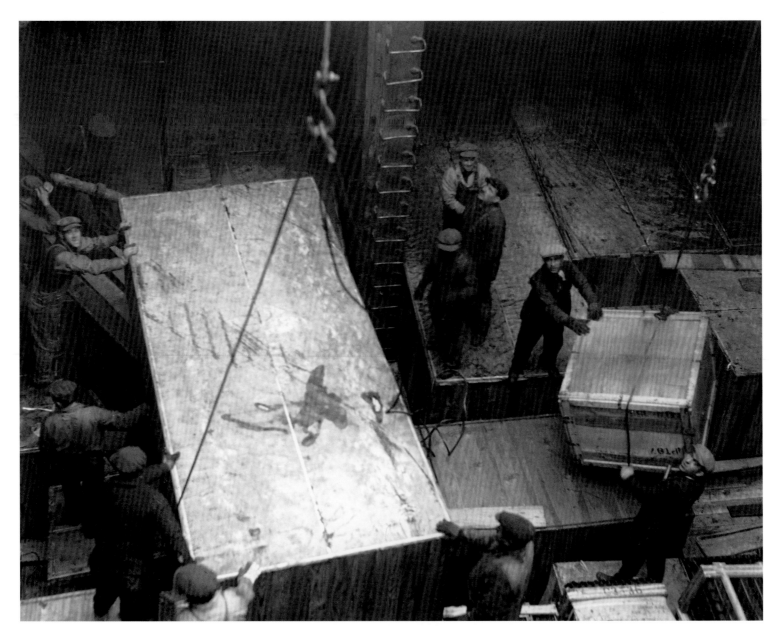

Packing crates into a ship's hold, 1925.

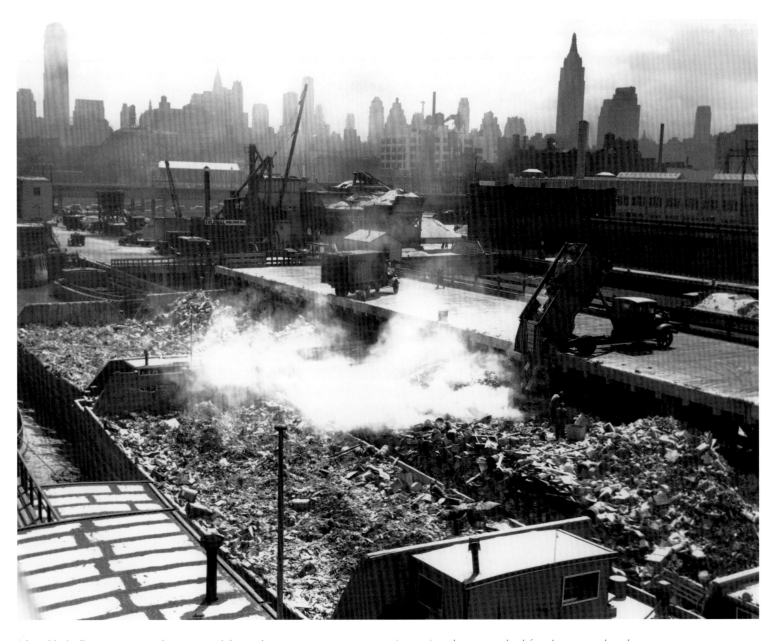

New York City appearing far removed from the steaming mountains of its refuse being readied for dumping elsewhere.

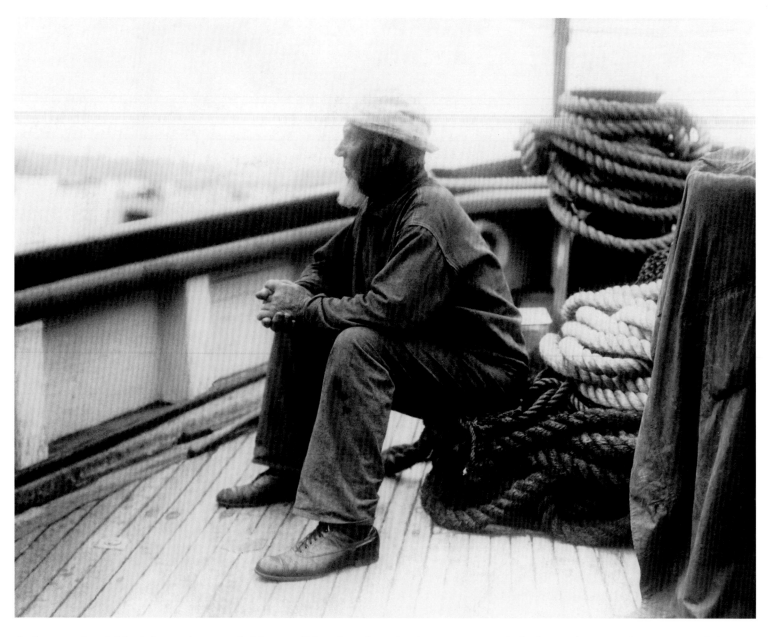

Archetype of an "old salt," seated on a coiled hawser. Edwin Levick evidently spent a great deal of time aboard working vessels of the New York waterfront, a habit that provided him access to moments such as this one.

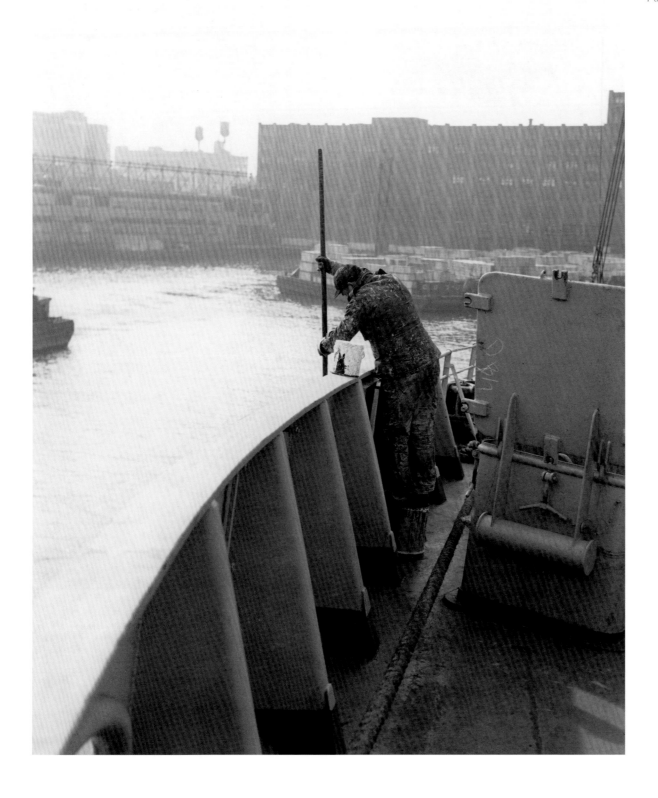

Painting the hull.

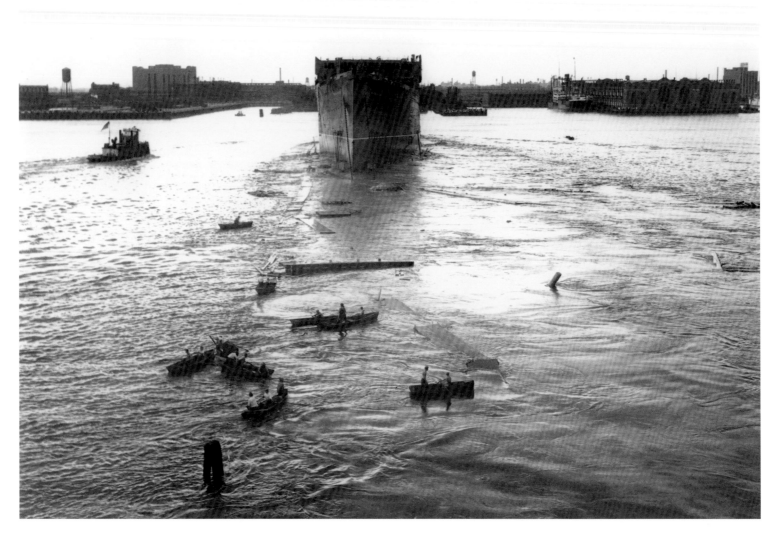

Freshly slipped down the ways at the New York Shipbuilding Corporation yard in Camden, New Jersey, in 1932, the ocean liner *Washington* is launched. Although much work remained before the 705-foot liner would be fully fitted out for its maiden voyage in 1933, the launch was an event that drew a devoted coterie of spectators, including the intrepid souls shown here in rowboats.

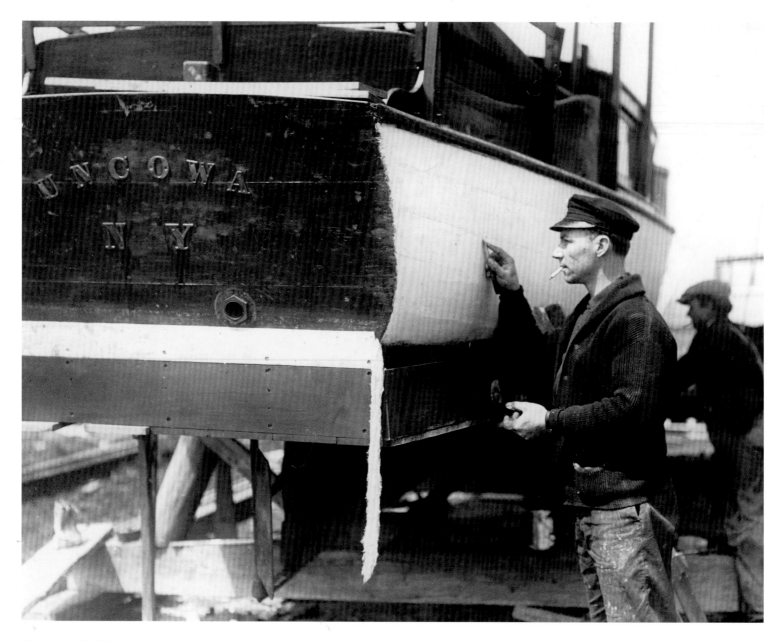

Repairing the *Uncowa*.

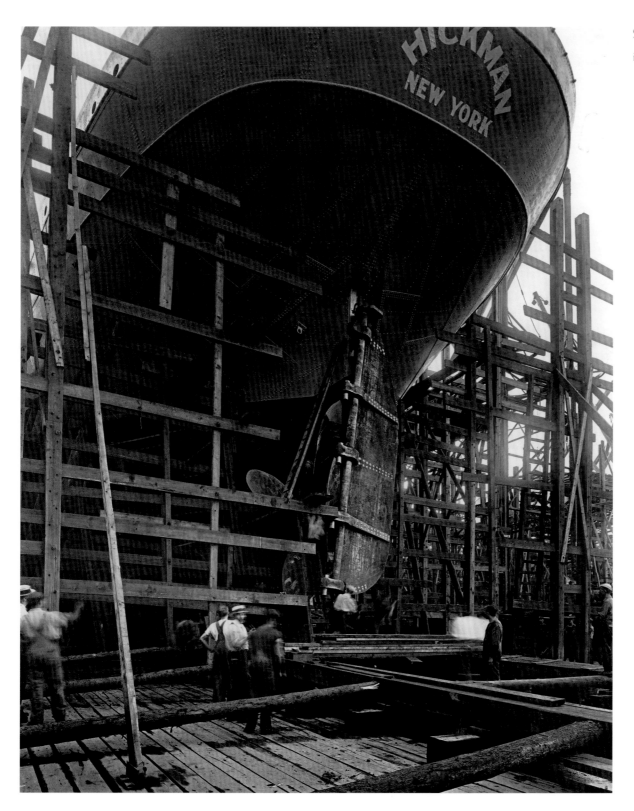

Stern of the *Hickman*
in dry dock.

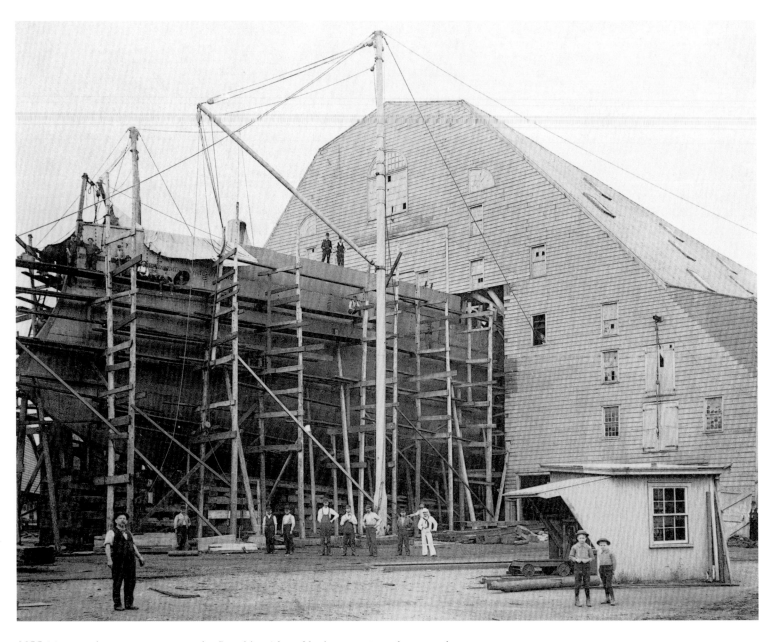

USS *Maine* under construction in the Brooklyn Navy Yard in an 1889 photograph that may have been part of P.L. Sperr's personal collection of old pictures.

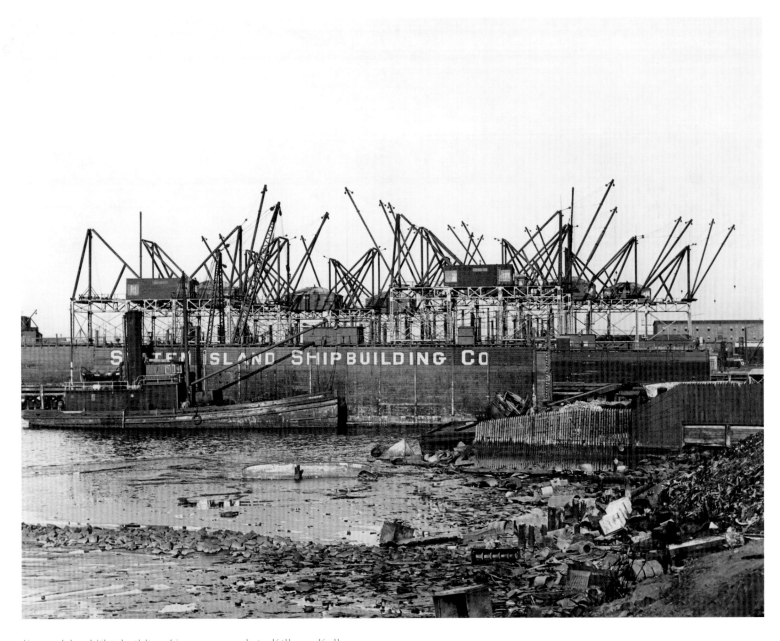

Staten Island Shipbuilding Company yards in Kill van Kull.

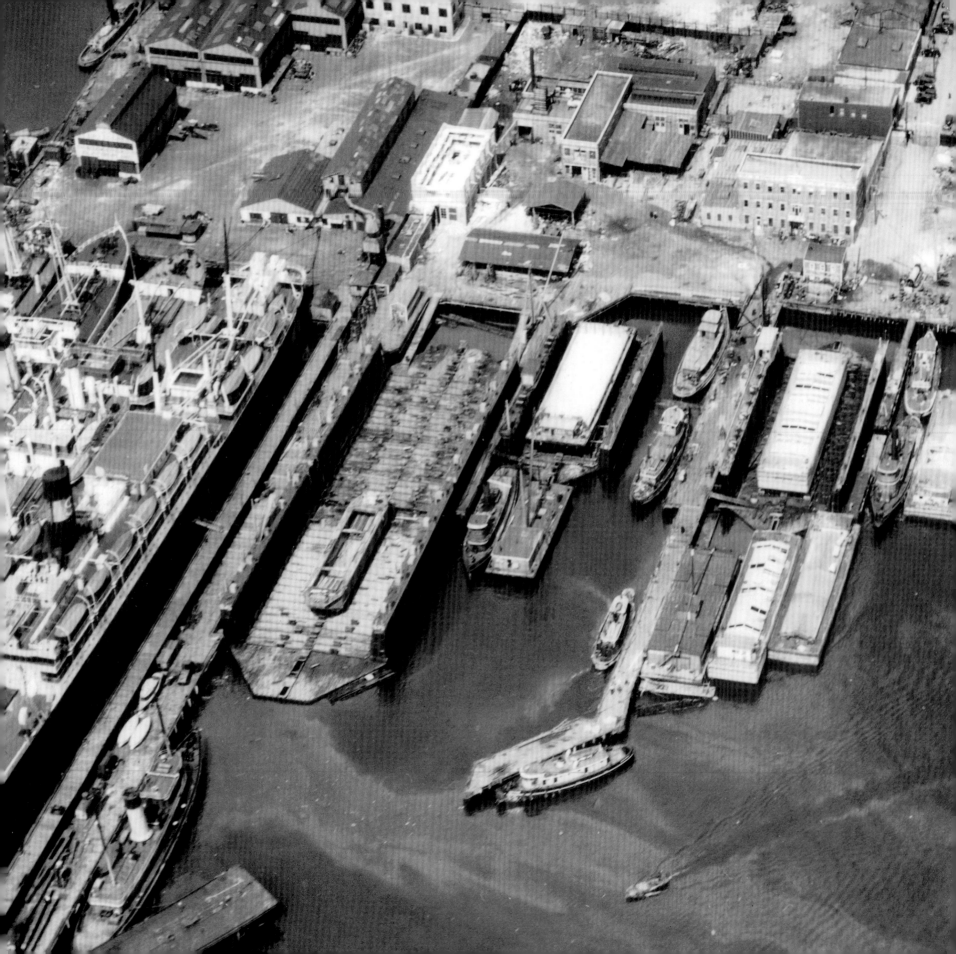

Previous spread: The Ira Bushey Shipyard at 764 Court Street in Brooklyn. Under the aegis of the US Maritime Commission, the shipyard built components for warships and related vessels during World War II. A War Department stamp on the reverse of a studio print reads "Released for Publication December 31, 1943."

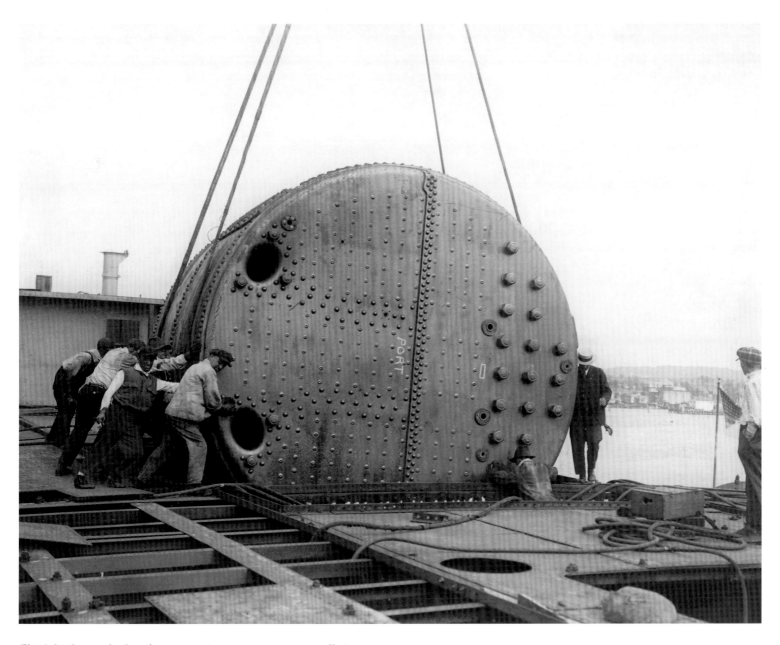

Ship's boiler pocked with massive rivets, en route to installation

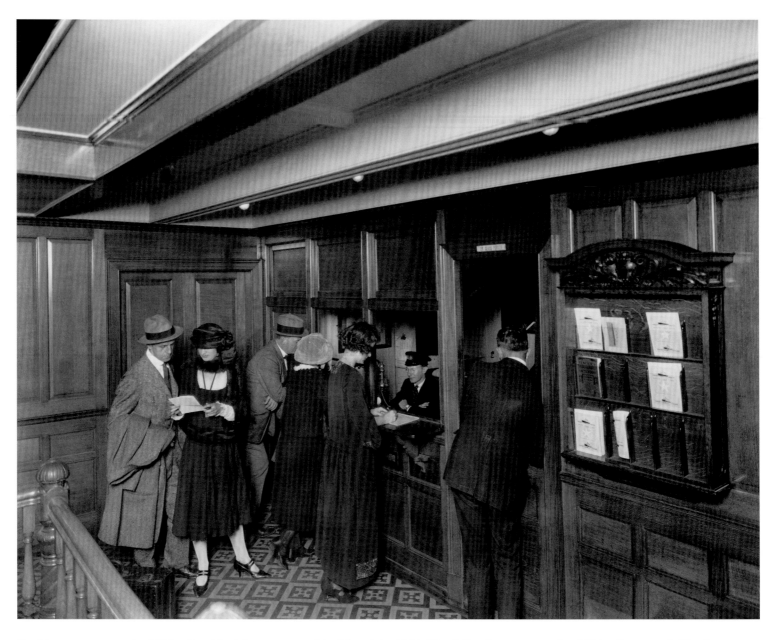

Booking passage on the White Star Line's luxury steamship *Olympic* in 1911. The following year another White Star vessel, *Titanic*, would sink on its infamous maiden voyage.

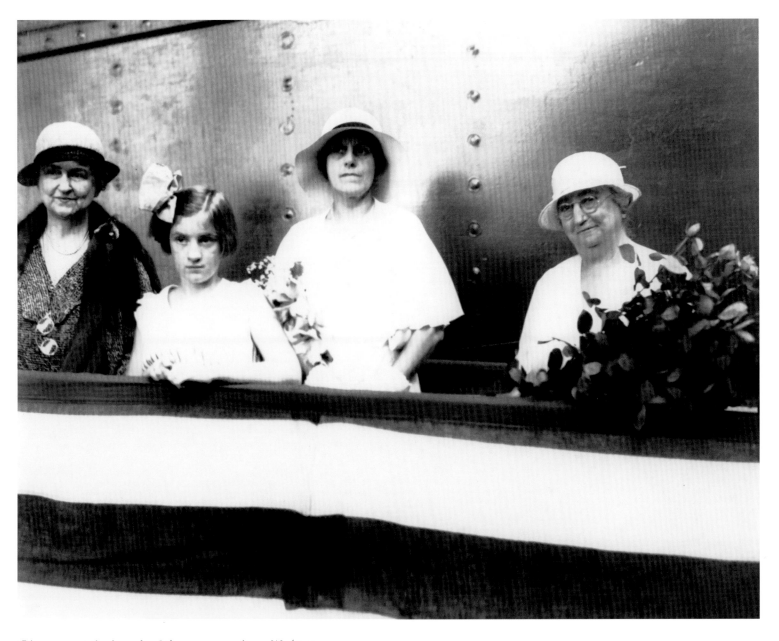

Observers at the launch of the passenger liner *Washington*.

Luggage and other cargo awaiting stowage in the *Olympic*'s hold in 1911. The range of items on the great ship's deck reflects its various classes of service: Posh trunks and fine leather cases commingle with burlap bundles and wicker baskets tied with rope.

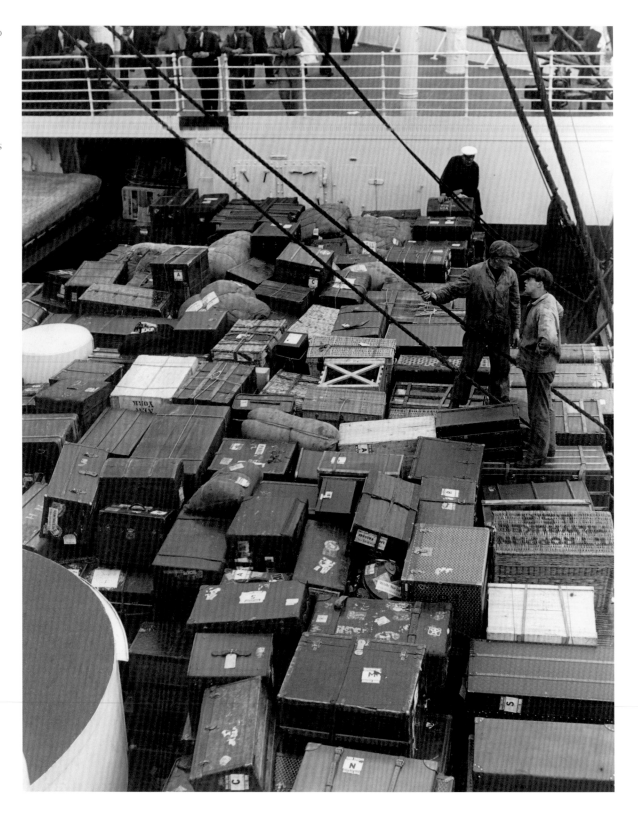

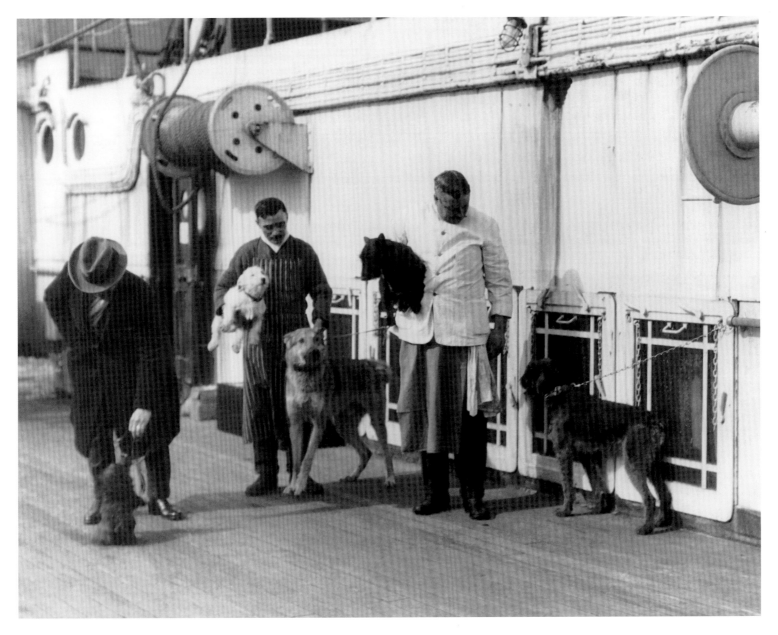

Pampered pets on the *Berengaria*. Originally a German-owned vessel (the *Imperator*), the ship was seized by the US Navy for use as a troop transporter during the First World War and renamed when it was later sold to the Cunard Line. In the 1930s it caught fire in New York Harbor; the burned-out hulk was sold for scrap.

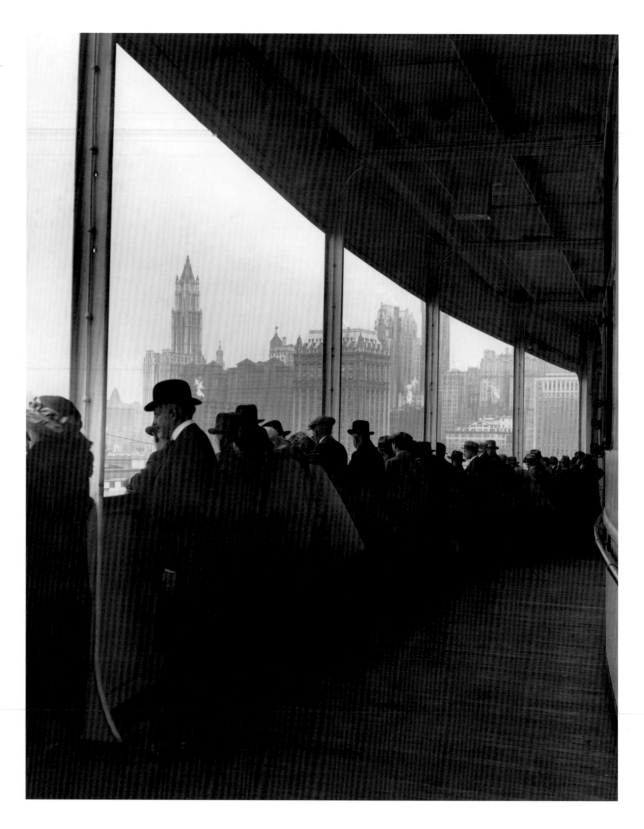

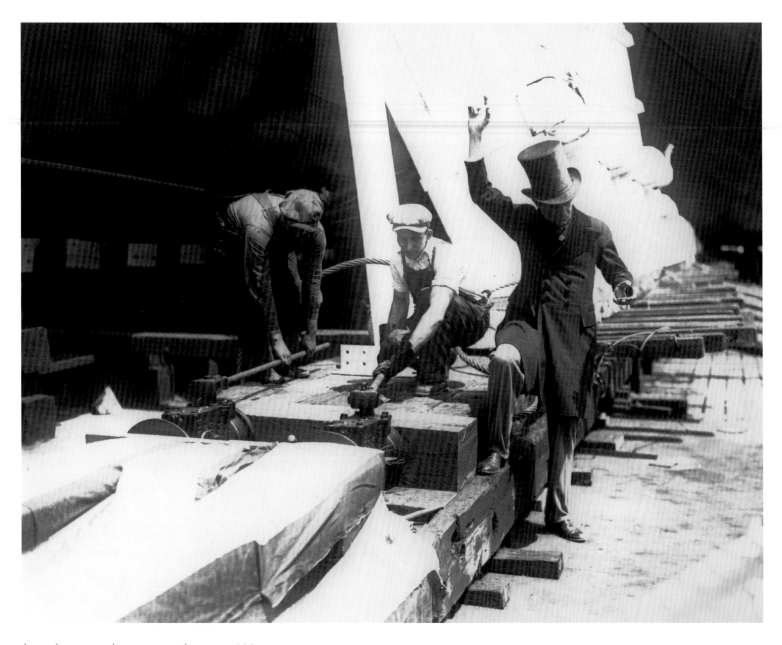

Launch crew with trigger mechanism, 1933.

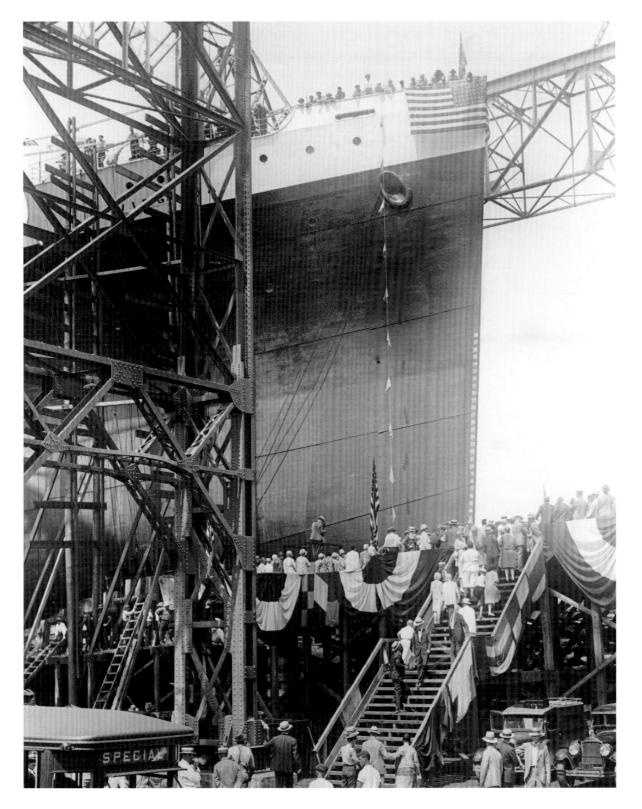

The *Virginia* on the ways during its 1928 launching ceremony. One of the ailing Edwin Levick's last photographs, this picture is notable for its careful framing and details such as the delicate shadows of a streamer of American flags marching up the massive hull.

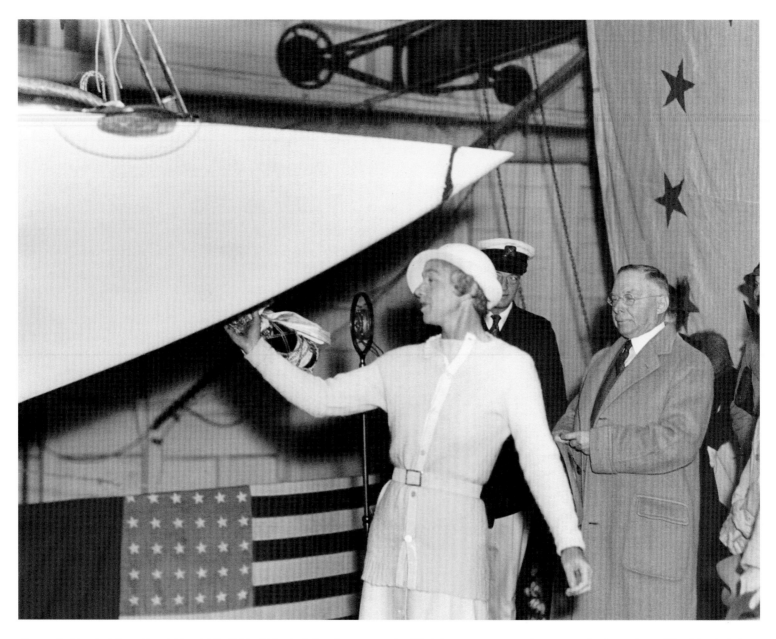

Gertrude Vanderbilt, wife of Harold S. "Mike" Vanderbilt, christening the *Virginia*—a major social event in the late 1920s. The Vanderbilts were leading lights of New York society and the New York Yacht Club, their yachts winning three America's Cup titles.

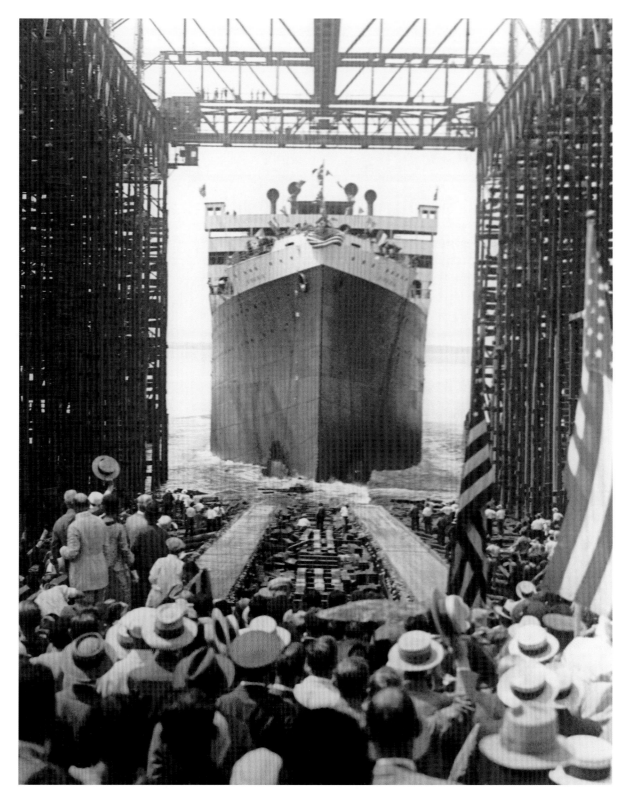

Slipping down the ways. Perfectly framed by scaffolding, the 12,000-ton *Virginia* is launched with maximum hoopla and enters service in the Panama–Pacific Line in the summer of 1928.

Boater-wearing summer crowd attending the Swedish Line motorship *J. S. Kungsholm*, 1928.

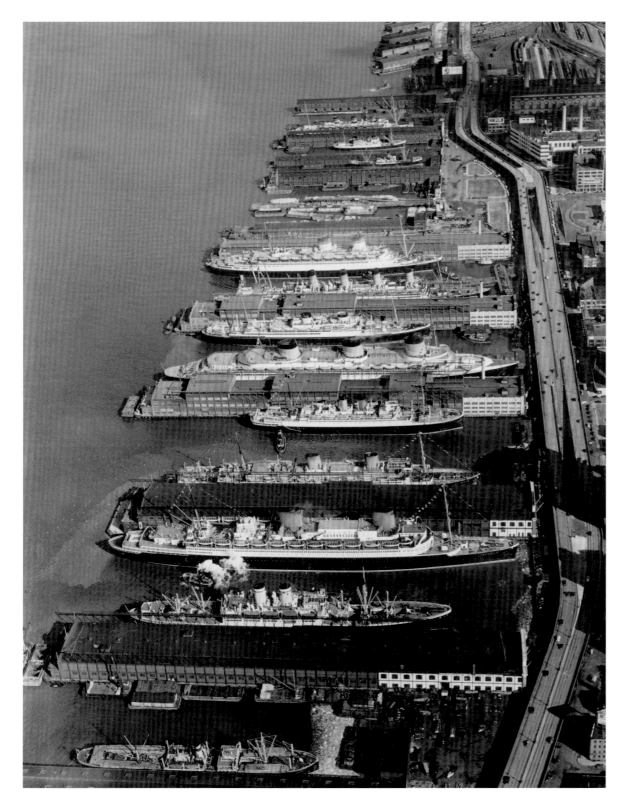

Luxury Liner Row, circa 1938. Appended to the back of the studio print is photographer Lionel Green's typed note: "A sight that will not be seen in New York for a long time while war clouds hover over Europe."

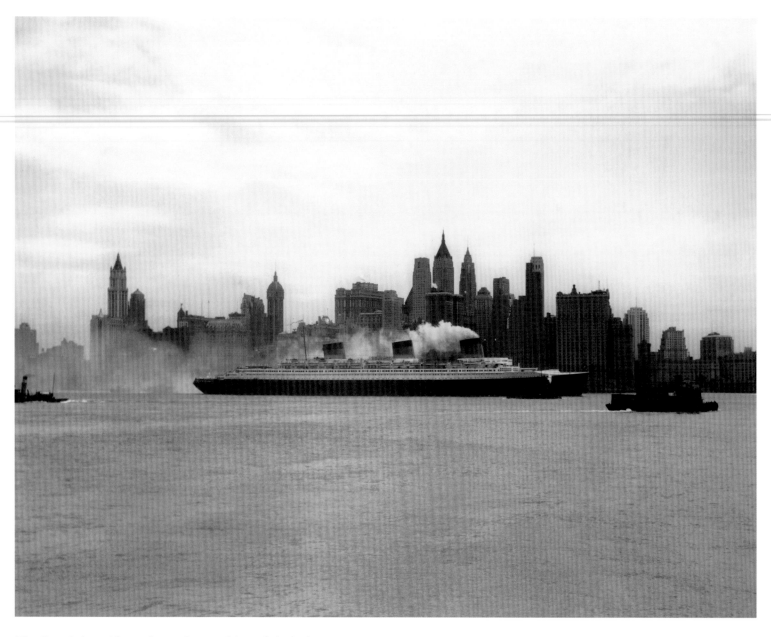

The French liner *Normandie*—a thousand feet of sleek chic in 1935.

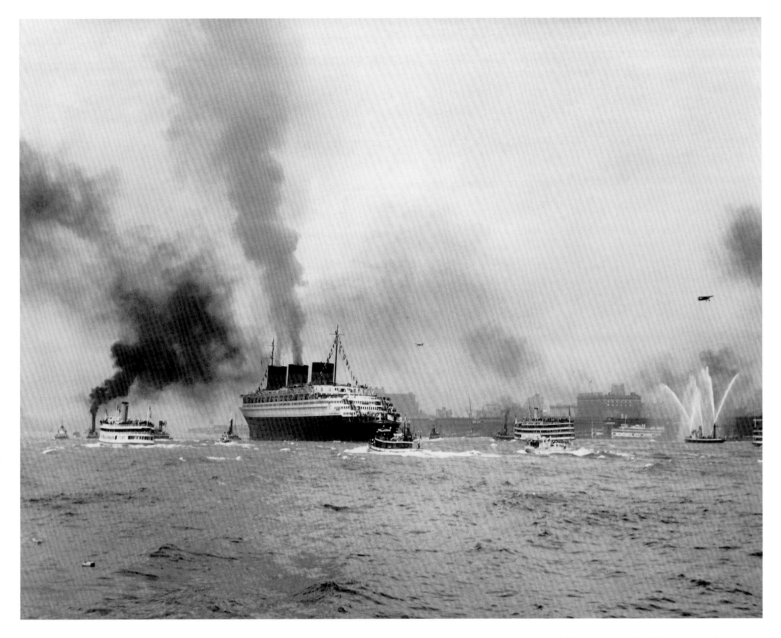

Banner-decked *Normandie*—all 83,000 tons of it—entering New York Harbor in a grand procession of fireboats, packed ferries, and attendant tugs. Small planes buzz overhead like curious insects.

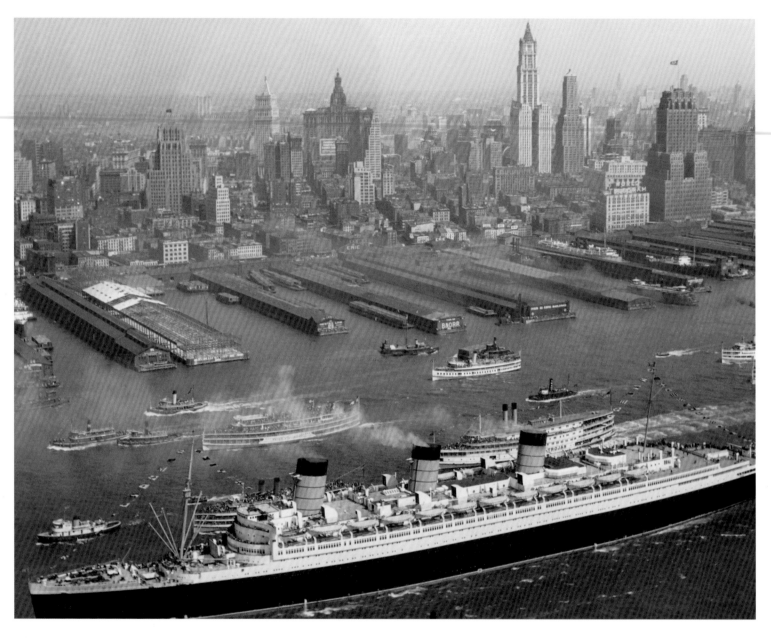

The *Queen Mary* arriving in New York at the culmination of its maiden voyage in 1936. Capable of sustaining speeds in excess of 30 knots, the ship had just set a new transatlantic speed record, winning the coveted "Blue Riband."

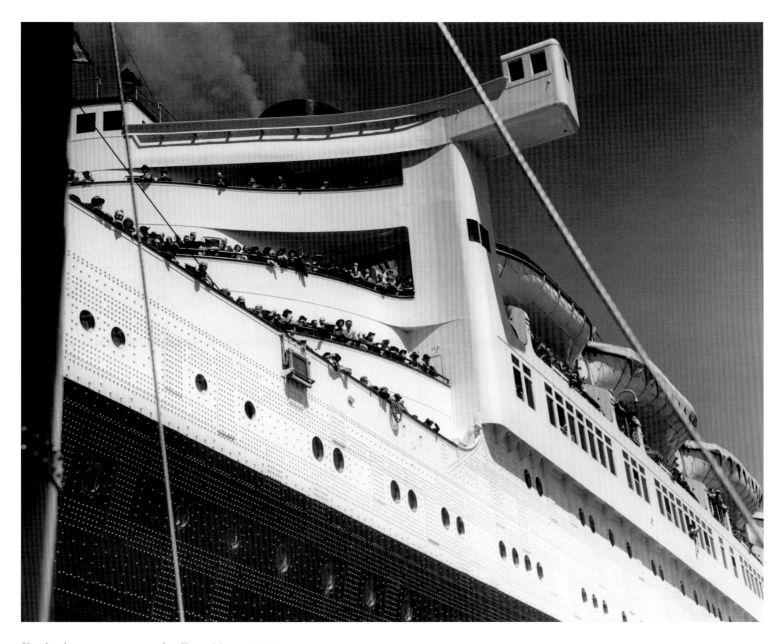

Dockside perspective on the *Queen Mary*, 1936.

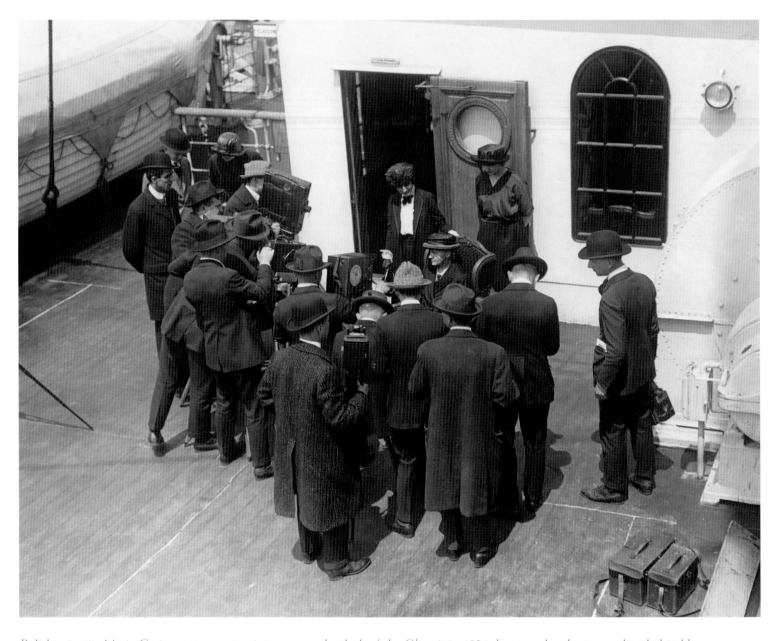

Polish scientist Marie Curie meets an attentive press on the deck of the *Olympic* in 1921, her two daughters standing behind her.

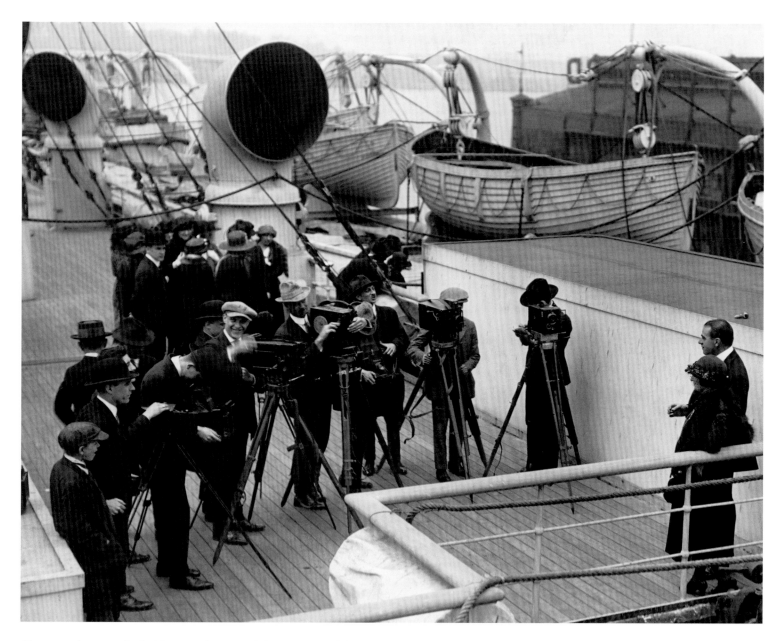

Photographers on deck. No record exists of the identity of this steamer, although it is evidently one of the high-status liners, judging by the elegant passengers. Nor do we know the names of the affluent couple being framed in the lenses of the attendant coterie of eight photographers. As interesting, perhaps, are the photographers themselves, caught in the midst of their work—one jotting notes, another adjusting his lens, another framing his subjects, and yet another calling out words of greeting or ice-breaking conversation.

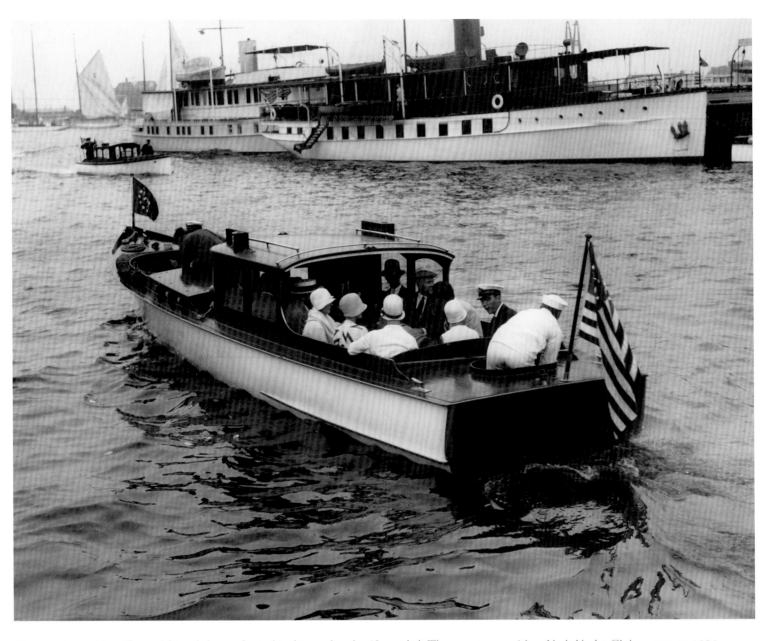

Vincent Astor, his wife, and friends being ferried to his yacht, the *Nourmahal*. The event was a New York Yacht Club outing in 1928.

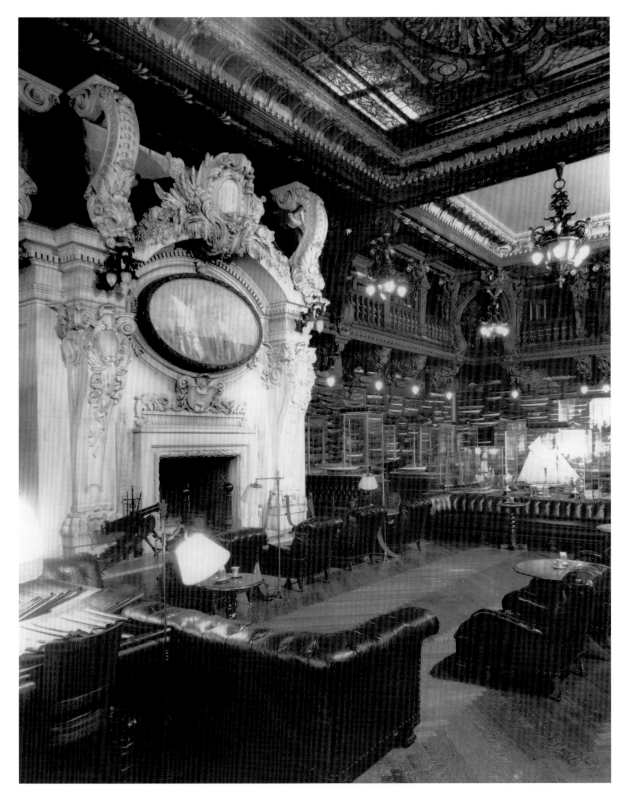

Interior of the New York
Yacht Club, which opened at
37 West Forty-fourth Street
in 1901 as a stunning example
of European-inspired Beaux
Arts architecture.

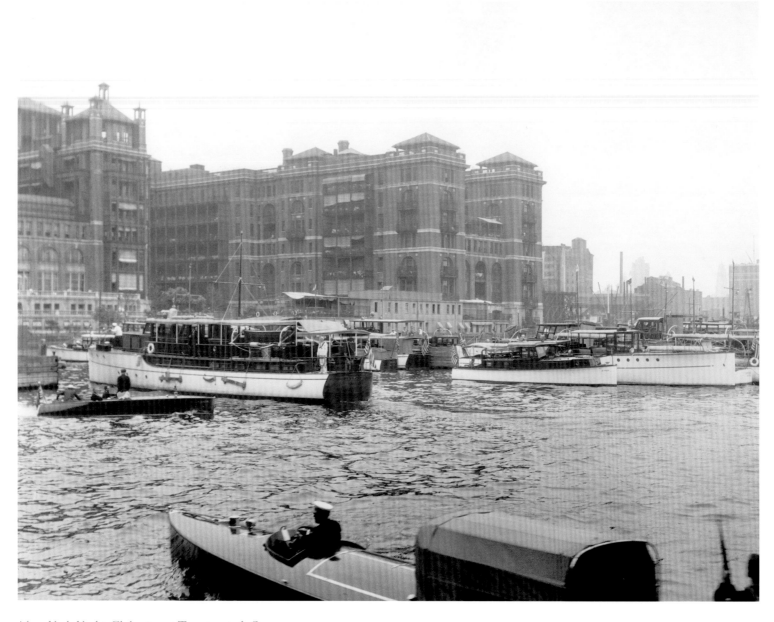

New York Yacht Club pier at Twenty-sixth Street.

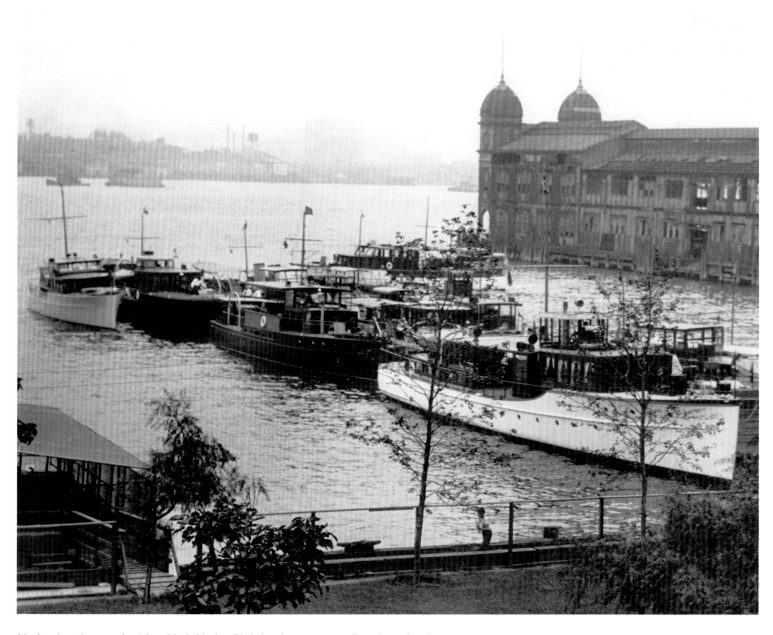

Yachts lined up at the New York Yacht Club landing in 1927, Pier A in the distance.

Steam yacht *Minnie W III* at anchor off the Upper West Side.

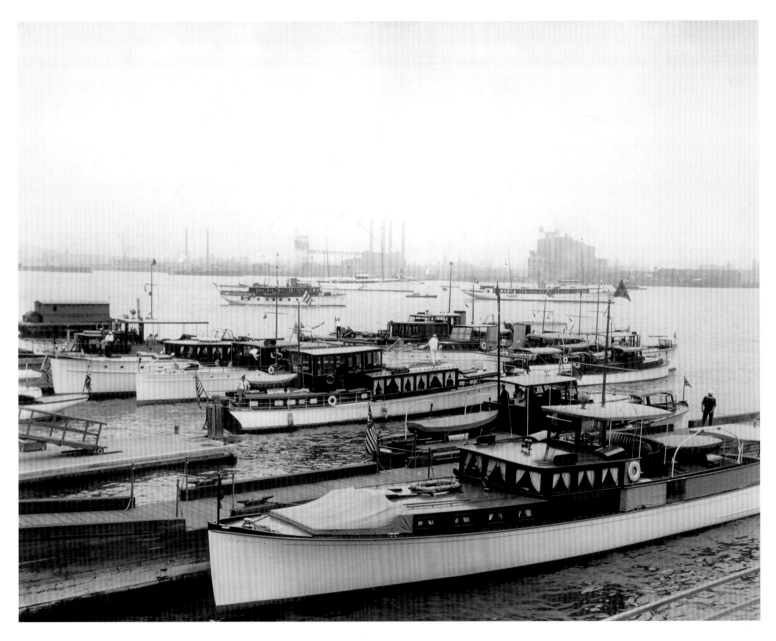

Fleet of motor yachts at the New York Yacht Club, late 1920s.

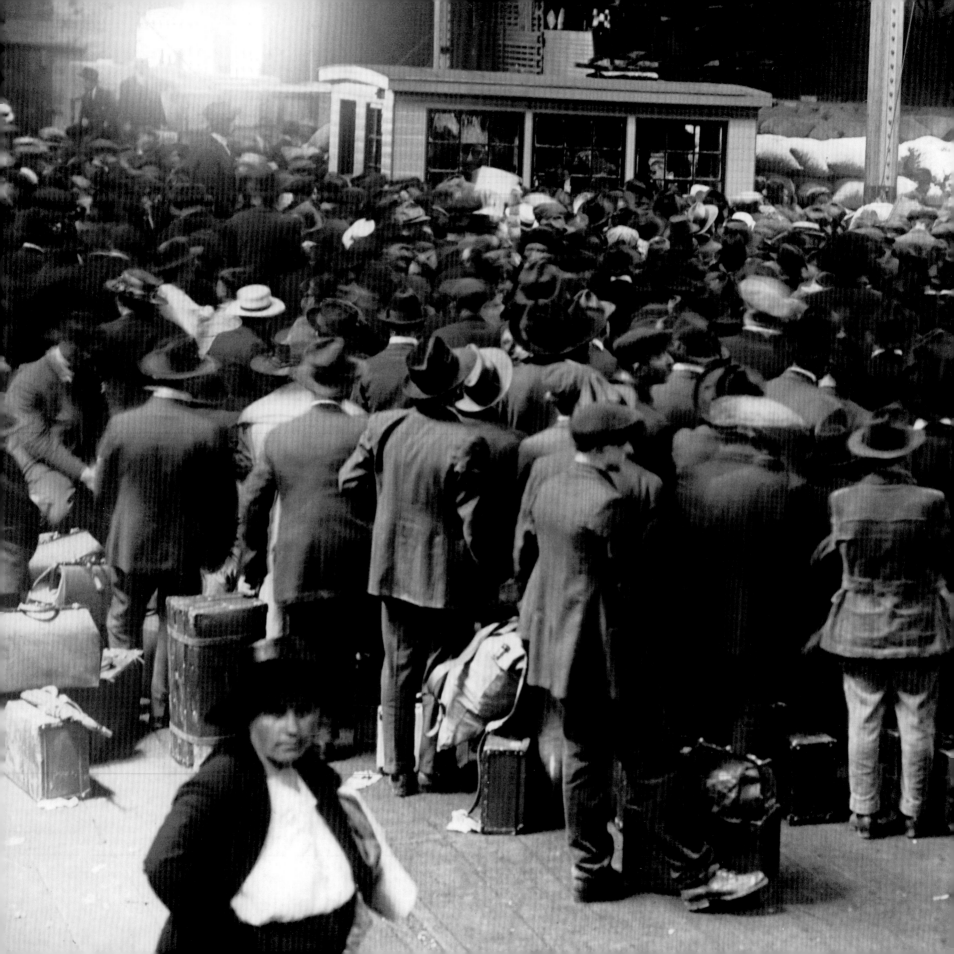

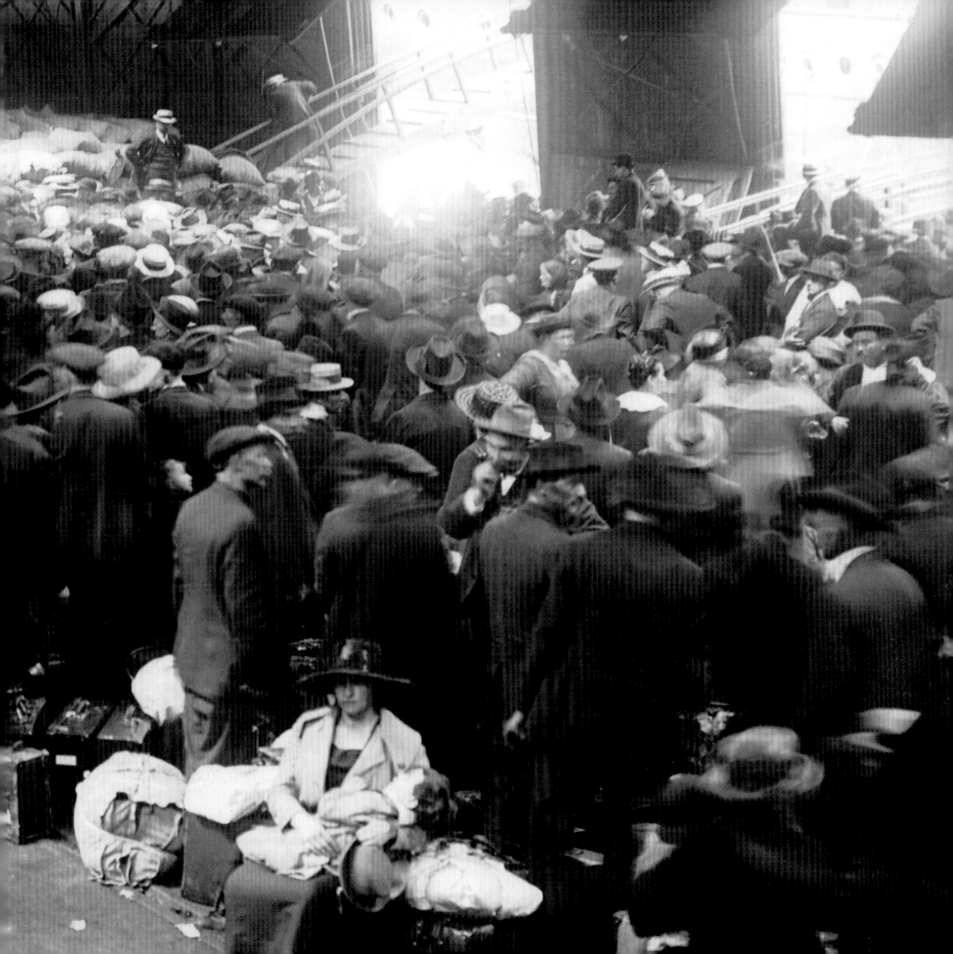

Previous spread: Rumpled, waiting steamer passengers inside a dimly lit dock building.

Right: A 1921 deck scene on the *Adriatic*.

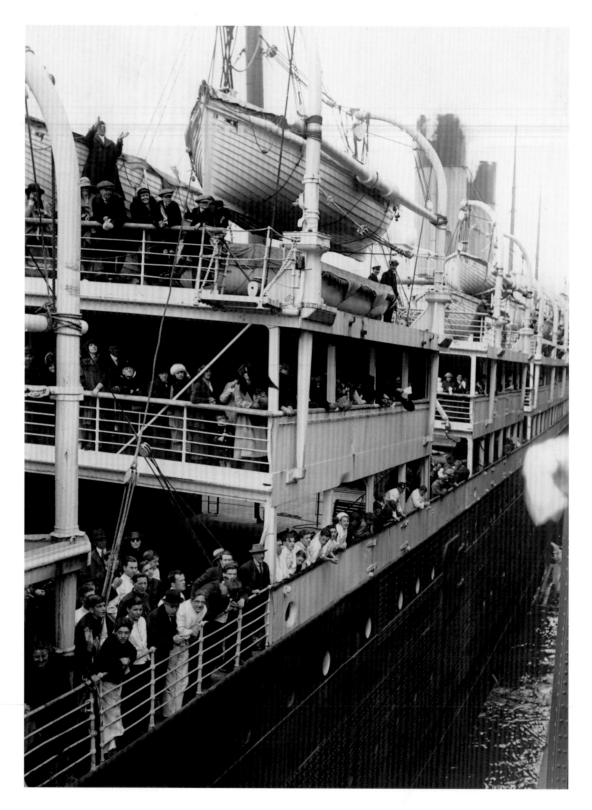

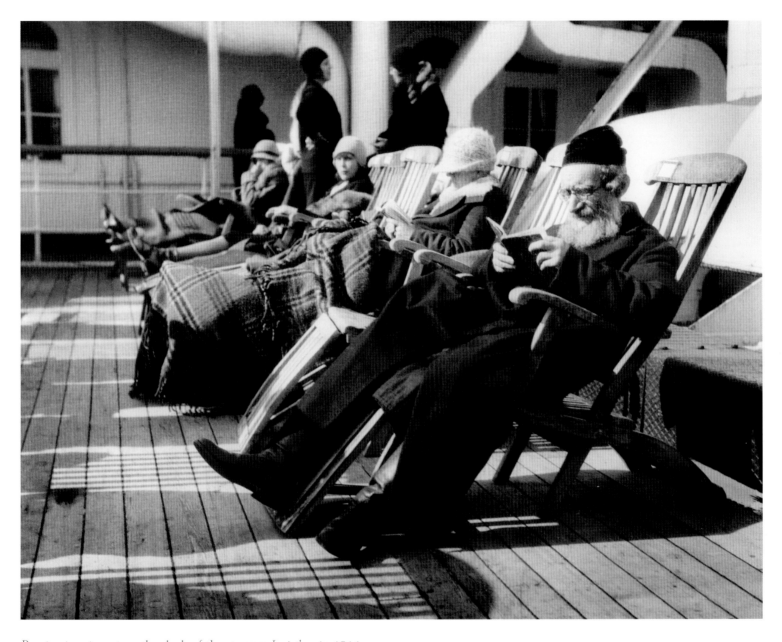

Russian immigrant on the deck of the steamer *Leviathan* in 1914.

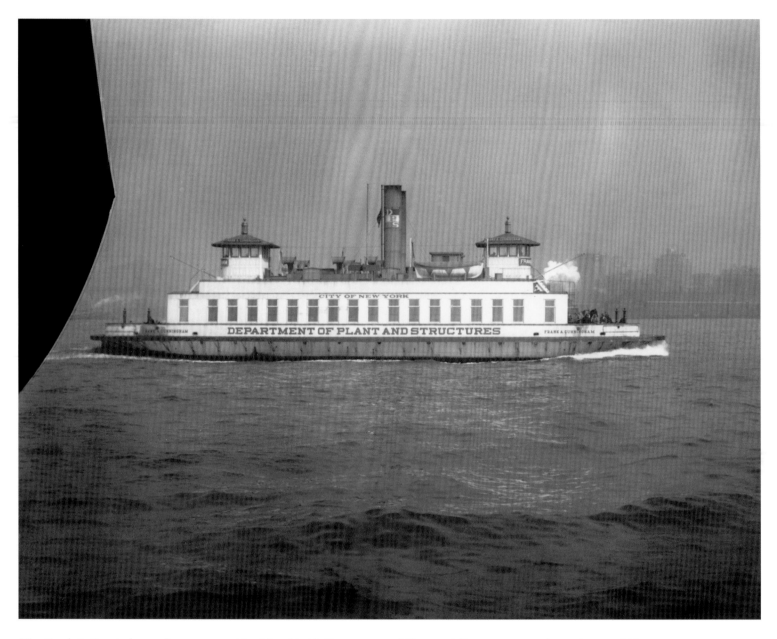

The *Frank A. Cunningham*, a ferry operated by New York's Department of Plant and Structures, on a hazy day in 1925.

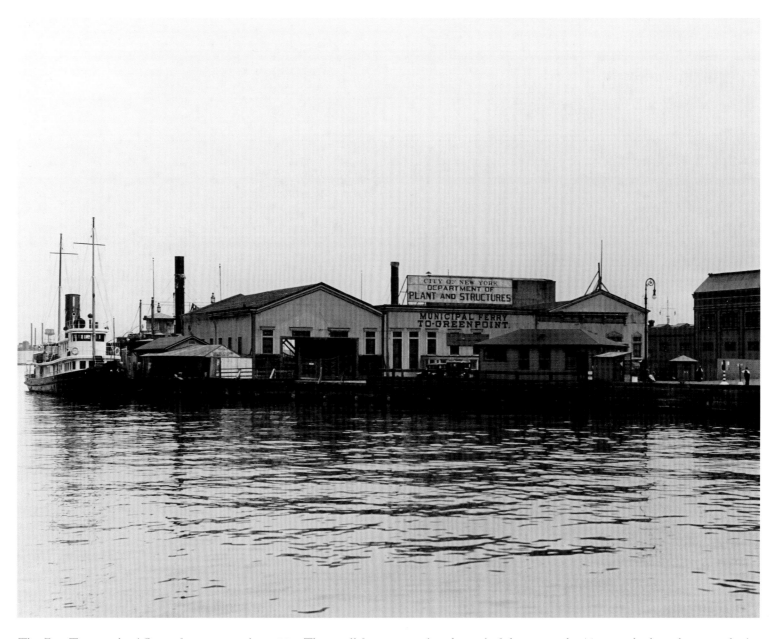

The East Twenty-third Street ferry terminal in 1934. The small ferry moored at the end of the pier is the *Macom*, which at this point had been operating for forty years.

Police patrol boat circa 1923, Ellis Island in the distance.

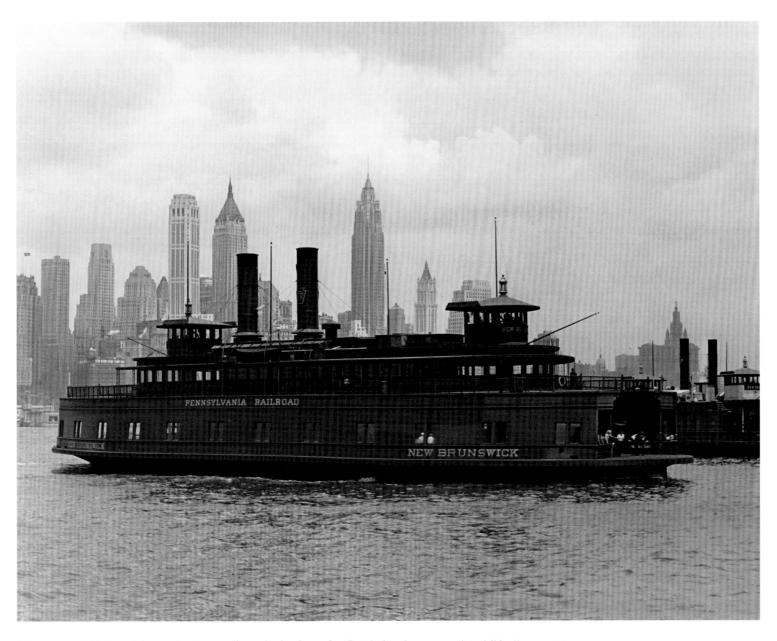

Pennsylvania Railroad ferry *New Brunswick*, with the ferry *Sea Gate* behind, in an undated P.L. Sperr picture.

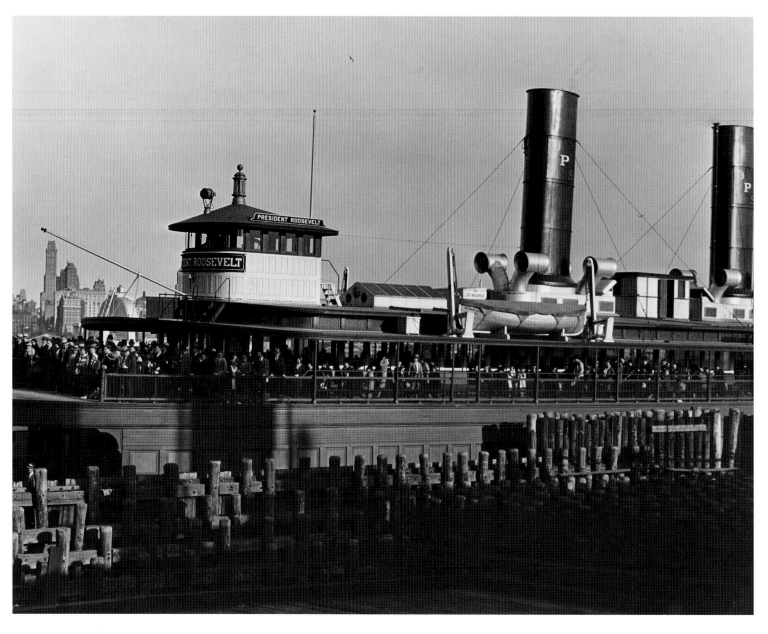

The *President Roosevelt* arriving at South Ferry in 1932.

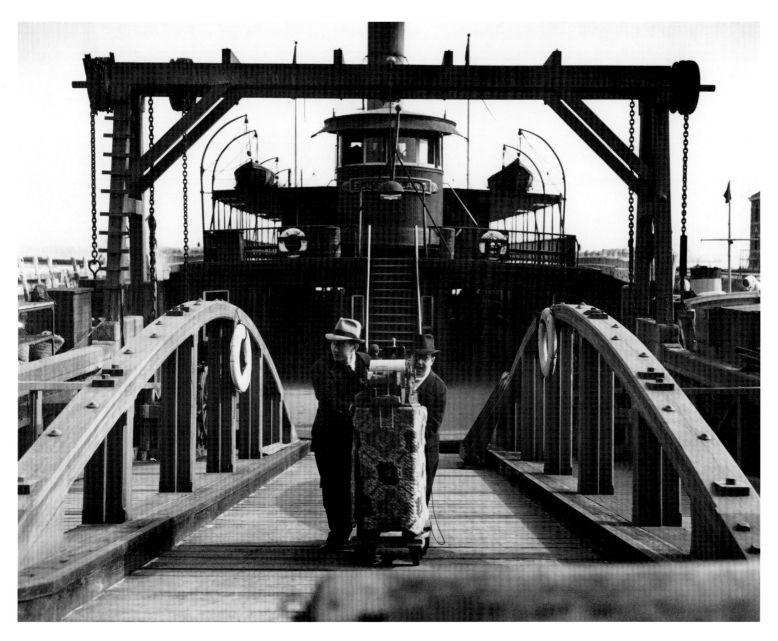

Mysterious equipment, wrapped in a floral-print quilt, being offloaded from the Ellis Island ferry.

Cleaning out the old ice at
Fulton Fish Market.

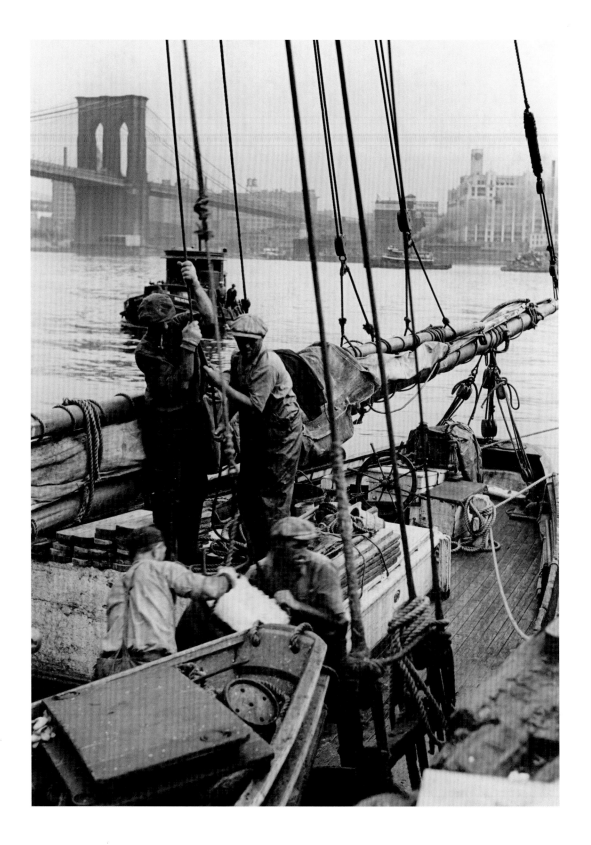

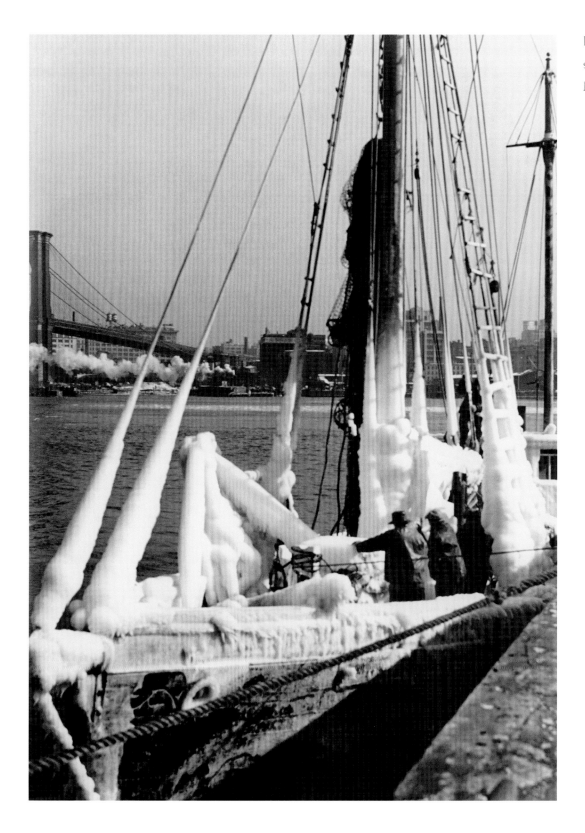

Iced-over fishing vessel at the Fulton Fish Market dock.

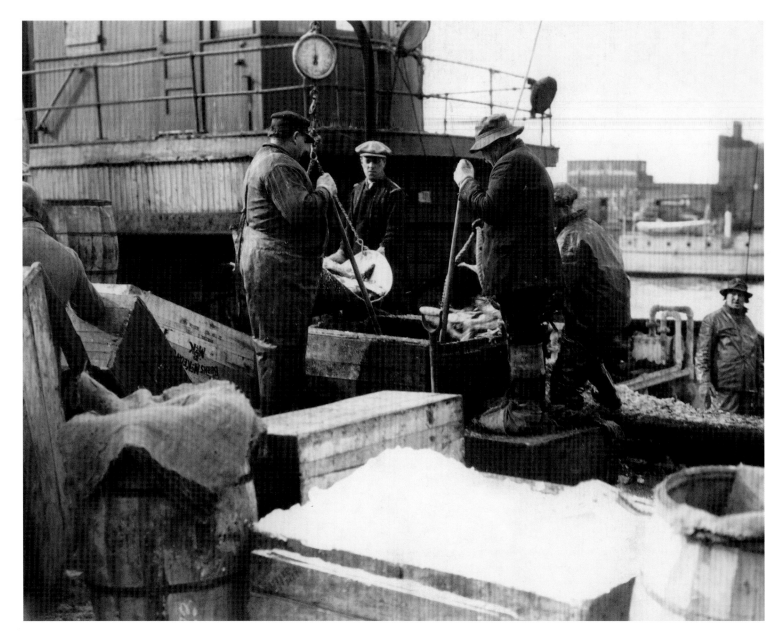

Weighing the catch. In the 1920s, when this picture appears to have been made, the piscine wares traded at commercial centers such as Fulton Fish Market often arrived on the decks of small, independent fishing vessels rather than in the cavernous holds of the larger, technology-laden trawlers and longliners that would soon come to dominate commercial fishing in the northeast. The simple dock scale shown in use here was adequate to the task of tallying a small-time operator's take.

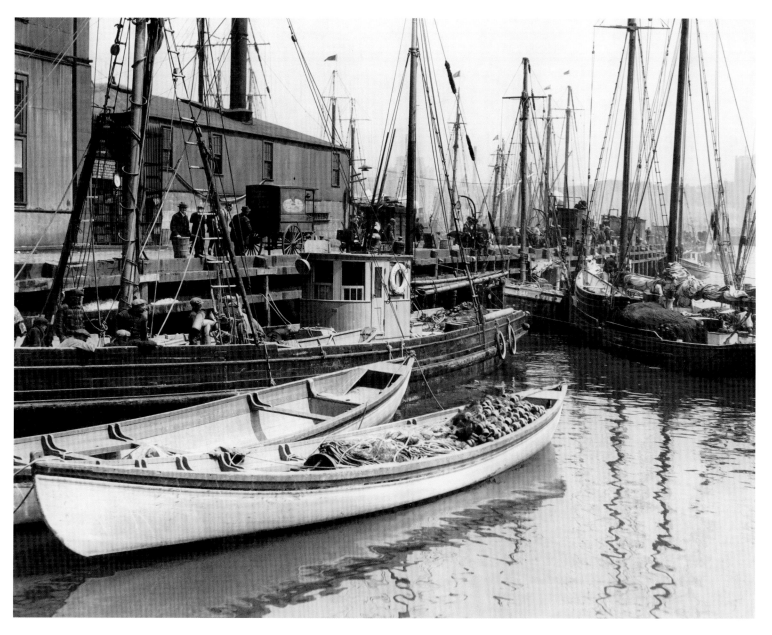

Fishing boats at Fulton Fish Market dock. Many boats fished with a crew of five or six to handle the arduous, often risky work of setting and hauling back the purse seines and handling the catch. In port, only when the vessel was washed down and nets stowed was there respite for the crew.

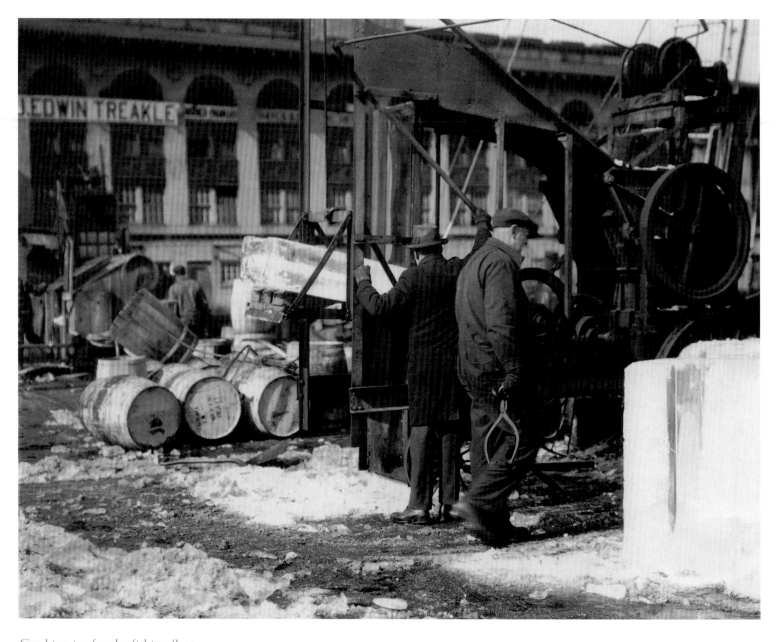

Crushing ice for the fishing fleet.

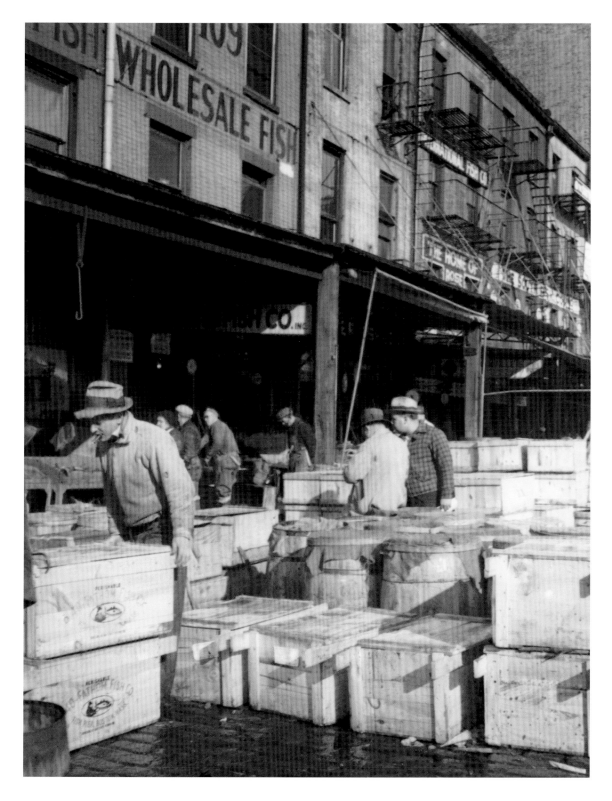

Seafood by the crate and barrelful at Fulton Fish Market. At least three wholesale operations are represented in this image—International Fish Company, Berman Fish Company, and the 40 Fathom Fish Company of Boston.

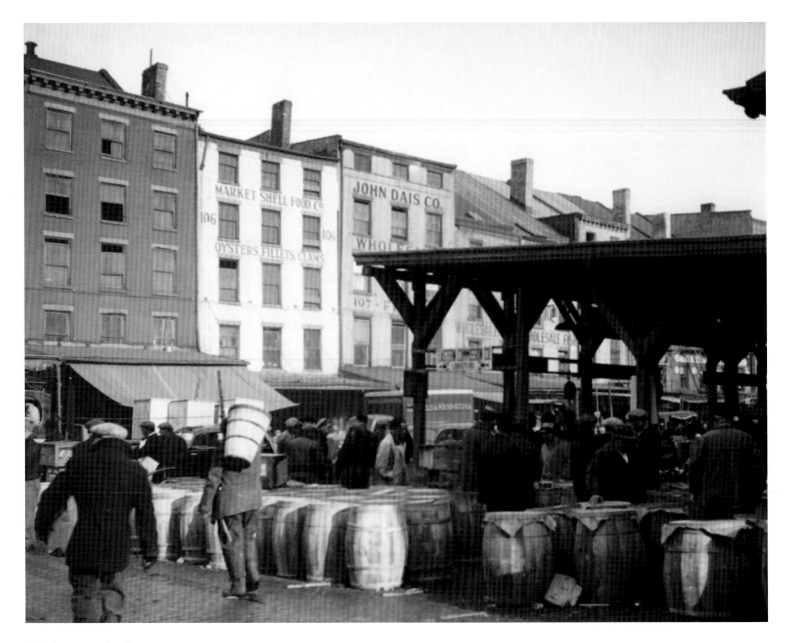

Fish buyers and sellers.

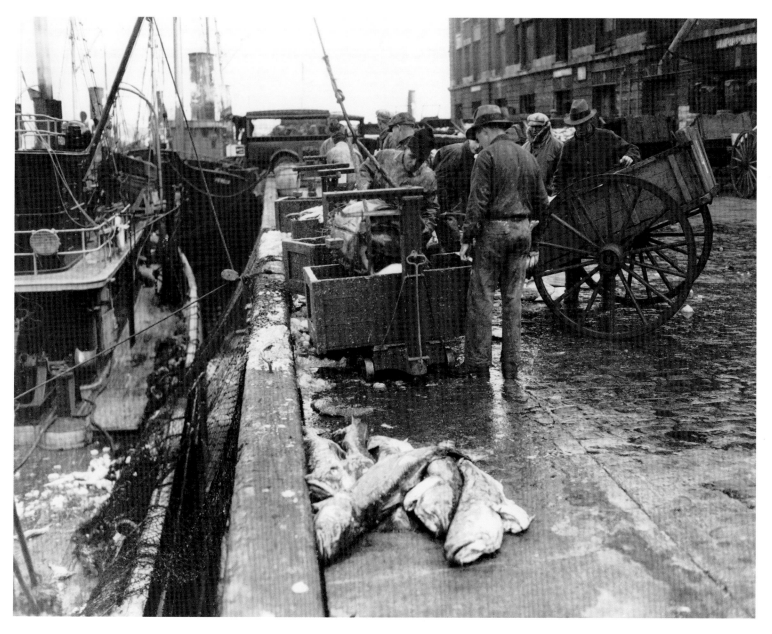

Freshly caught cod and waiting carts on the dock at Fulton Fish Market. Edwin Levick's log notes that this photograph was part of a series he took for a "fishing trawler story, Batten, Barton, Dustin and Osborne."

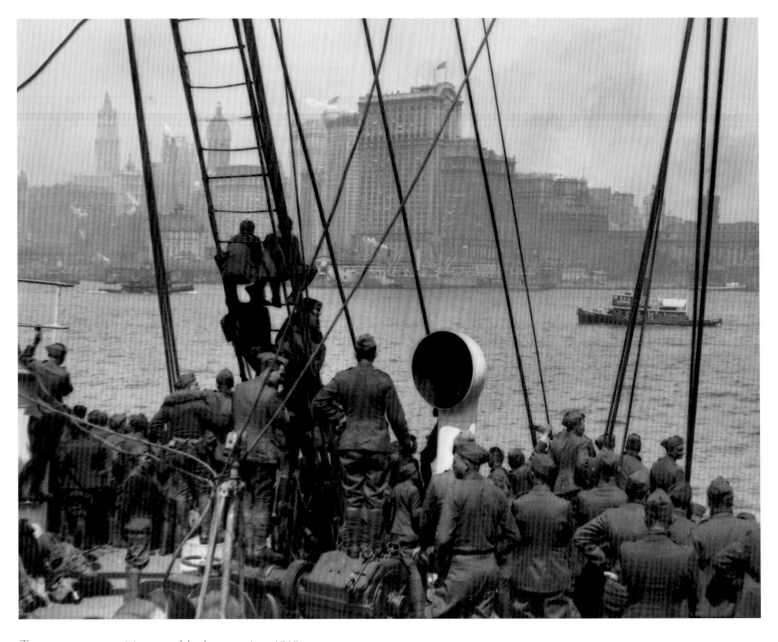

Troop transport cruising past Manhattan, circa 1918.

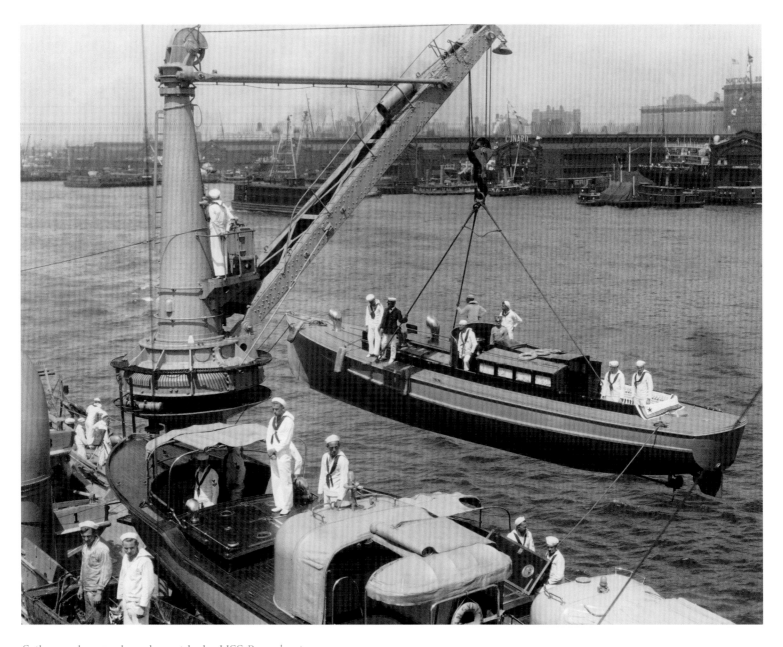

Sailors and motor launches with the USS *Pennsylvania*.

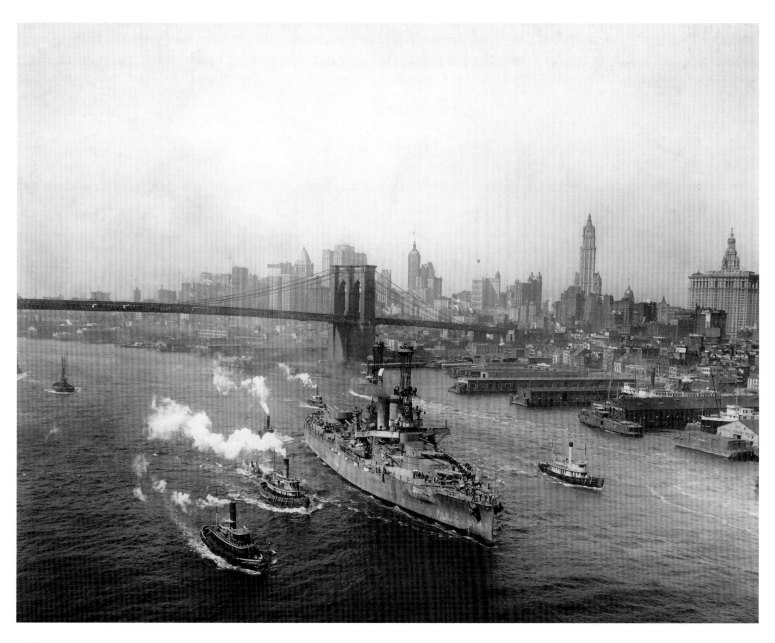

USS *Wyoming* cruising up the East River, circa 1917. This battleship, like others of its era, was central to President Theodore Roosevelt's vision of an "American Century," which had been launched with the Great White Fleet world tour that set forth in 1907.

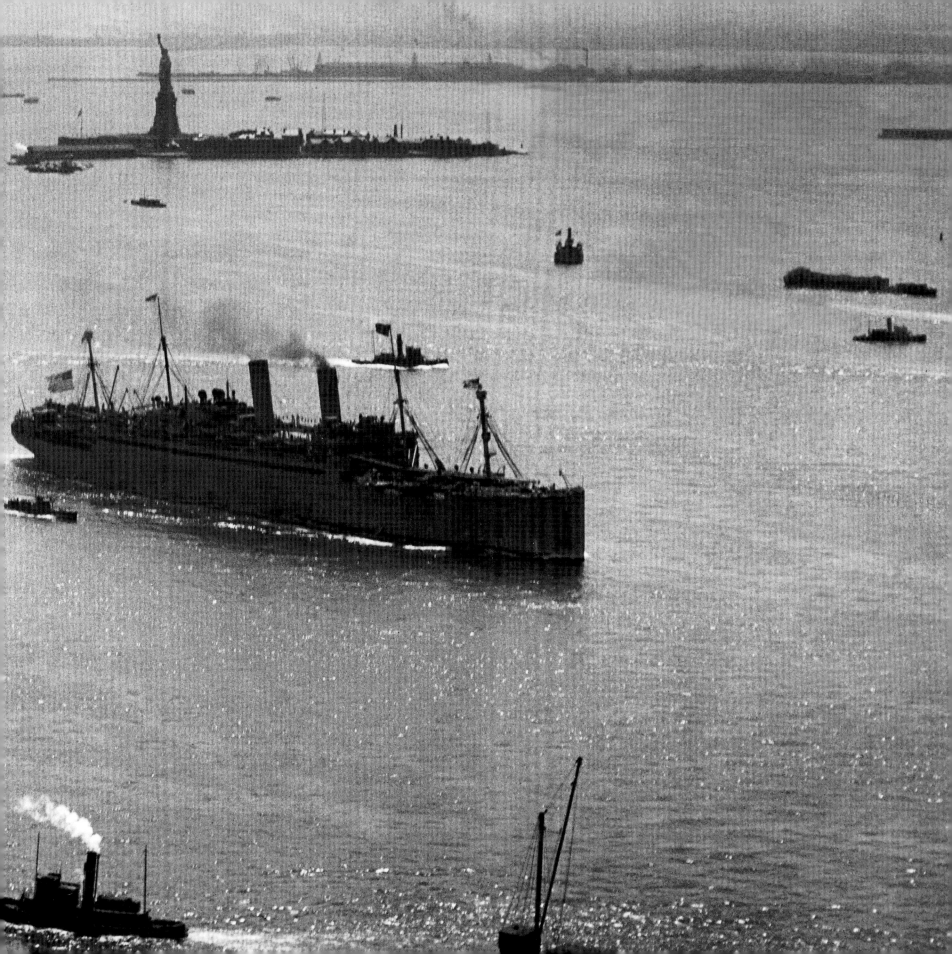

Previous spread: The USS *George Washington* making a triumphant entrance into New York Harbor.

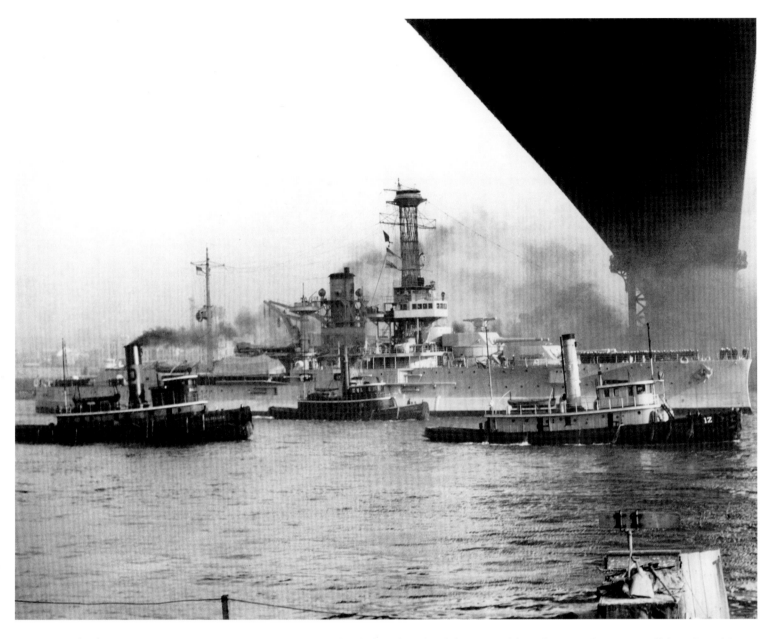

Battleship *Florida*, with tugs, under the Manhattan Bridge—the dark underside of the span adding drama and tension to Edwin Levick's composition. In December 1918, after assisting the British Grand Fleet in the North Sea in World War I, the ship joined the Victory Fleet Review in New York Harbor.

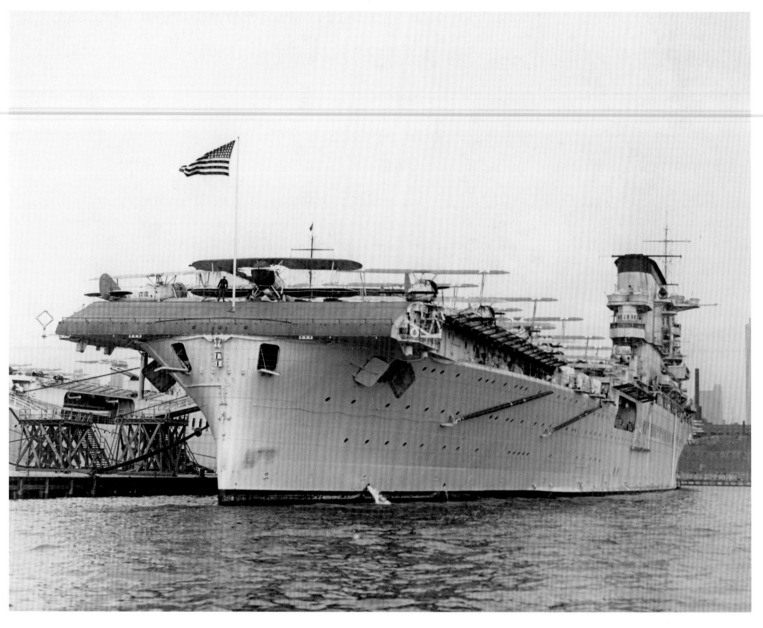

The pioneering aircraft carrier USS *Lexington*, built in 1925, at the West Fiftieth Street dock. At the time, the biplanes on its flight deck were state-of-the-art military aircraft.

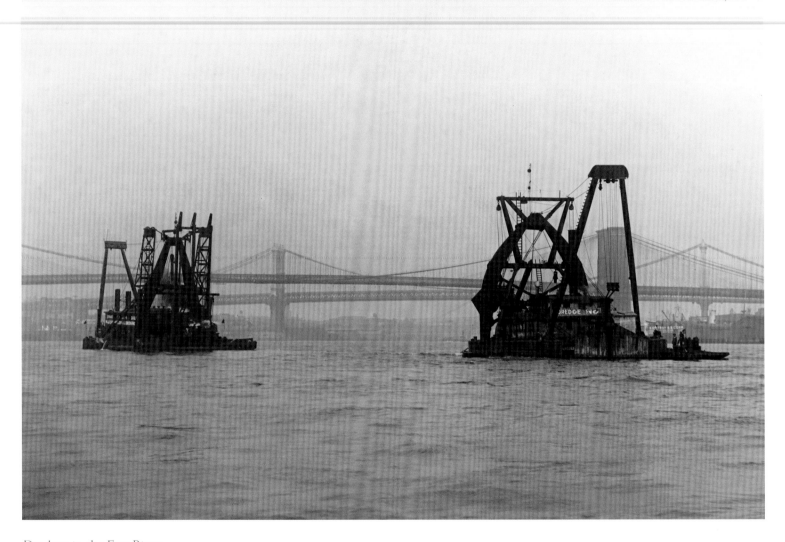

Dredges in the East River.

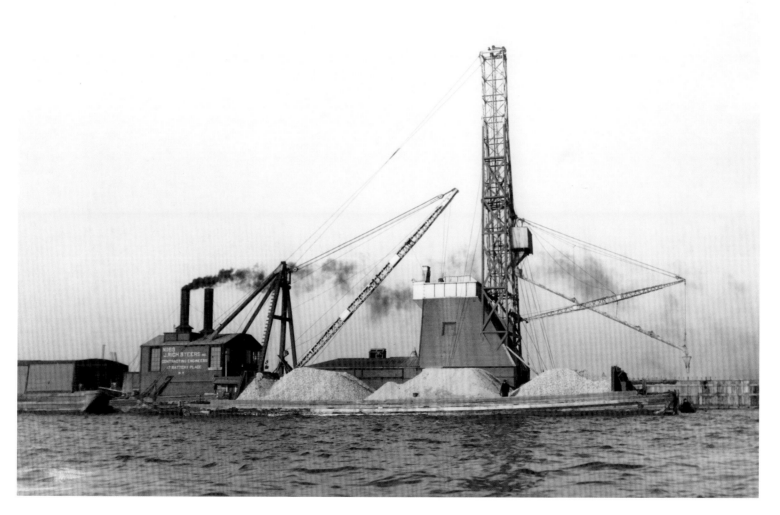

Mixer and piler off Greenville, New Jersey. The machines belonged to the J. Rich Steers Company ("contracting engineers"), a reincarnation of the J. Rich Steers Sand and Gravel Company, which had worked the New York waterfront from the 1880s. As the waterfront evolved, so did the more nimble waterfront enterprises; in the early 1960s, J. Rich Steers Company built the tower foundations for the Verrazano Narrows bridge linking Brooklyn and Staten Island.

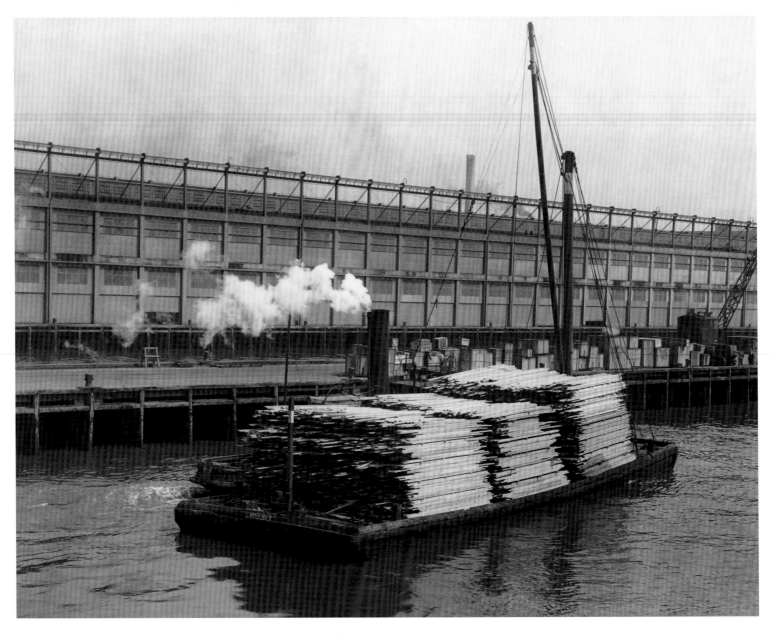

Lumber barge steaming into a waterfront berth. The milled lumber could have been destined for any one of a number of building projects in the rapidly growing metropolis. Dry docks constructed by New York's then-thriving shipbuilding industry also demanded large quantities of lumber.

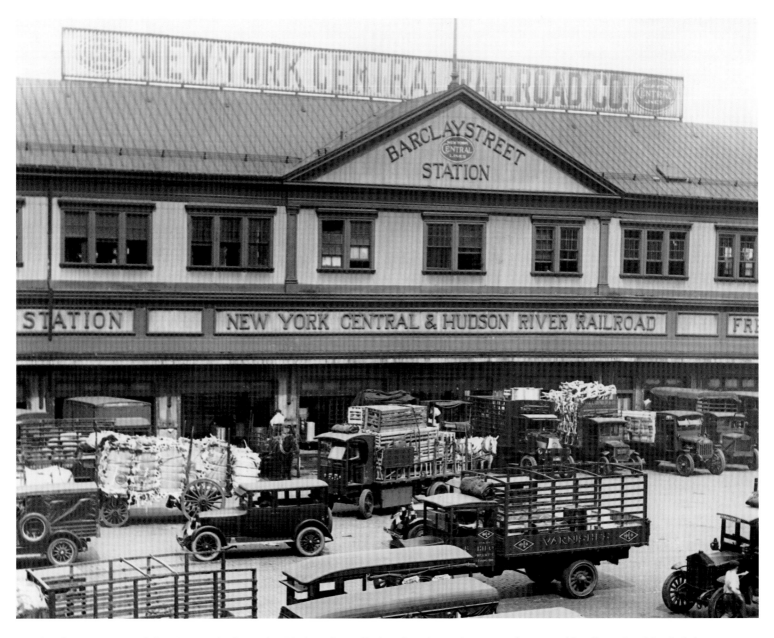

Barclay Street station of the New York Central & Hudson River Railroad in the early 1900s. Organized by Cornelius Vanderbilt in 1869, in its heyday the New York Central system spread throughout much of New York State, into New Jersey, and beyond. The Barclay Street Station's Lower West Side neighborhood evolved into the area known today as Tribeca.

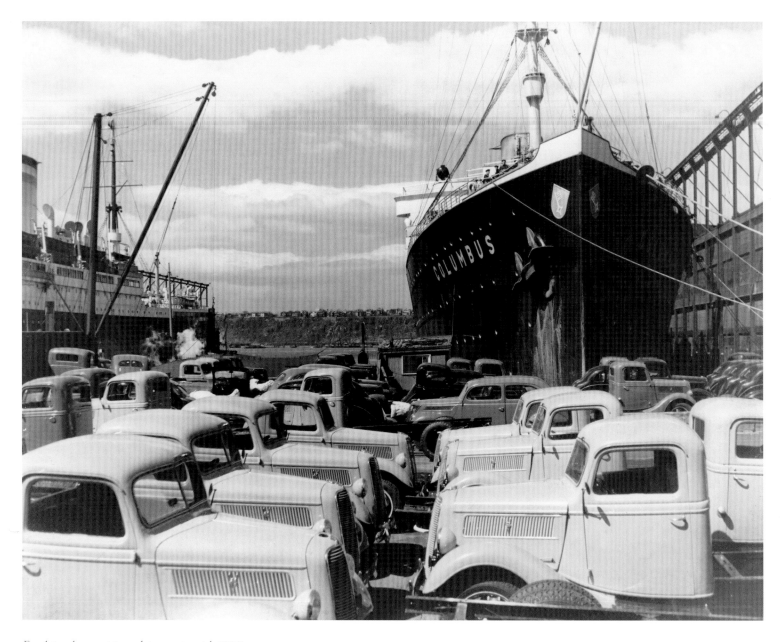

Ford trucks awaiting shipment, mid-1920s.

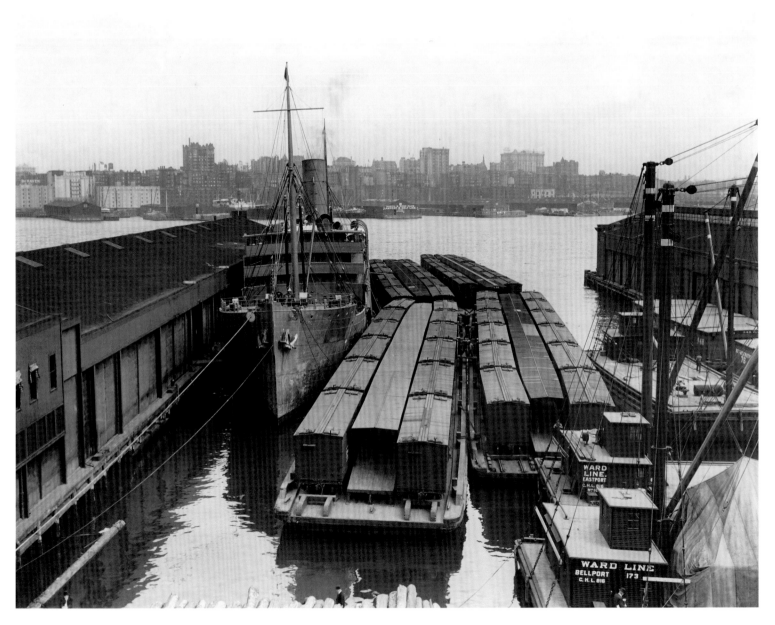

Rail cars on barges tucked cheek-by-jowl into a crowded berth, 1920s. This photograph unwittingly captures two endangered species—the Northeast's then-flourishing rail transport business and the Port of New York, both of which would be largely displaced by truck and air transport within two decades.

Tugs and barges crossing the East River. Little of the romance of the harbor is evident in this top-down view of a firmly industrial scene that was becoming increasingly commonplace along New York's waterfront.

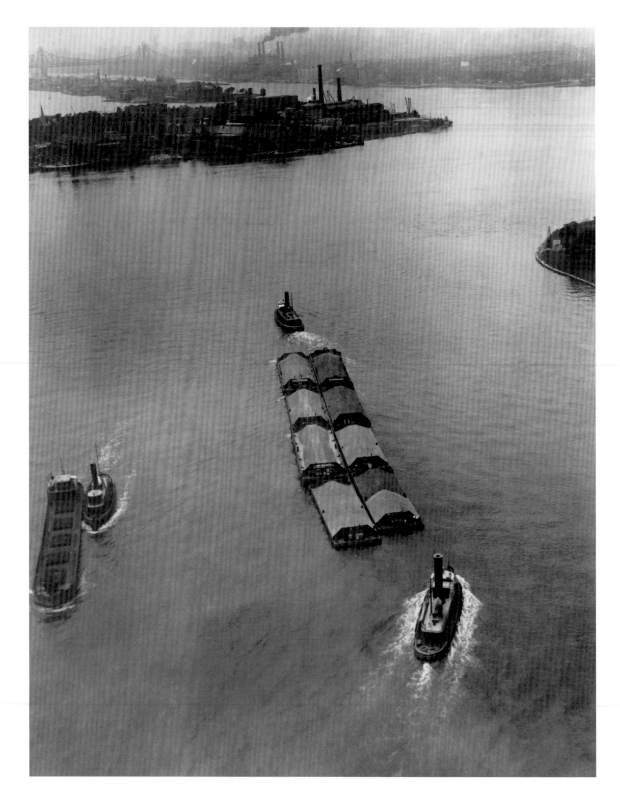

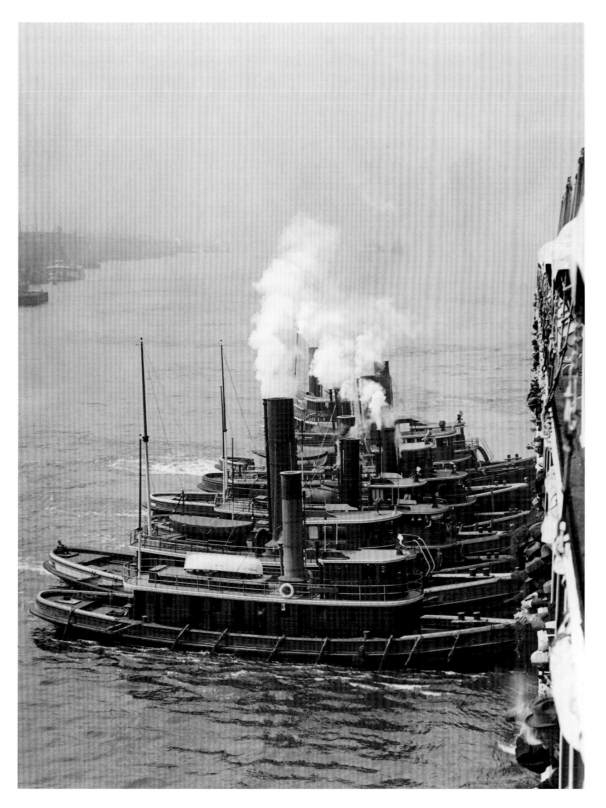

Phalanx of tugs moving
the steamship *Mutual*.

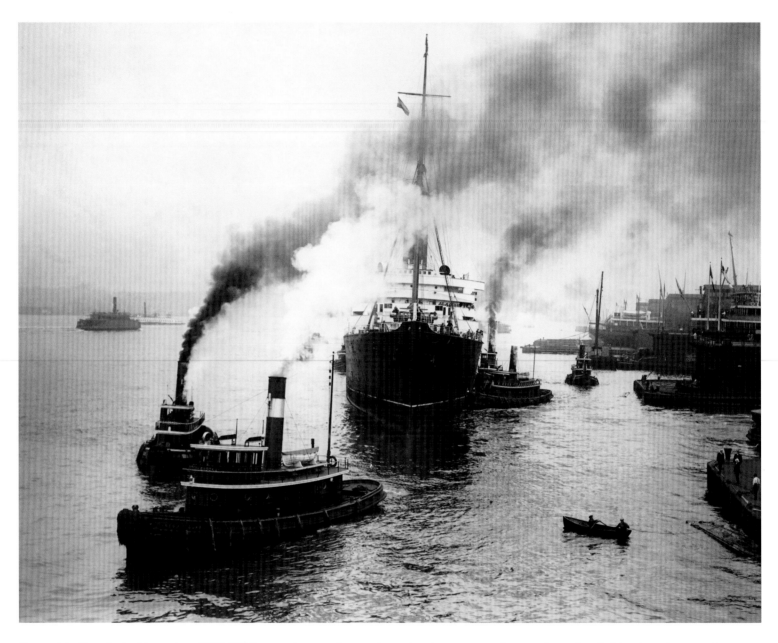

Steamship *Caronia* docking, circa 1920. While men in straw hats wait on the pier, two men in a rowboat dwarfed by the other vessels appear to be ferrying a line, perhaps to the lead tug, the *James M. Brooks*. This sort of scene would not long remain a part of waterfront life.

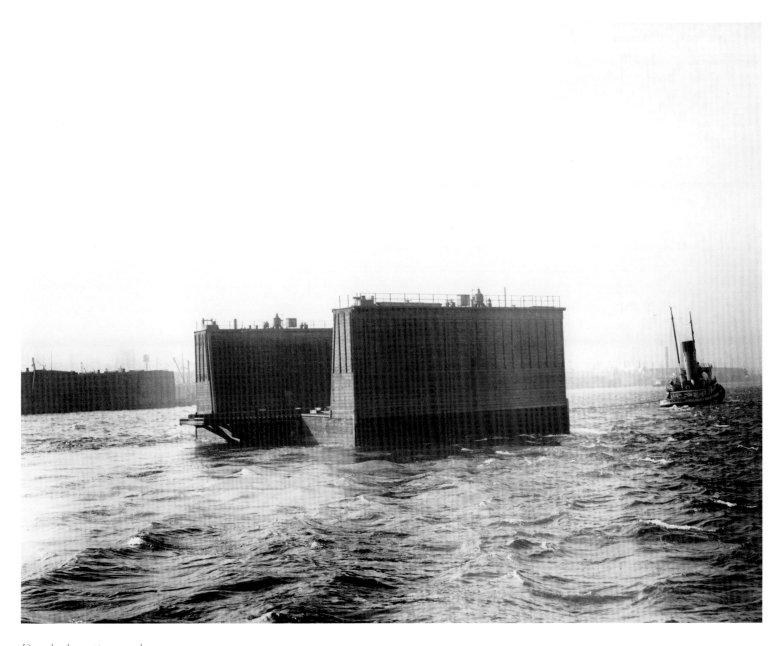

Dry dock sections under tow.

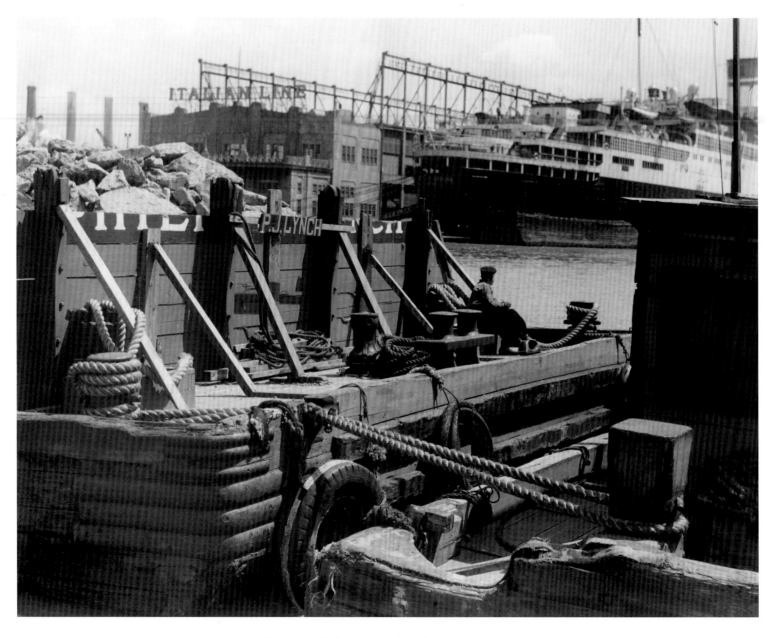

A scow worker contemplates a moored steamship of the Italian Line, which began operating in the early 1930s.

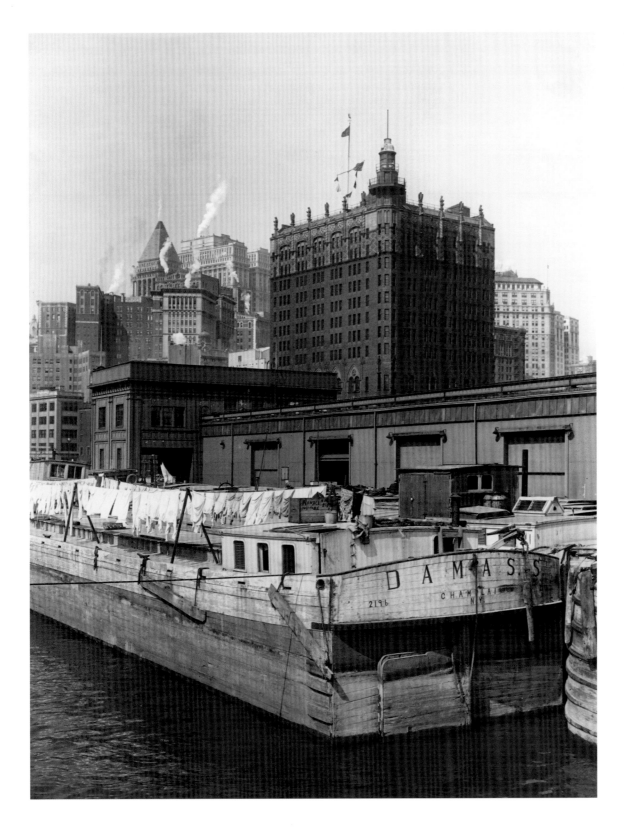

Wash day aboard the barge
Damass; only a block or two
away is the flag-flying
Seaman's Church Institute.

Children on a grain barge.

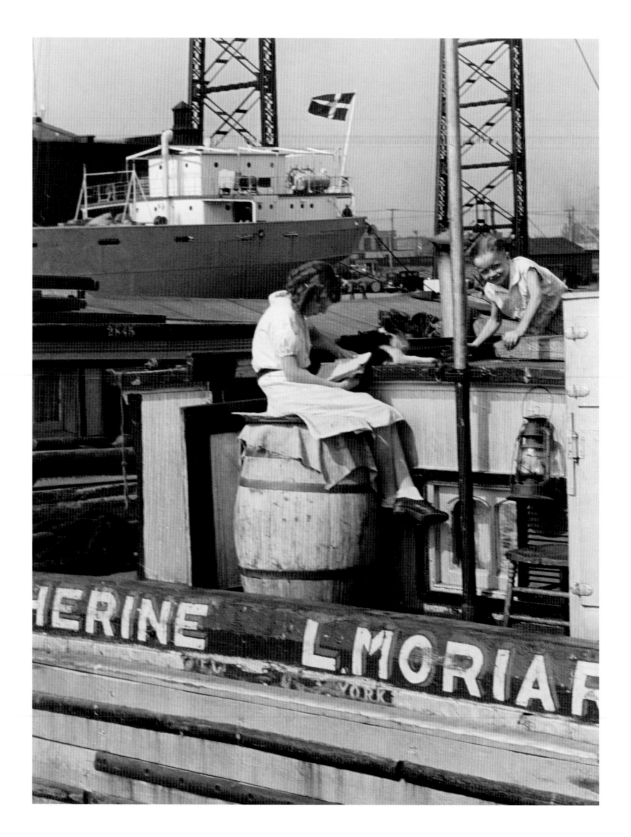

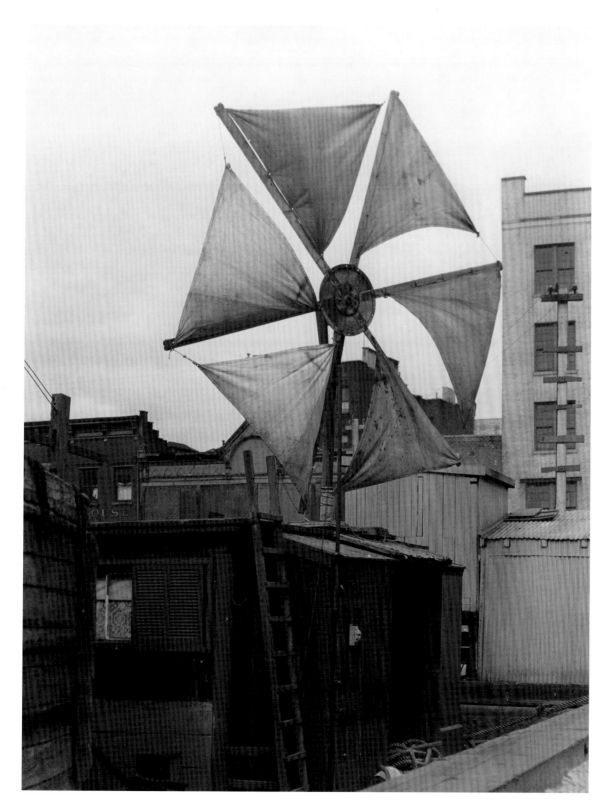

Before electric refrigeration was available to keep fish and other perishable cargos from spoiling, ice barges like this picturesque relic with its windmill sails serviced the waterfront.

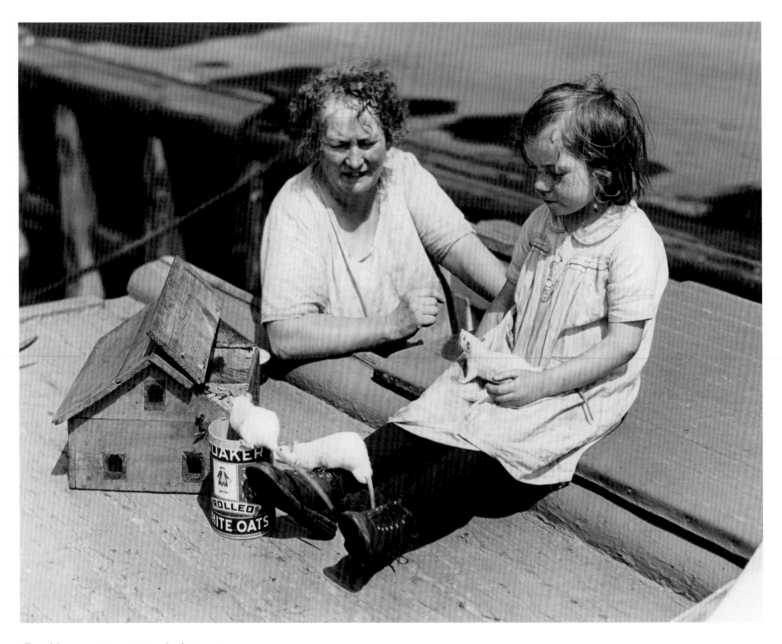

Canal barge pets—a trio of white rats.

NOTES ON THE PHOTOGRAPHS

These notes, listed by page number, include the photographer, each photograph's title, and The Mariners' Museum collection reference number. In some cases a title comes from an inscription added by the photographer; in other instances it derives from notes scrawled in a logbook or on the back of a print.

ii

Edwin Levick

Battleship USS Wyoming
Cruising up the East River, circa
1917, detail

Museum Collection 40275

vi

J. Jay Hirz

Snub Nose of a Submarine in the
New York Navy Yard

Museum Collection
153275

x

Edwin Levick

New York City Skyline, 1912

Museum Collection 29463

4

Edwin Levick

Horse-Drawn Carts Mingle with
Motor Vehicles on South Street

Museum Collection 40277

6

P.L. Sperr

Schooner RR Govin

Museum Collection 5618

8

Edwin Levick

Resolute

Museum Collection 96631

13

Edwin Levick

Crowd Seeing Off the Olympic

Museum Collection 56288

15

Edwin Levick

Unloading Sulfur from the
Mandelta

Museum Collection 60026

16

Lionel Green

Loading Food and Libations onto a
Steamship

Museum Collection 1591

17

P.L. Sperr

Dockworkers Nosing Barge up to
Pier

Museum Collection 5669

19

Edwin Levick

Crafting Templates for a Ship's
Shaft Tunnel

Museum Collection 153497

21

Edwin Levick

Crowd at a Steamship Departure

Museum Collection 92470

24

Edwin Levick

Immigrants—First Sight of Statue
of Liberty on Olympic

Museum Collection 58705

27
P.L. Sperr
Ferries Wilkes-Barre *and* Bound
Brook
Museum Collection 153700

28
P.L. Sperr
Fishing Fleet at Fulton Fish Market
Museum Collection 2322

31
Edwin Levick
Battleship Maryland *in the East
River*
Museum Collection 66235

34
Edwin Levick
*Manhattan Skyline from the
Brooklyn Shore of the East River,
circa 1925*
Museum Collection 103632

37
Edwin Levick
*Riverside Park Overlooking the
Hudson River*
Museum Collection 47365

38–39
Edwin Levick
*View over the East River to
Manhattan,* detail
Museum Collection 21334

40
Edwin Levick
*Longshoremen Transferring Cargo
from Barge to Ship's Hold.*
Museum Collection 53110

41
Edwin Levick
*Aerial View of the East River and
Brooklyn Bridge*
Museum Collection 40403

42
Edwin Levick
*The Five-Masted Merchant
Schooner* Dorothy Palmer
Museum Collection 65870

43
Edwin Levick
The Seamen's Church Institute
Museum Collection 153639

44
P.L. Sperr
Seamen's Church Institute Building
Museum Collection 153640

45
P.L. Sperr
The Schooner Theoline *at
Pier 11*
Museum Collection 154106

46
Edwin Levick
Horse-Drawn Wagons
Museum Collection 8814

47
Edwin Levick
*Horse Carts Waiting outside a
Warehouse*
Museum Collection 60025

48
Edwin Levick
*Dock Street at the Beginning of the
Twentieth Century*
Museum Collection 20021

49
Edwin Levick
Heavy Traffic on South Street
Museum Collection 24273

50
Edwin Levick
Clearing away Snow
Museum Collection 1903

51
Edwin Levick
New York's Political Scene
Museum Collection 55657

52
Edwin Levick
*The Chelsea Docks on Hudson
Avenue*
Museum Collection 19819

54
P.L. Sperr
Ferryboat American Legion
Museum Collection 976

55
Edwin Levick
*Pier 14, North River, New York
City*
Museum Collection 155

56
Edwin Levick
Shamrock IV *and* Resolute
Jockeying for the Start
Museum Collection 51805

57
Levick Collection
Launching Tamerlane, *1933*
Museum Collection 116702

59

Edwin Levick

Majestic *in Dry Dock*

Museum Collection 65115

60

Edwin Levick

Cunard Company Steamship

Museum Collection 20201

62

Edwin Levick

Newtown Creek, Brooklyn

Museum Collection 41255

63

Edwin Levick

Yacht Chrysolite *on Fire, with*
 Patrol Boat

Museum Collection 144665

64

Edwin Levick and Sons

Barge in High Wind

Museum Collection 60244

65

Edwin Levick

Tugs Working in Ice

Museum Collection 43075

66

Edwin Levick

Longshoreman and Coiled Hawser

Museum Collection 81316

67

Edwin Levick

Loading Cargo in Winter

Museum Collection 146046

68

Edwin Levick

Men with Hawsers

Museum Collection 81315

69

Edwin Levick

Steamship Majestic *with Propeller*

Museum Collection 65118

70

J. Jay Hirz

Deck Scene, City of New York
 with Veendam

Museum Collection 153537

71

P.L. Sperr

Suomen Joutsen

Museum Collection 154169

72

P.L. Sperr

Airship Akron *over Ferryboat*
 President Roosevelt

Museum Collection 153164

74–75

Edwin Levick

Hauling in a Hawser at the
 Railroad Docks, detail

Museum Collection 54258

77

P.L. Sperr

New Haven Railroad Tugs,
 Harlem River

Museum Collection 153896

78

Edwin Levick

Passengers Aboard the Olympic

Museum Collection 56283

80

Levick Collection

Boxes of Coconut in Refrigerated
 Storage

Museum Collection 146056

81

Edwin Levick

Rubber Tires Stacked for Export in
 a Ship's Hold

Museum Collection 58968

82

Edwin Levick

Loading Bales of Cotton

Museum Collection 35386

83

Edwin Levick

Unloading Bananas

Museum Collection 20074

84

Edwin Levick

Bananas Being Loaded into
 Waiting Carts

Museum Collection 59849

85

Edwin Levick Collection

Armored Car on South Street

Museum Collection E-11524

86

Edwin Levick

Passenger Compartment of Bus
 Destined for the Middle East

Museum Collection 118648

89

Edwin Levick

Loading Airplane Parts on Pan
 America

Museum Collection 125576

90

Edwin Levick

Pan America

Museum Collection 125579

91

Edwin Levick

Bull Being Loaded onto the Santa
 Teresa

Museum Collection 59690

92

Edwin Levick

Argentine Cattle Disembarking the
 Santa Rosalia

Museum Collection 81940

93

Edwin Levick

Unloading Cork

Museum Collection 153817

94

Edwin Levick

Packing Crates into a Ship's Hold

Museum Collection 81805

95

Edwin Levick Collection

Furness Withy & Company
 Garbage Scows, 1937

Museum Collection 130081

96

Edwin Levick

"Old Salt" Seated on Coiled
 Hawser

Museum Collection 35904

97

Edwin Levick

Painting the Hull

Museum Collection 153973

98

Edwin Levick

Launching the Washington

Museum Collection 115786

100

Edwin Levick

Repairing the Uncowa

Museum Collection 154854

101

Edwin Levick

Stern of the Hickman *in Dry*
 Dock

Museum Collection 45193

102

P.L. Sperr

USS Maine *under Construction in*
 the Brooklyn Navy Yard

Museum Collection 153113

103

P.L. Sperr

Staten Island Shipbuilding
 Company Yards in Kill van Kull

Museum Collection 153859

104–105

Edwin Levick

Ira Bushey Shipyard, detail

Museum Collection 130193

107

Edwin Levick

Ship's Boiler

Museum Collection 44478

108

Edwin Levick

Booking Passage on the White Star
 Line's Luxury Steamship
 Olympic, 1911

Museum Collection 64727

109

Edwin Levick

Launching the Washington

Museum Collection 115793

110

Edwin Levick

Luggage on Deck of Olympic

Museum Collection 58709

111

Levick Collection

Pets on the Berengaria

Museum Collection 66338

112

Edwin Levick

Manhattan from the Deck of the
 Majestic

Museum Collection 60712

114

Edwin Levick

Launch Crew with Trigger
 Mechanism

Museum Collection 116109

115

Edwin Levick

Launching the Virginia

Museum Collection 97282

116

Edwin Levick Collection

Gertrude Vanderbilt Christening the
 Virginia

Museum Collection 119783

117

Edwin Levick

Launching of the Virginia, 1928

Museum Collection 97285

118

Edwin Levick

Motorship J.S. Kungsholm,
 1928

Museum Collection 107693

119

Lionel Green

Luxury Liner Row, circa 1938

Museum Collection 153512

120

Edwin Levick Collection

The Normandie, *1935*

Museum Collection 124964

121

Edwin Levick

Normandie *Entering New York*

Harbor

Museum Collection PB22995

122

Edwin Levick Collection

Queen Mary *Arriving in New*

York, 1936

Museum Collection 153745

123

Edwin Levick Collection

Dockside Perspective on the

Queen Mary, 1936

Museum Collection 127647

124

Edwin Levick

Madame Marie Curie aboard

Olympic with Two Daughters,

1921

Museum Collection 55654

125

Edwin Levick

Photographers on Deck

Museum Collection 55507

126

Edwin Levick

Vincent Astor, His Wife, and

Friends Being Ferried to the

Nourmahal, 1928.

Museum Collection 97395

127

Edwin Levick Collection

Interior of the New York Yacht

Club

Museum Collection 124262

128

Edwin Levick

New York Yacht Club Pier at

Twenty-sixth Street

Museum Collection 91507

129

Edwin Levick

New York Yacht Club Landing,

1927

Museum Collection 91511

130

Edwin Levick

Steam Yacht Minnie W III *at*

Anchor off the Upper West Side

Museum Collection 30473

131

Edwin Levick

New York Yacht Club Landing

Museum Collection 91509

132–133

Edwin Levick Collection

Waiting Steamer Passengers, detail

Museum Collection 58668

134

Edwin Levick Collection

Deck Scene on the Adriatic, *1921*

Museum Collection 55524

135

Photo bears the stamp

PHOTO BY REMY

Russian Immigrant on the Deck of

the Steamer Leviathan, *1914*

Museum Collection 153406

136

Edwin Levick

Ferry Frank A. Cunningham,

1925

Museum Collection 116112

137

P.L. Sperr

Macom *at East Twenty-third*

Street Ferry Terminal, 1934

Museum Collection 154723

138

Edwin Levick

Police Patrol Boat, circa 1923

Museum Collection 37587

139

P.L. Sperr

Pennsylvania Railroad Ferry New

Brunswick, *with the Ferry* Sea

Gate

Museum Collection 153898

140

P.L. Sperr

The President Roosevelt

Arriving at South Ferry,

1932

Museum Collection 154133

141

Edwin Levick

Offloading from the Ellis Island

Ferry

Museum Collection 153698

142

P.L. Sperr

Cleaning Out the Old Ice at

Fulton Fish Market

Museum Collection 153883

143

P.L. Sperr

Iced-over Fishing Vessel at the
Fulton Fish Market Dock

Museum Collection 153666

144

Edwin Levick

Weighing the Catch

Museum Collection 94303

145

Edwin Levick

Fishing Boats at Fulton Fish
Market Dock

Museum Collection 88875

146

Edwin Levick Collection

Crushing Ice for the Fishing Fleet

Museum Collection 94314

147

Photo bears stamp ATLAS
PHOTOS

Men at Fulton Fish Market

Museum Collection 154011

148

Photo bears stamp ATLAS
PHOTOS

Fish Buyers and Sellers at Fulton
Market

Museum Collection 154012

149

Edwin Levick

Freshly Caught Cod and Waiting
Carts on the Dock at Fulton Fish
Market

Museum Collection 114453

150

Edwin Levick

Troop Transport Cruising Past
Manhattan, circa 1918

Museum Collection 151600

152

Edwin Levick

Sailors and Motor Launches with
the USS Pennsylvania

Museum Collection 55031

153

Edwin Levick

Battleship USS Wyoming
Crusing up the East River, circa
1917

Museum Collection 40275

154–155

Edwin Levick

The USS George
Washington *Entering New*
York Harbor, detail

Museum Collection 47453

157

Edwin Levick

Battleship Florida, *with Tugs,*
under the Manhattan Bridge

Museum Collection 88930

158

P.L. Sperr

Aircraft Carrier USS
Lexington

Museum Collection 153235

160

Edwin Levick

Dredges in the East River

Museum Collection 58627

161

Edwin Levick Collection

Mixer and Piler off Greenville,
New Jersey

Museum Collection 135677

162

Edwin Levick

Lumber Barge Steaming into a
Waterfront Berth

Museum Collection 59954

163

Edwin Levick

Barclay Street Station, New York
Central & Hudson River Railroad

Museum Collection 79863

164

Edwin Levick

Ford Trucks Awaiting Shipment,
mid-1920s

Museum Collection 154165

165

Edwin Levick

Rail Cars on Barges, 1920s

Museum Collection 41283

166

Edwin Levick

Harbor Scene

Museum Collection 41685

167

Edwin Levick

Tugs Moving the Steamship
Mutual

Museum Collection 58663

168

Edwin Levick

Steamship Caronia *Docking,*
 circa 1920

Museum Collection 62139

169

Edwin Levick

Dry Dock Sections under Tow

Museum Collection 81311

170

Edwin Levick

A Scow Worker with Italian Line
 Steamship

Museum Collection 143757

171

Edwin Levick

Wash Day aboard the Barge
 Damass

Museum Collection 60040

172

P.L. Sperr

Children on a Grain Barge

Museum Collection 8395

173

P.L. Sperr

Old Ice Barge

Museum Collection 7886

174

P.L. Sperr

Canal Barge Pets

Museum Collection PJ36

182

P.L. Sperr

RR Govin, *1919*

Museum Collection 154116

Page 182: Spars and rigging of the RR *Govin.*

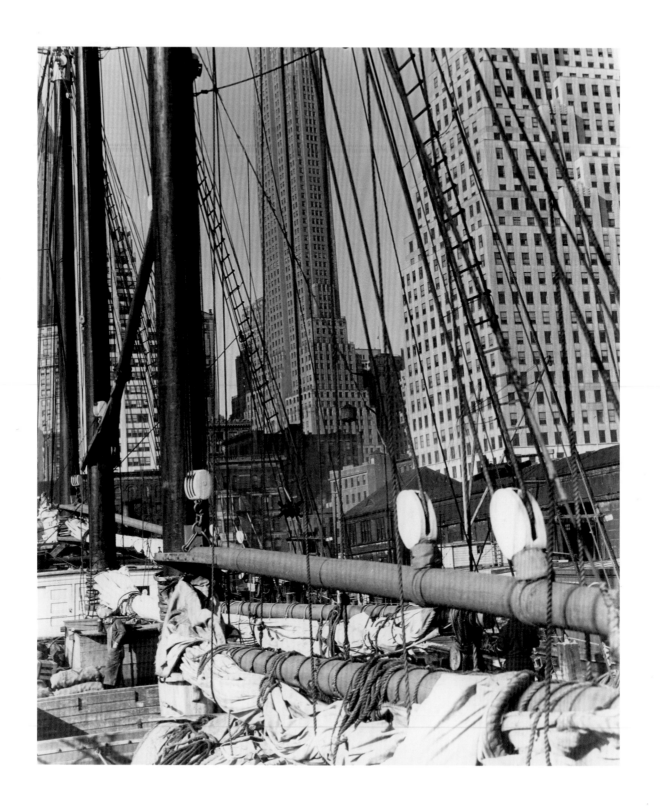